W9-BRA-915

IN THE BEGINNING, ALL THE WORLD WAS AMERICA.

John Locke

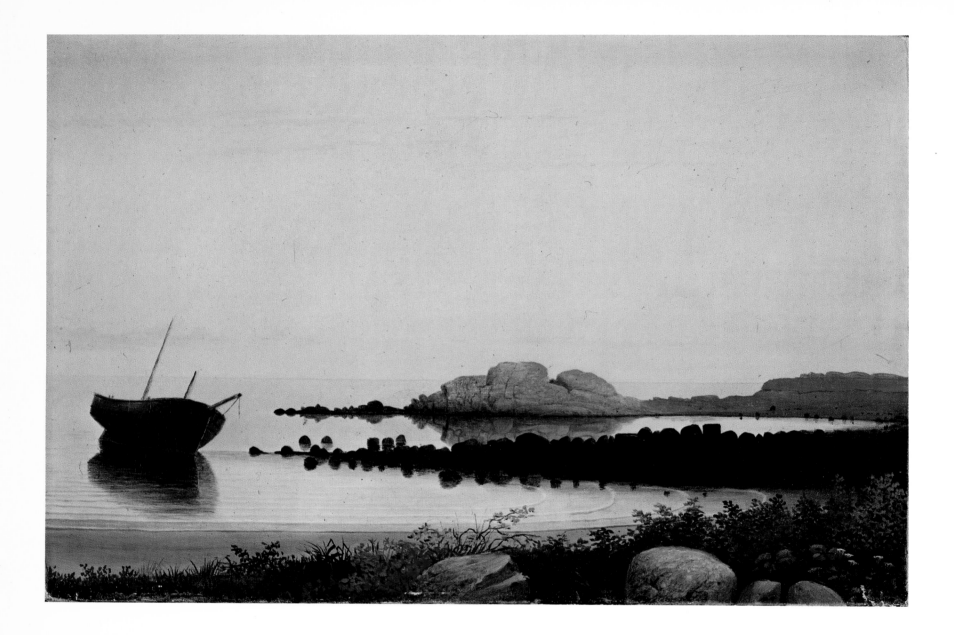

THE NATURAL PARADISE

PAINTING IN AMERICA 1800-1950

THE MUSEUM OF MODERN ART, NEW YORK

EDITED BY KYNASTON MCSHINE

ESSAYS BY

BARBARA NOVAK

ROBERT ROSENBLUM

JOHN WILMERDING

This book and the exhibition it accompanies
have been made possible
through the generous support of the
National Endowment for the Arts in Washington, D.C.,
a Federal agency.

Copyright © 1976 The Museum of Modern Art
All rights reserved
Library of Congress Catalog Card Number 76-23513
Paperbound ISBN 0-87070-504-0
Clothbound ISBN 0-87070-505-9
Designed by Carl Laanes
Type set by Custom Composition Company, York, Pa.
Printed by Halliday Lithograph Corporation, West Hanover, Mass.
Color printed by Lebanon Valley Offset, Annville, Pa.
The Museum of Modern Art
11 West 53 Street, New York, N.Y. 10019
Printed in the United States of America

Frontispiece: FITZ HUGH LANE
Brace's Rock, Eastern Point, Gloucester. 1863
Oil on canvas, 10 x 15 in. (25.4 x 38.1 cm.). Private collection
Endpapers: Detail from
ASHER B. DURAND. *In the Woods.* 1855

GRATEFUL acknowledgment is made to the following pub-
lishers for permission to reprint copyrighted material:

From *Starting from San Francisco* by Lawrence Ferlinghetti,
copyright © 1961 by Lawrence Ferlinghetti. Reprinted by
permission of New Directions Publishing Corporation.

From *The Poetry of Robert Frost* edited by Edward Connery
Lathem. Copyright 1923, © 1969 by Holt, Rinehart and
Winston. Copyright 1951 by Robert Frost. Reprinted by
permission of Holt, Rinehart and Winston, Publishers.

From *Studies in Classic American Literature* by D. H.
Lawrence. Copyright 1923, 1951 by Frieda Lawrence. Copy-
right © 1961 by the Estate of the late Frieda Lawrence. All
rights reserved. Reprinted by permission of The Viking Press,
Inc.

From *The Complete Poems of Emily Dickinson* edited by
Thomas H. Johnson. Reprinted by permission of Little,
Brown and Company.

I dwell in Possibility—
A fairer House than Prose—
More numerous of Windows—
Superior—for Doors—

Of Chambers as the Cedars—
Impregnable of Eye—
And for an Everlasting Roof
The Gambrels of the Sky—

Of Visitors—the fairest—
For Occupation—This—
The spreading wide my narrow Hands
To gather Paradise—

Emily Dickinson

PREFACE

The Natural Paradise: Painting in America 1800–1950 celebrates the Bicentennial of the United States of America. This bicentenary observance has stimulated numerous evaluations of various aspects of American art, providing the welcome opportunity to examine the true nature of the American achievement and to make some judgments about its overall contribution to art history. This book and the exhibition it accompanies explore a particular theme: the Romantic tradition in American art.

Since its founding, The Museum of Modern Art has acknowledged in its program that other periods of art history can illuminate the present and provide a more general understanding of modern art. The exhibition *Turner: Imagination and Reality,* held in 1966, manifested Turner's transcendent vision and enhanced our perception of contemporary developments in painting, particularly the work of those abstract painters whose expressionist manipulation of light and color echoed the nineteenth-century English artist's elemental purity and painterliness.

The Museum of Modern Art has always had a special commitment to the visual arts in America. In 1930, the year after its founding, the first painting acquired for the collection was Edward Hopper's *House by the Railroad* (1925); in the same year the exhibitions *Paintings by 19 Living Americans* and *Homer, Ryder, Eakins* were held.

Since then all aspects of American art have been exhibited, including the historical survey *Romantic Painting in America,* directed by James Thrall Soby and Dorothy Miller in 1943. That exhibition was one of the first to trace the tradition of Romanticism in American painting.

At the time no one could have foreseen the subsequent remarkable achievements of the Abstract Expressionists. Their notable work, so sublime in feeling, compels another exploration and survey of American Romanticism.

It has been a privilege to bring together these masterpieces of nineteenth- and twentieth-century art from public and private collections. On behalf of the Trustees of The Museum of Modern Art, I wish to acknowledge a great debt of gratitude to all of the lenders to the exhibition who have graciously consented to share their works with a wide audience on this occasion. Particular thanks are extended to the institutions and their Trustees who generously agreed in this special year to allow their works to be seen in this context. Their cooperation and enthusiasm have been an immeasurable source of encouragement.

The Trustees of The Museum of Modern Art gratefully thank the National Endowment for the Arts, which has provided funds to make this project possible, and the New York State Council on the Arts, which provides general support for the Museum's exhibition program. Both have contributed generously in recent years to this Museum and have been of great importance to the creative arts in America.

The preparation of the exhibition and this accompanying volume represents a complex undertaking. To all who have given unstintingly of their advice and time, I am profoundly grateful.

Three distinguished scholars—Barbara Novak, Robert Rosenblum, and John Wilmerding—have been invited to share their insights with us. Their contributions enhance our knowledge and understanding of American art. They have moreover facilitated my task in organizing the exhibition, and their goodwill is acknowledged with profound appreciation.

Many museum colleagues have provided invaluable assistance. My thanks go to Robert T. Buck, Jr., at the Albright-Knox Art Gallery, Buffalo; Wilder Green at The American Federation of Arts, New York; John Maxon, Milo M. Naeve, and A. James Speyer at The Art Institute of Chicago; K. G. Pontus Hultén at the Centre National d'Art et de Culture Georges Pompidou, Musée National d'Art Moderne, Paris; Mark Davis at the Century Association, New York; Roy Slade and Dorothy W. Phillips at the Corcoran Gallery of Art, Washington, D.C.; Ian McKibbin White and William H. Elsner at The Fine Arts Museums of San Francisco; Abram Lerner and Charles W. Millard at the Hirshhorn Museum and Sculpture Garden, Washington, D.C.; Henry Geldzahler, John K. Howat, and Natalie Spassky at The Metropolitan Museum of Art, New York; Laura C. Luckey at the Museum of Fine Arts, Boston; Joshua C. Taylor, Walter Hopps, and William H. Truettner at the National Collection of Fine Arts, Washington, D.C.; Charles B. Ferguson at the New Britain Museum of American Art, New Britain, Connecticut; George W. Neubert at The Oakland Museum, Oakland, California; Evan H. Turner, Anne d'Harnoncourt, Joseph Rishel, and Darrel L. Sewell at the Philadelphia Museum of Art; Laughlin Phillips and James McLaughlin at The Phillips Collection, Washington, D.C.; Henry T. Hopkins at the San Francisco Museum of Modern Art; Willis F. Woods at the Seattle Art Museum; Jon Nelson at the University of Nebraska Art Galleries, Lincoln, Nebraska; James Elliott and Peter O. Marlow at the Wadsworth Atheneum, Hartford, Connecticut; Thomas N. Armstrong III and Barbara Haskell at the Whitney Museum of American Art, New York; and Alan Shestack and Theodore E. Stebbins, Jr., at the Yale University Art Gallery, New Haven, Connecticut.

Doris Bry, Eugene C. Goossen, Henry A. LaFarge, Dominique de Menil, and Irving Sandler have been enormously helpful, for which I am deeply appreciative.

The Hirschl and Adler Galleries, the Coe Kerr Gallery, and the Washburn Gallery of New York and the Vose Galleries of Boston have provided valuable information.

Particular thanks are owed to Mary Davis for providing this publication with the chronicle and selected bibliography. Kate Linker generously assisted in the research of the texts by twentieth-century artists. I wish to express my thanks to the editors and publishers of the contemporary artists who are cited.

This undertaking has involved many of my colleagues at the Museum, and without their enthusiasm and cooperation, this book and the exhibition it accompanies could not have been realized. I am especially grateful to William Rubin, Director of the Department of Painting and Sculpture. Richard Palmer, Coordinator of Exhibitions, with his customary patience and goodwill, has supervised the many administrative details in the organization of this project.

I especially acknowledge the contribution of Jane Fluegel, who guided this complex book through all its phases. Her perceptions and suggestions were invaluable. Another special expression of gratitude must go to Carl Laanes, whose design has enriched this volume. With his usual care Jack Doenias oversaw the printing and production of the book, and Frances Keech handled the many details of correspondence for permissions; I wish to thank them both.

The debt owed to the staff of the Department of Painting and Sculpture is immeasurable, particularly that to Laura Rosenstock, Curatorial Assistant. She has been both a collaborator and researcher, giving untiring attention to the innumerable details every phase of this task presented. Diane Farynyk has handled the voluminous correspondence and carried out many related duties with extraordinary skill. Her crucial supporting work has been appreciated.

Jean Volkmer and her conservation department have manifested all their professional expertise as problems have arisen. I am grateful to them. The Registrar's department has coped with various challenges of this project.

8

Among many other members of the Museum's staff who have assisted in various ways I would like to thank Judith Cousins, Fred Coxen, Kate Keller, Francis Kloeppel, Richard H. Koch, Carolyn Lanchner, John Limpert, Jr., Carl Morse, and Richard Tooke.

Finally, I wish to express my appreciation to many friends and allies who have willingly assisted in solving problems and have listened during the many months this book and exhibition have been in preparation. They gave encouragement, advice, and support when needed. It is impossible to list here all those who have so liberally given of their time, skill, and knowledge. This enterprise would have been impossible without the insights gained from many authors and teachers.

This book and the exhibition are presented as a tribute to American art. Homage is paid to the artists represented here; they have enriched the lives of all of us. To those who have helped shape a deep love for American art and the Romantic Spirit, *The Natural Paradise* is respectfully dedicated.

Kynaston McShine

ILLUSTRATIONS

THE PRIMAL AMERICAN SCENE

by Robert Rosenblum

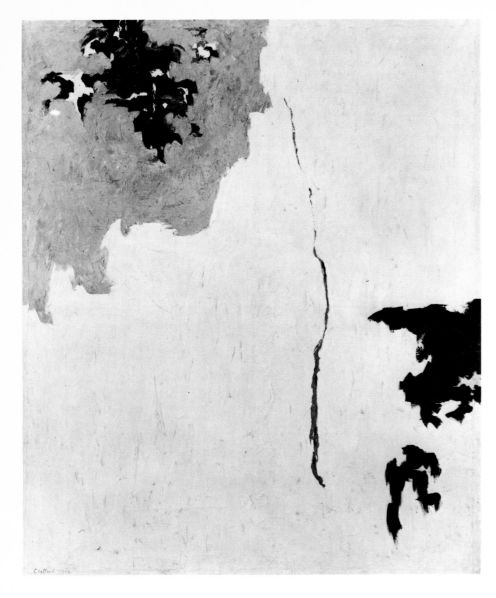

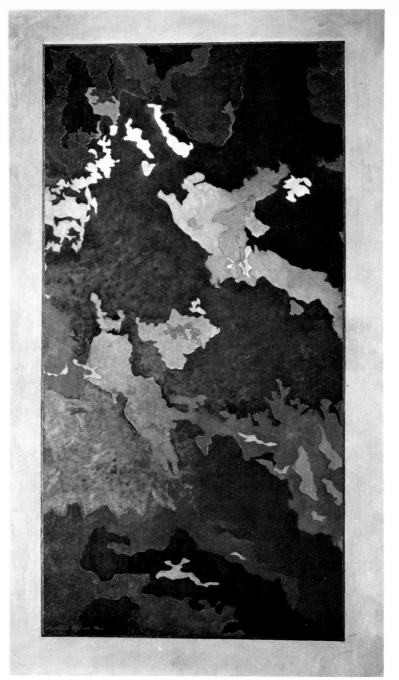

above: CLYFFORD STILL. *1949-F.* 1949
Oil on canvas, 80 x 65 in. (203.2 x 165.1 cm.)
Collection Carter Burden, New York

right: AUGUSTUS VINCENT TACK. *Night, Amargosa Desert.* 1937
Oil on canvas mounted on composition board, 71½ x 35 in. (181.6 x 88.9 cm.)
The Phillips Collection, Washington, D.C.

IN 1943, The Museum of Modern Art held an exhibition entitled *Romantic Painting in America.* The tracing of this elusive theme—for it is easier to feel what Romanticism might be than to define it—began in the late eighteenth century with paintings by John Singleton Copley and Benjamin West of vast international importance, but ended in the early 1940s with many works that today, even at our most generous, look embarrassingly slight and provincial. Do we still remember, or even wish to reconsider, artists like Robert Archer, Eugene Ludins, Elizabeth Sparhawk-Jones, Paul Mommer—to name just a few who brought this survey to a conclusion? Their oblivion would almost suggest that this long Romantic tradition in America reached its final gasp during the Second World War.

What happened afterward, of course, is a familiar story. It seemed, especially at the time, that suddenly, almost out of nowhere, American painting loomed into an international importance that it had not enjoyed since the days of Copley and West, who were after all expatriates working in a London milieu. Painters whose names were Arshile Gorky, Barnett Newman, Jackson Pollock, Mark Rothko, and Clyfford Still could not only, by the late 1940s, hold their own against European art of the decade, but could even be claimed to have successfully rerouted the mainstream of Western painting from Paris to New York. The art-historical mythology constructed around this brilliant surge of American painting after the Second World War implied two drastically different artistic eras, a kind of B.C. and A.D. chronology. B.C. would mean American painting before the War—perhaps lovable to locals, but quickly discerned as provincial, awkward, and inconsequential. A.D. would mean, in the words of The Museum of Modern Art's round-up exhibition, *The New American Painting,* a display of national pride that was shown, mainly to responses of hostility or bewilderment, in eight European countries in 1958–59.

So dazzlingly "new" did this painting appear that, at first glance, these canvases looked like nothing under the sun. But gradually, European twentieth-century ancestors began to reveal themselves—among them Kandinsky, Miró, Masson, and Mondrian, and even Cubism and Impressionism. The grandeur of the American achievement seemed to demand a search for equally grand roots, especially to justify the sense that the spearhead of European modernism had now crossed the Atlantic. Like most sweeping generalizations, this one was both true and false. The true part had to do with the fact that, after 1945, American painting, to almost everyone's surprise, did demand the kind of international attention it had seldom merited before, and therefore did adopt the role of heir to European avant-garde traditions. The false part had to do with the fact that the urge to establish the noblest European pedigree for the *New American Painting* kept many from seeing that the roots of this painting were also to be found on the American side of the ocean. Now, in the year of the Bicentennial, it is especially appropriate to explore the native soil from which the Abstract Expressionists grew. This book and the exhibition it accompanies should therefore help to reassess the proportions of America to Europe in their achievement, and to consider what aspects of their work should be regrafted onto American trees. For in Europe, as in America, the masters of Abstract Expressionism included here—Gorky, Gottlieb, Newman, Pollock, Rothko, and Still—are usually thought about in a context that turns its back not only upon American painting between the two world wars, but upon indigenous nineteenth-century traditions as well.

That this balance needs redressing should be clear from a single case, that of Augustus Vincent Tack. One would think that anybody who had ever visited The Phillips Collection in Washington, D.C.—and that obviously would include most of the professional audience concerned with twentieth-century art—would have noticed that Tack's works from the 1920s to the 1940s offered, in their vision of primeval landscapes and skyscrapes reduced to near-abstract patterns, the closest imaginable prophecy of Clyfford Still (compare Tack's *Night, Amargosa Desert* with Still's painting, opposite page); and that anybody who

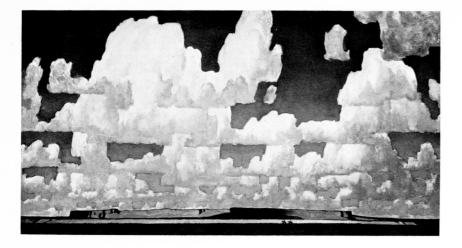

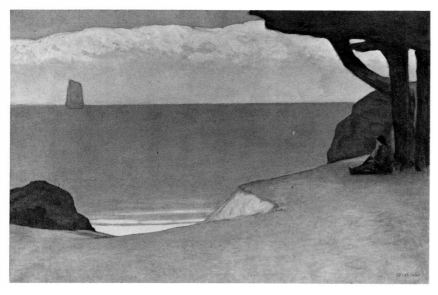

MAYNARD DIXON. *Cloud World.* 1925
Oil on canvas, 34 x 62 in. (86.4 x 157.5 cm.)
Collection Mr. and Mrs. Clay Lockett, Tucson, Arizona

GOTTARDO PIAZZONI. *Decoration for over the Mantel.* c. 1926–27
Oil on canvas, 30¼ x 46¼ in. (76.8 x 117.5 cm.)
San Francisco Museum of Modern Art. Albert M. Bender Collection

ventured further to see Tack's immense theater curtain of 1944 at the Lisner Auditorium of George Washington University in Washington, D.C., would not only have swiftly added this heroic accomplishment to any pantheon of "modernist" painting before the Abstract Expressionists, but would again have noticed in the cosmic subject (entitled *The Spirit of Creation, or Time and Timelessness*) and in the monumental dimensions (so daring for an abstract painting) a firm American foundation for the forms and mystical ambitions of Still's art. But in fact, Tack's name unaccountably went unmentioned in virtually all standard surveys of American twentieth-century art or, for that matter, of Abstract Expressionism, and it is only now, in the 1970s, that his work and its connections with later developments are beginning to be disclosed.

There are going to be many such shocks of recognition in the works of as yet unstudied American artists who preceded the leap from provincial to international status. Two California artists of Tack's generation—Gottardo Piazzoni and Maynard Dixon—also add to this exhibition some early twentieth-century surprises that may make the rush to Abstract Expressionism less precipitous. The Swiss-born Piazzoni, for one, seems to have paralleled, in California rather than the Alps, such contemporary Swiss developments as Ferdinand Hodler's and Augusto Giacometti's distillations of nature into a world of Symbolist silence and near-abstract purity. And in the case of Dixon, too, a painting like *Cloud World* (left, above) obliges us to reconsider the landscape origins of painters like Still as well as thickening the context for Georgia O'Keeffe's later recreations of Western skies. In fact, traditionally honored masters like O'Keeffe, as well as Milton Avery, Arthur G. Dove, Marsden Hartley, and John Marin, are surely going to provide stronger foundations for understanding painting after 1945. (It was only when an artist of Rothko's stature claimed his admiration for and debt to Avery—so clearly revealed here—that a tentative bridge between the two worlds was projected.) But in general, until now

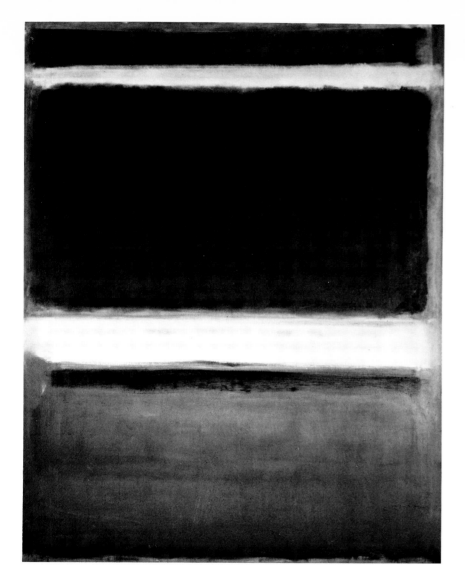

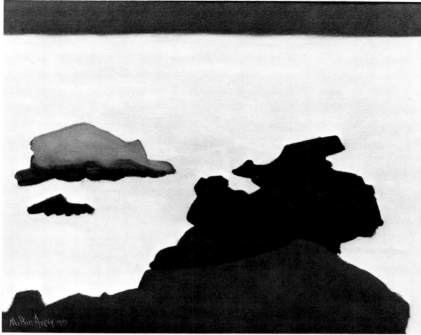

MARK ROTHKO. *Magenta, Black, Green on Orange.* 1949
Oil on canvas, 85½ x 64¾ in. (217.1 x 164.5 cm.)
Estate of Mrs. Mark Rothko

MILTON AVERY. *White Sea.* 1947
Oil on canvas, 30 x 40 in. (76.2 x 101.6 cm.)
Collection Mr. and Mrs. Warren Brandt, New York

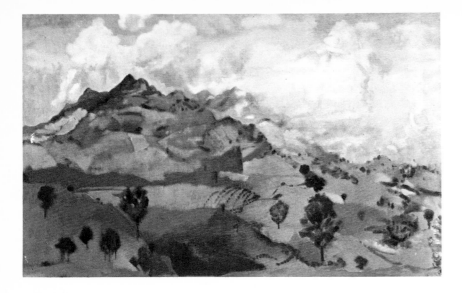

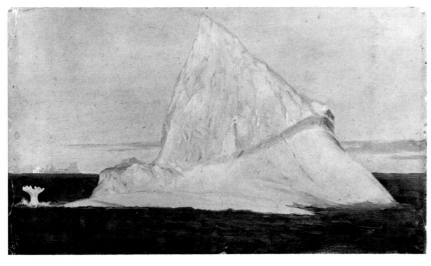

ARTHUR B. DAVIES. *The Umbrian Mountains.* 1925
Oil on canvas, 25⅞ x 39⅞ in. (65.7 x 101.3 cm.)
Corcoran Gallery of Art, Washington, D.C.

FREDERIC EDWIN CHURCH. *Iceberg.* 1859
Pencil and oil on cardboard, 12 x 20⅛ in. (30.6 x 51.1 cm.)
Cooper-Hewitt Museum of Design, Smithsonian Institution, New York

American painting before Abstract Expressionism seemed to be the parochial domain of critics and historians who were often less than knowledgeable about events across the Atlantic; whereas American painting after 1945 seemed to belong to an audience concerned exclusively with mainline modernism, a group that was happy to forget the frequently awkward, indigenous traditions in order to welcome the glories of Abstract Expressionism to the forefront of modern art.

It is high time to join these two worlds, and to find out whether Rothko and Pollock, for instance, are not as compatible with O'Keeffe and Ryder, or even Heade and Homer, as they are with Matisse and Masson. One means of testing this is the way of this survey, which would trace American landscape continuities from the early nineteenth-century to the 1950s, continuities that pertain not only to pictorial traditions, but inevitably to the facts of native American landscape experience, absorbed by all these artists at home and reflected even when they travel, like Frederic E. Church, to the tropical Edens of Latin America or the no-man's land of Labrador (left, below), or like Arthur B. Davies, to the civilized mountains and valleys of Italy (left, above). Thus, in this Bicentennial anthology, certain moods, certain configurations recur so often that, upon finally arriving in the metaphorical world of Abstract Expressionism, we can all the more easily recognize the sources of those feelings and shapes that at first seemed so unfamiliar.

The typical Rothko, for example, has often been described in terms of its presentation of impalpable luminosity, in which one or two horizontal divisions are remotely evoked but are left in a state of organic process that implies a primitive, inchoate world as yet undefined by a rational, geometric order. On American grounds, Rothko's special fusion of lambent color and atmospheric expansiveness has occasionally been related to Avery's painting of the 1940s, but it is remarkable, too, how common this image of primordial light is in earlier American landscape, especially in the Luminist mode of the nineteenth century.

Augustus Vincent Tack. *Aspiration.* c. 1931
Oil on canvas, 76½ x 135½ in. (194.3 x 344.2 cm.)
The Phillips Collection, Washington, D.C.

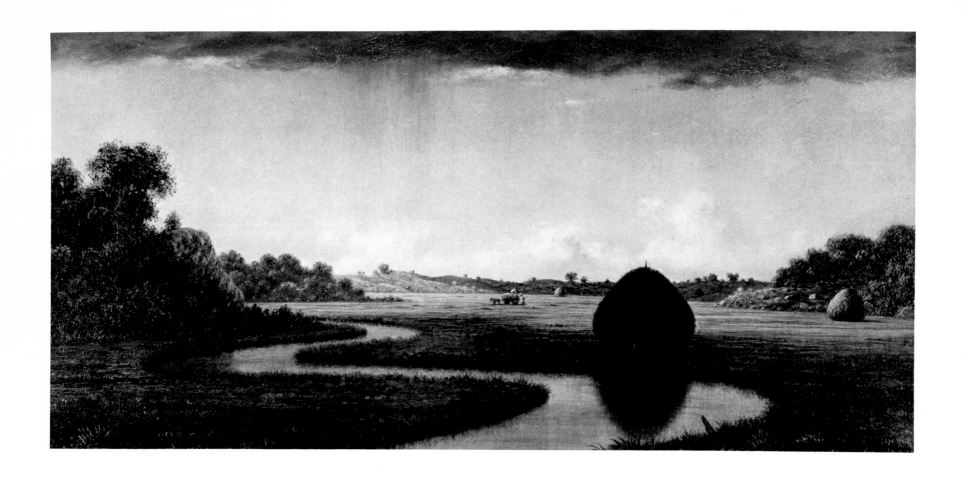

MARTIN JOHNSON HEADE. *Newburyport Marshes: Passing Storm.* c. 1865–70
Oil on canvas, 15 x 30 in. (38.1 x 76.2 cm.)
Bowdoin College Museum of Art, Brunswick, Maine

SANFORD R. GIFFORD. *Kauterskill Falls.* 1862
Oil on canvas, 48 x 39⅞ in. (121.9 x 101.4 cm.)
The Metropolitan Museum of Art, New York
Bequest of Maria De Witt Jesup, 1915

ALBERT BIERSTADT. *Cloud Study: Sunset.* c. 1870–90.
Oil on paper mounted on board, 13⅜ x 18⅞ in. (34 x 48 cm.)
The Detroit Institute of Arts
Gift of Mr. and Mrs. Harold O. Love

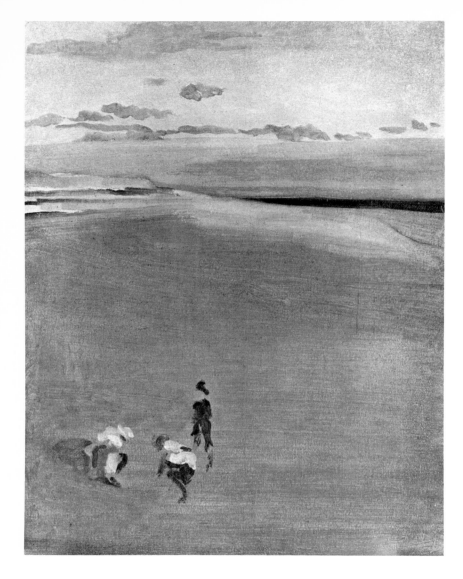

above: JAMES ABBOTT MCNEILL WHISTLER. *Beach at Selsey Bill.* c. 1865
Oil on canvas, 24 x 18¾ in. (61 x 47.7 cm.)
New Britain Museum of American Art, New Britain, Connecticut

opposite: THOMAS WILMER DEWING. *The White Birch.* c. 1896–99
Oil on canvas, 42 x 54 in. (106.7 x 137.2 cm.)
Washington University Gallery of Art, St. Louis

22

Thus, Martin Johnson Heade's *Newburyport Marshes: Passing Storm* (page 20) already immerses us in a Book of Genesis terrain, where a sweeping panoramic horizon, echoed in the dark strip of cloud above, propels us into an all-pervasive sunlight that seems to radiate far beyond the confines of the painting. Again and again, we experience in Heade's landscapes, or in those by John Frederick Kensett and Fitz Hugh Lane, that silent, primordial void of light and space where material forms, whether animal, vegetable, or mineral, are virtually pulverized or banished by the incorporeal deity of light. Sanford R. Gifford's *Kauterskill Falls* (page 21) also takes us to such a site, where distant rock, water, and mountain become as apparitional in their luminous but intangible presence as the uncongealed cloud shapes that hover in Rothko's paintings. Albert Bierstadt's *Cloud Study: Sunset* (page 21) explores in miniature the glowing majesties of ethereal spaces; and of course, such completed spectacles as Church's view of the volcanic mountain Cotopaxi in Ecuador (page 51) evoke the first fires of Creation in the blazing vista of an Andean site that, for the intrepid nineteenth-century artist-traveler, was even purer than the relatively overpopulated and over-visited Alps or Catskills.

The sense of a strange, haunting openness—one, incidentally, that European critics in the 1950s discerned in Abstract Expressionist painting and associated with the awesome spaces of America—can even be experienced in the work of those later nineteenth-century American artists who were content to whisper rather than to shout, and who remained within the confines of more intimate, domesticated landscapes inhabited by people of Jamesian gentility. They, too, would often set their fragile and anonymous dramatis personae against strangely open, luminous spaces that evoke a primal landscape scene. Thus, both James Abbott McNeill Whistler's English beachscape at Selsey Bill (left) and Thomas Wilmer Dewing's *The White Birch* (opposite) offer the poignant contrast of figures excerpted from a world of nineteenth-century elegance and absorbed in unbounded light and atmosphere, articulated

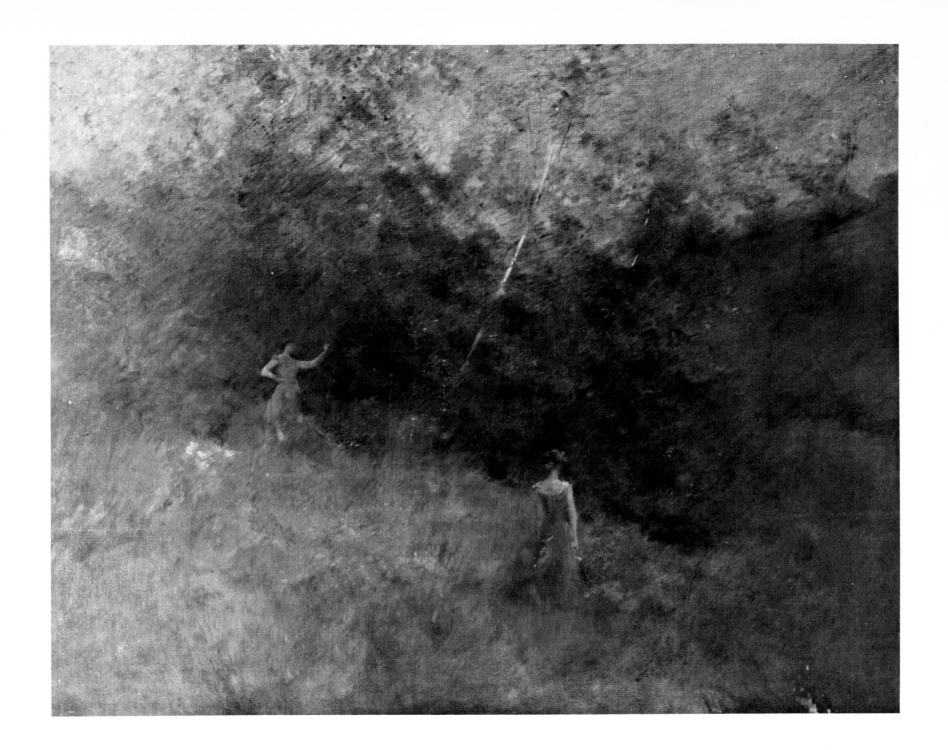

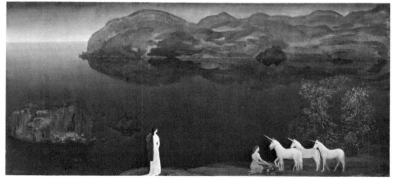

only by the most tremulous ground plane. Strangely unprotected in these empty, unlocalized spaces (Whistler's beach could as easily be on Long Island as in England), these figures in contemporary dress seem like wanderers who have left their homes and intruded upon a silent, almost barren territory. The mood, especially in Dewing, now changes from outward to inward, and the landscape becomes more imaginary than real. In art-historical terms, it is a shift to the realm of Symbolist painting, where such luminous, hushed stillness conjures up primal experiences that are more psychological than cosmological.

It is curious to see how often this mood of uncanny quiet and mystery recurs in the twentieth century, not only in the work of Arthur B. Davies, whose landscapes can be so ideally harmonious and un-polluted that we can unhesitatingly accept that the local fauna are unicorns (left, below), not horses, but in that of Maxfield Parrish (at long last included here within the traditional pantheon of early twenti-eth-century masters), who can cast a spell of light and silence so pure and so intense that, were we to see the students in his pristine New England country schoolhouse (left, above), aglow with magical sun-light, we would not be surprised to find them belonging to as strange a race as Davies's unicorns. And even Edward Hopper's overtly literal records of twentieth-century America can often share the poignancy of these remote idyls. His record of the sun setting across railroad tracks (opposite, above) that stretch out as endlessly as Lane's horizons (opposite, below) may at first seem more like documentary American-Scene prose than a poetic meditation; yet at second glance, the mysteries of the American landscape tradition begin to dominate, with the unbounded void of sunset glow quietly creating a timeless setting that seems to predate and postdate by eons the timebound railroad tracks and tower that pass before it.

The depiction of such luminous, expansive silence, associated with a primeval nature only recently touched by the mind and hand of man, has its counterpart in images of a no less primeval chaos, whether that of

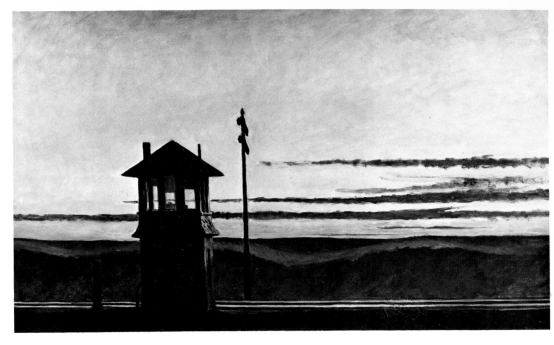

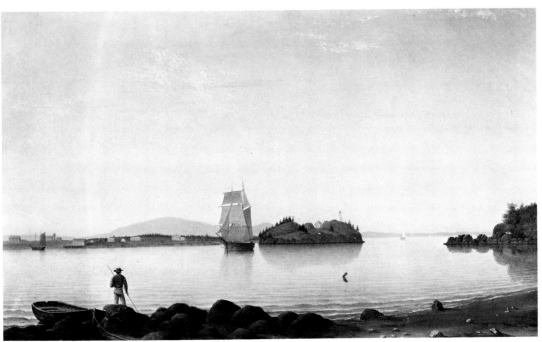

opposite above:
MAXFIELD PARRISH. *Village School House.* 1937
Oil on composition board, 31 x 25 in. (78.8 x 63.5 cm.)
Everson Museum of Art of Syracuse and Onondaga County,
Syracuse, New York
Extended loan from the Pratt-Northam Foundation

opposite below:
ARTHUR B. DAVIES. *Unicorns.* 1906
Oil on canvas, 18¼ x 40¼ in. (46.4 x 102.3 cm.)
The Metropolitan Museum of Art, New York
Bequest of Lillie P. Bliss, 1931

right above:
EDWARD HOPPER. *Railroad Sunset.* 1929
Oil on canvas, 28¼ x 47¾ in. (71.8 x 121.3 cm.)
Whitney Museum of American Art, New York
Bequest of Josephine N. Hopper

right below:
FITZ HUGH LANE. *Owl's Head, Penobscot Bay, Maine.* 1862
Oil on canvas, 16 x 26 in. (40.6 x 66.1 cm.)
Museum of Fine Arts, Boston
M. and M. Karolik Collection

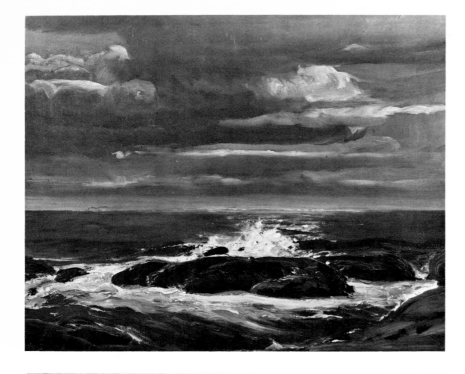

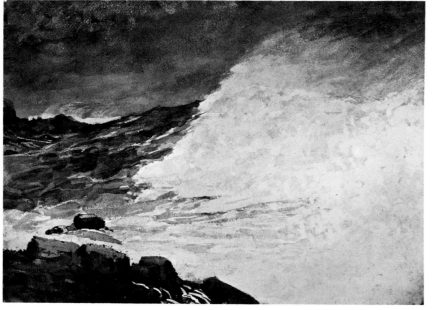

water or of matter, of foaming surf or of mountain chasms. It is fascinating to see, for instance, how constantly the Romantic theme of a turbulent sea recurs in this anthology, whether in literal or in fantastic terms. Albert Pinkham Ryder and Winslow Homer offer the classic polarity here between the imaginary and the empirical. Ryder invents storm-swept, moonlit seas (opposite) as mythic environments in which remote legends could be enacted, whereas Homer literally confronts and documents the savage pounding of the Atlantic Ocean on the rocky shores of Prout's Neck, Maine (left, below). The archetypal viewpoints of these two masters were to have continuous consequences in the early twentieth century, not only in the *Flying Dutchman* of Eilshemius (page 28), a passionate variation of Ryder's visionary painting (page 28), but in George Bellows's view of an Atlantic coastline (left, above) almost as threatening as Homer's Maine or in Edwin Dickinson's spectral evocation of a stranded brig (page 29), which hovers precariously between the literal, in its glimmers of palpable rock and wood, and the hallucinatory, in its molten, ectoplasmic atmosphere. And of course, the most prominent masters of the early twentieth century to perpetuate the traditions of the sea's primal energies are John Marin and Marsden Hartley, who translate these overwhelming forces into the more overtly reductive language of European modernism—the crystalline thrusts of dynamic Cubist planes in Marin (page 31), the heaving groundswell of Cézanne's volumes in Hartley (page 30). But once more, such American marine traditions persisted into younger generations, as seen in two works by Jackson Pollock, the early *Seascape* of 1934 (page 31), whose awkward but authentic passions, constrained within the smallest dimensions, bear out the artist's often-quoted statement of 1944 that Ryder was the only American painter who interested him, and *The Deep* (page 121), a late painting of 1953, whose plunging infinities, from foaming white surface to darkest depths, offer one of the most literal references in Pollock's mature work to the elemental powers of nature so explicit in his early work.

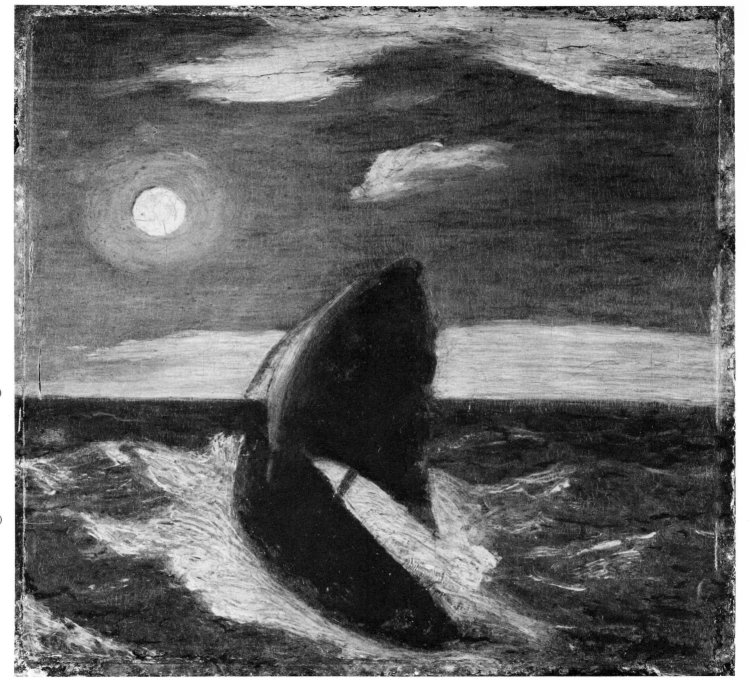

opposite above:
GEORGE BELLOWS
The Sea. 1911
Oil on canvas,
34 x 44⅛ in. (86.3 x 111.9 cm.)
Hirshhorn Museum and
Sculpture Garden,
Smithsonian Institution,
Washington, D.C.

opposite below:
WINSLOW HOMER
Prout's Neck, Breaking Wave
1887. Watercolor,
15⅛ x 21½ in. (38.5 x 54.7 cm.)
The Art Institute of Chicago
Mr. and Mrs. Martin A.
Ryerson Collection, 1933

right:
ALBERT PINKHAM RYDER
Toilers of the Sea. c. 1880–84
Oil on wood,
11½ x 12 in. (29.2 x 30.5 cm.)
The Metropolitan Museum
of Art, New York
George A. Hearn Fund, 1915

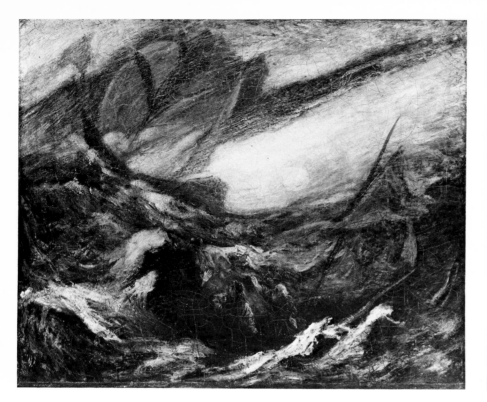

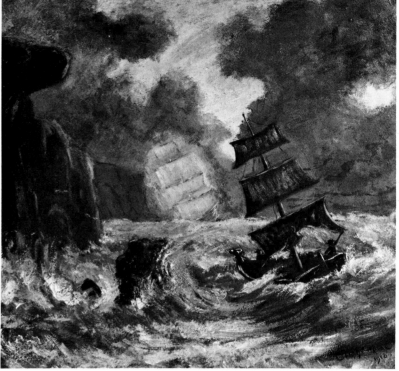

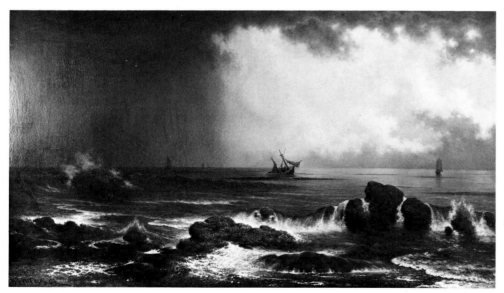

above left:
ALBERT PINKHAM RYDER. *The Flying Dutchman.* Before 1890
Oil on canvas, $14\frac{1}{4}$ x $17\frac{1}{4}$ in. (36.2 x 43.9 cm.)
National Collection of Fine Arts,
Smithsonian Institution, Washington, D.C.

above right:
LOUIS MICHEL EILSHEMIUS. *The Flying Dutchman.* 1908
Oil on composition board, $23\frac{1}{2}$ x $25\frac{1}{2}$ in. (59.7 x 64.8 cm.)
Whitney Museum of American Art, New York

left:
MARTIN JOHNSON HEADE. *Coastal Scene with Sinking Ship.* 1863
Oil on canvas, $40\frac{1}{4}$ x $70\frac{1}{4}$ in. (102.2 x 178.4 cm.)
Shelburne Museum, Inc., Shelburne, Vermont

opposite:
EDWIN DICKINSON. *Stranded Brig.* 1934
Oil on canvas, 40 x 50 in. (101.6 x 127 cm.)
Museum of Fine Arts, Springfield, Massachusetts
Government Collection

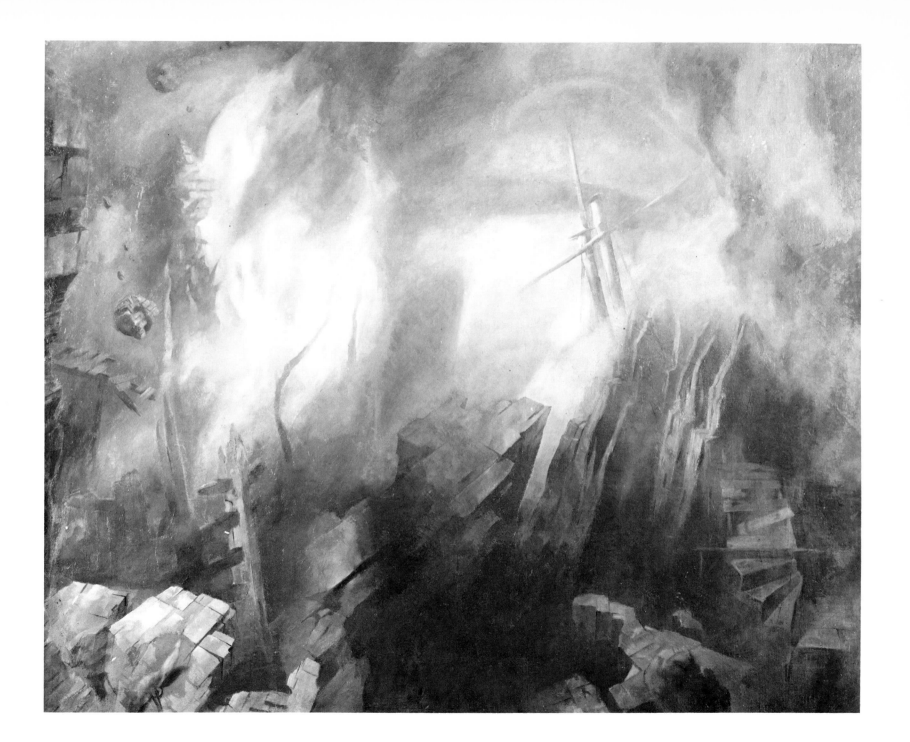

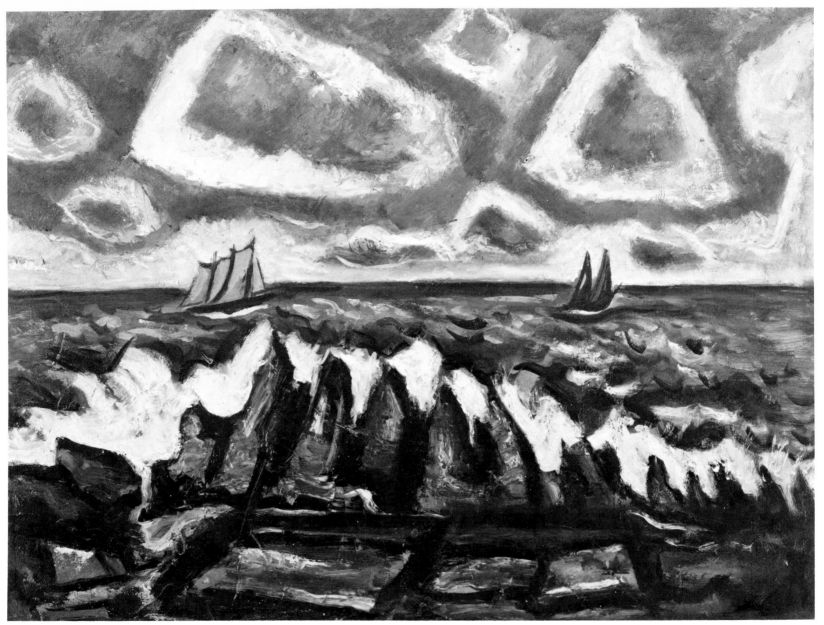

above: MARSDEN HARTLEY
Northern Seascape—Off the Banks. 1936–37
Oil on composition board, 18¼ x 24 in. (46.4 x 61 cm.)
Milwaukee Art Center. Bequest of Max E. Friedman

opposite above: JOHN MARIN. *Buoy, Maine.* 1931
Watercolor, 14¾ x 19¼ in. (37.5 x 48.9 cm.)
The Museum of Modern Art, New York
Gift of Philip L. Goodwin

opposite below: JACKSON POLLOCK. *Seascape.* 1934
Oil on canvas,
12 x 16 in. (30.4 x 40.6 cm.)
Collection Lee Krasner Pollock

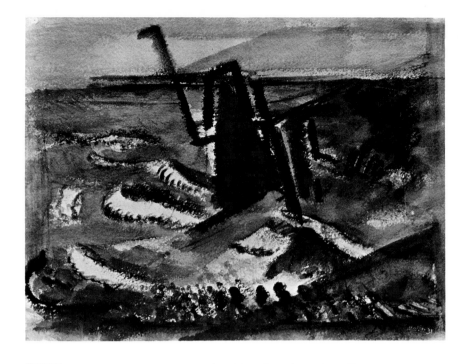

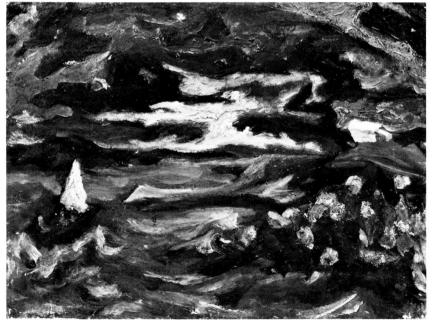

In this context, it should be remembered that Pollock's one-man show of 1948 at Betty Parsons Gallery was organized around the theme of the four elements—air, fire, earth, and water—finally rendered with poured skeins of paint that liberated them still further from the congested materiality of pigment that clung to such early efforts to render intangible forces as *The Flame* of c. 1934–38 (page 53). This pursuit of a primeval nature was, in fact, a persistent muse among Pollock's contemporaries, whether realized in literal or abstract terms. Mark Tobey's *Edge of August* (page 113), a translation of nature's teeming energies into an allover calligraphy that is precise in its threaded detail but ghostly in total effect, is one such parallel; but so, too, is much of the work of Andrew Wyeth, so often maligned by audiences attuned to more overtly avant-garde traditions. Thus, Wyeth's *Spring Beauty* (page 32), a view of the springtime burgeoning of flowers, and his *Hoffman's Slough* (page 114), a desolate, scraggy wasteland, restate, with their lean and parched literalism of botanical and geological minutiae, the kind of nature motifs universalized in Tobey's and Pollock's profusions of infinite, microscopic complexities, as well as offering records of the kind of bleak American terrain that was often metamorphosed in the abstract configurations of Clyfford Still and Barnett Newman (whose postcard photographs of Maine, taken in the summer of 1963, select Wyeth-like sites).

But once more, the primeval nature of the 1940s seems to be only a late manifestation of a native tradition. With this in mind, it is worth noting that when William Baziotes and Theodoros Stamos take us back to the pulsating origins of life in *Primeval Landscape* and *The Fallen Fig* (page 34), they subsume such late nineteenth-century American fantasies as Elihu Vedder's Darwinian *The Lair of the Sea Serpent* (page 34), which provides the Victorian pseudoscientific equivalent of the biomorphic pictorial myths of our own century. Similarly, the attraction to other kinds of origins—those of the solar system or of the universe itself—resonates throughout American painting. Barnett Newman's

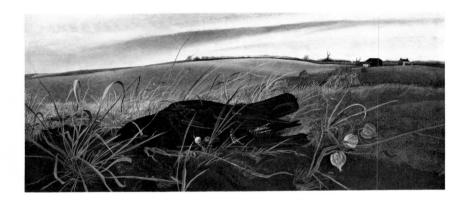

Andrew Wyeth. *Winter Fields.* 1942
Tempera, 17⅜ x 41 in. (44.1 x 104.1 cm.)
Collection Mr. and Mrs. Benno C. Schmidt, New York

Albert Pinkham Ryder. *The Dead Bird.* c. 1890–1900
Oil on wood, 4¼ x 9⅞ in. (10.8 x 25 cm.)
The Phillips Collection, Washington, D.C.

Andrew Wyeth. *Spring Beauty.* 1943
Drybrush and ink, 20 x 30 in. (50.8 x 76.2 cm.)
University of Nebraska Art Galleries, Lincoln
The F. M. Hall Collection

JACKSON POLLOCK. *Summertime (Number 9A, 1948)*. 1948
Oil and enamel on canvas, 33¼ x 218 in. (84.5 x 553.6 cm.)
Collection Lee Krasner Pollock

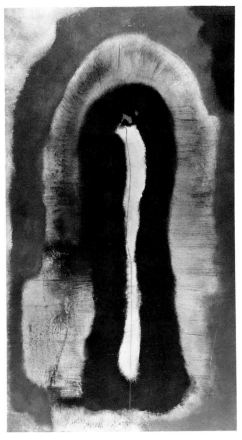

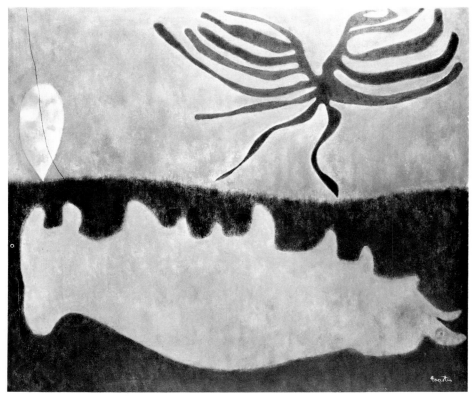

above: THEODOROS STAMOS. *The Fallen Fig.* 1949
Oil on composition board, 48 x 25⅞ in. (121.9 x 65.7 cm.)
The Museum of Modern Art, New York. Given anonymously

left above: ELIHU VEDDER. *The Lair of the Sea Serpent.* 1864
Oil on canvas, 21⅛ x 36 in. (53.7 x 91.5 cm.)
Museum of Fine Arts, Boston. Bequest of Thomas G. Appleton

left below: WILLIAM BAZIOTES. *Primeval Landscape.* 1953
Oil on canvas, 60 x 72 in. (152.4 x 182.9 cm.)
Samuel S. Fleisher Art Memorial, Courtesy Philadelphia Museum of Art

opposite above: BARNETT NEWMAN. *Pagan Void.* 1946
Oil on canvas, 33 x 38 in. (83.8 x 96.6 cm.)
Collection Annalee Newman, New York

opposite below: ADOLPH GOTTLIEB
Flotsam at Noon (Imaginary Landscape). 1952
Oil on canvas, 36⅛ x 48 in. (91.7 x 121.9 cm.)
The Museum of Modern Art, New York. Gift of Samuel A. Berger

Pagan Void (right, above) and the celestial orbs magnetized over Adolph Gottlieb's primitive earth in *Flotsam at Noon (Imaginary Landscape)* (right, below) are, in some ways, only the most recent recreations of the sun and moon worship found especially in the work of many early twentieth-century modernists. As represented here, Arthur G. Dove, Georgia O'Keeffe, and Morris Graves (page 36) all respond with an almost Druidic imagination to the way earth, tree, or animal quiver in response to the luminous magic of primordial solar or lunar energies.

These pagan fantasies evoke myths of a world before man that Longfellow found a century earlier in his "forest primeval" and that have never stopped haunting the motifs and organic forms of so much American painting. Thus, Clyfford Still's craggy paintscapes, with their suggestions of the immeasurably slow changes of prehistoric geology and botany can almost be experienced as abstract translations of Cole's, Bierstadt's, and Moran's views of the American wilderness. And they can also be seen in terms of more immediate twentieth-century precedents, recalling Tack's or Dixon's reduction of the landscape of the American West to jagged patterns that confound tree and mountain, desert and sky, shadow and substance, and revitalizing the spookily animate vocabulary of Charles Burchfield, in whose work the most demonic forces of a primeval nature—including sound and wind—can even absorb houses or churches in a flickering network of crabbed silhouettes (page 37).

Wherever we look in nineteenth- and twentieth-century American landscape painting, we can find, in documentary or visionary terms, that obsessive fascination with the heavenly and hellish extremes of nature. For the nineteenth century, these vistas of luxuriant paradises, magical sunsets, awesome chasms, threatening winds, and turbulent seas seemed to provide relics of a primeval past that could locate the American continent at the origins of a grand cosmic scheme, whether biblical or Darwinian, and that could offer a symbol of purity and timelessness to counter the unceasing pollution of these American Holy Lands by the

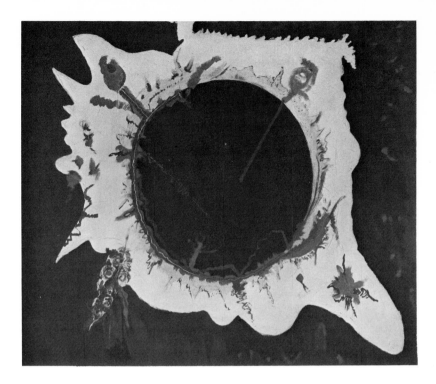

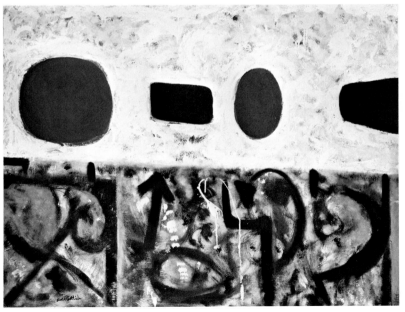

above: MORRIS GRAVES. *Snake and Moon.* 1938–39
Gouache and watercolor, 25½ x 30¼ in. (64.8 x 76.8 cm.)
The Museum of Modern Art, New York

left above: GEORGIA O'KEEFFE. *Evening Star III.* 1917
Watercolor, 9 x 11⅞ in. (22.9 x 30.2 cm.)
The Museum of Modern Art, New York
Mr. and Mrs. Donald B. Straus Fund

left below: ARTHUR G. DOVE. *Sunrise III.* 1937
Wax emulsion on canvas, 24⅞ x 35⅛ in. (63.2 x 89.2 cm.)
Yale University Art Gallery, New Haven, Connecticut
Gift of Katherine S. Dreier
to the Collection Société Anonyme

opposite: CHARLES BURCHFIELD. *House and Tree by Arc Light.* 1916
Watercolor, 20 x 13⅞ in. (50.8 x 35.3 cm.)
Munson-Williams-Proctor Institute, Utica, New York
Edward W. Root Bequest

inroads of modern industry. For the twentieth century, this sacrosanct world of prehistoric nature moved to a more overtly metaphorical realm, providing for the generation of artists following the First World War—from O'Keeffe, Tack, Dove, and Stella to Graves and Tobey—a retreat into private, pagan mythologies that sought out the mysterious secrets of nature as eternal truths that might oppose the grim facts of a manmade civilization which, between 1914 and 1918, had collapsed under its own weight. And by 1945, after Hiroshima, this worship of primeval nature reached even more mythic extremes, as if after the apocalypse, the Abstract Expressionists needed to reexperience the first days of creation, turning as they did to images of molten energies, unformed matter, lambent voids. From Cole to Newman, these American painters have all sought a wellspring of vital forces in nature that could create a rock-bottom truth in an era when the work of man so often seemed a force of ugliness and destruction. And it would seem that for American artists, elemental nature is still a source of myth and energy. Were this view of "the natural paradise" to extend into the generation that followed the Abstract Expressionists, it would have to leave the realm of paint and canvas and move to the land itself, and precisely to what is left of those remote, still pristine regions of Nevada, Arizona, Utah, or California, which for the 1960s and 1970s are the equivalent of the unspoiled American wildernesses that inspired a Cole or a Church. In a world that seems hell-bent on extinguishing its natural sources of life, the creators of earthworks—Michael Heizer, Robert Smithson, Dennis Oppenheim, Walter de Maria, Christo—have found yet another way to establish contact with the deities of American landscape that have now reigned for two centuries.

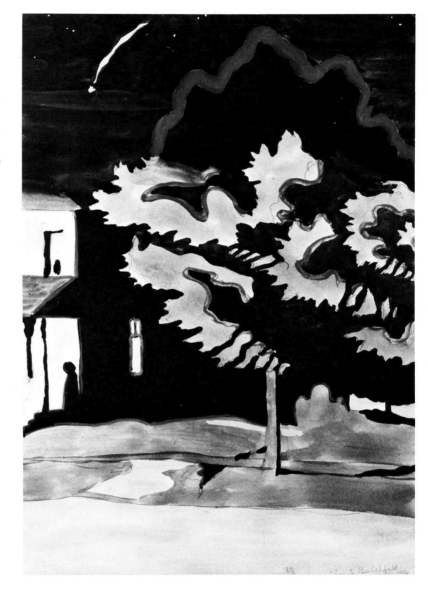

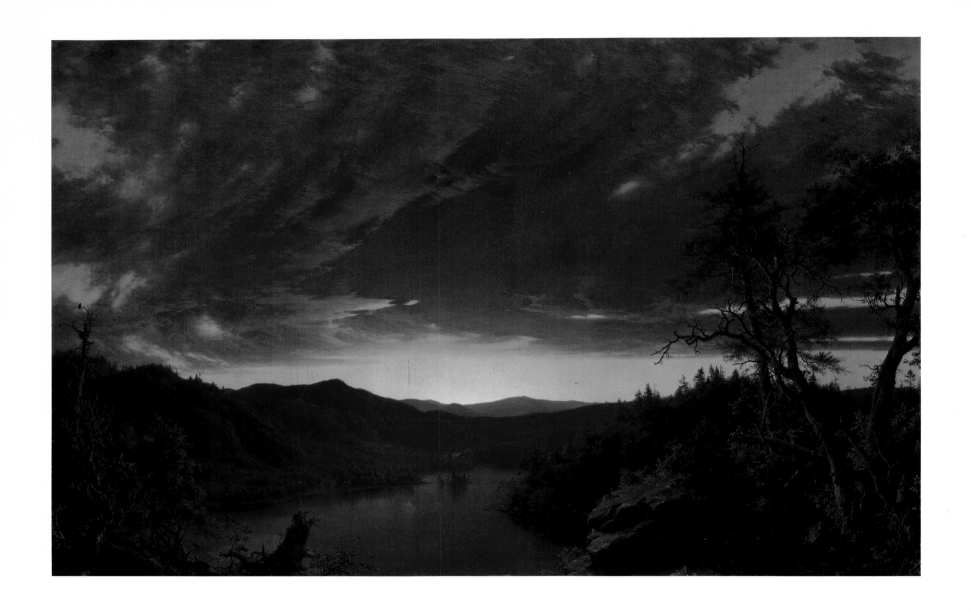

FREDERIC EDWIN CHURCH. *Twilight in the Wilderness.* 1860
Oil on canvas, 40 x 64 in. (101.6 x 162.5 cm.)
The Cleveland Museum of Art
Purchase, Mr. and Mrs. William H. Marlett Fund

FIRE AND ICE IN AMERICAN ART
POLARITIES FROM LUMINISM TO ABSTRACT EXPRESSIONISM

by John Wilmerding

THE history of modern art celebrates the Abstract Expressionist movement as the first decisive assertion of originality and independence in American painting. Writing of the painters in this group, Clement Greenberg stated in 1955 that "their works constitute the first manifestation of American art to draw a standing protest at home as well as serious attention from Europe. . . . This country had not yet made a single contribution to the mainstream of painting or sculpture."[1] One interesting consequence deriving from this cultural self-esteem has been the emergence in the last decade of serious scholarly and popular attention to America's art of the nineteenth century. As historians more precisely perceived the phases and varieties of early landscape painting, they focused particularly on Luminism as a distinctively imaginative national expression.

Indeed, Barbara Novak has argued that "luminism is one of the most truly indigenous styles in the history of American art."[2] Its most noted practitioners included Fitz Hugh Lane, Martin Johnson Heade, Sanford R. Gifford, and in varying degrees other painters associated with the later Hudson River School. Luminism as a style was most popular generally between the late 1850s and early 1870s. Its most distinguishing features included spacious landscape compositions, often emphatically horizontal in format, with conscious attention to serenity of mood, glowing effects of atmosphere and light, and thin, tight brushwork suitable to their crystalline visions of nature. Like Abstract Expressionism a century later, Luminism provided a revealing index of the national temperament in its time and place.

It is one of the curious features of historiography that a notably powerful movement or style in contemporary art will often help to reveal similar but previously unappreciated characteristics of an earlier school or mode of art. We know how the example of van Gogh provided a vehicle for the first modern appreciation of El Greco's work. It is no surprise that in the wake of Pop art should follow new interest in the realism of Grant Wood and American art of the 1930s. Natural,

too, are the connections we can now draw between the ambitious earthworks of recent years and the bold large-scale photographs taken across the American West a century ago.

In fact, Luminism and Abstract Expressionism share certain characteristics.[3] Together they form a major parenthesis around the evolution of American art over the last century. Luminism is the culmination of the country's first nationalist expression in painting, the Hudson River School, while Abstract Expressionism towers as a central development of twentieth-century art, continuing to possess vital influence today. In their consciousness of the spiritual as well as physical presence of the country's landscape, their celebration of an expansive continental and pictorial scale, their evocation of both personal and national energies, the two movements present telling distillations of the American character.

There are, to begin with, interesting parallels in their developments. The founding figures in each period were Europeans who emigrated to America against a background of political turbulence in Europe—the Napoleonic Wars at the close of the eighteenth century and the disturbing events leading up to the Second World War during the second quarter of the twentieth. Within a narrow period of years just around 1800, a number of painters crossed the Atlantic from England and the Continent, among them Thomas Birch, Francis Guy, Michel Felice Corné, William Groombridge, Robert Salmon, Joshua Shaw, and most importantly, Thomas Cole. During the early decades of the new century this group began the first comprehensive recording of American city views and landscape scenery along the Eastern seaboard. Cole particularly came to articulate a national consciousness through his paintings, which we now recognize as the beginning of America's first major landscape style. Out of his ideas and formulas the Luminist style emerged in the hands of the second-generation Hudson River School painters who followed him.

Similarly, two key figures in formulating the basic language of

Abstract Expressionism were European-born: Arshile Gorky, who came to the United States in 1920, and Hans Hofmann, who arrived in 1932. Furthermore, at the beginning of the Second World War, several exponents of Surrealism in Europe fled to New York, providing a major stimulus for the course and character of Abstract Expressionism. Among them were André Breton, Marc Chagall, Salvador Dali, Max Ernst, André Masson, Matta, and Yves Tanguy. Moreover, two of the foremost Abstract Expressionists, Willem de Kooning and Mark Rothko, also foreign-born, made their way to New York in the mid-1920s. It is a paradox that at these two crucial moments in the history of American art Europeans should have catalyzed the definition of the country's most original and nativist painting.

Incidentally, the greatest collection of Hudson River School and Luminist painting ever formed was that of another foreigner, the Russian émigré Maxim Karolik, who presented it to the Boston Museum of Fine Arts in the 1940s, at the very time when the Abstract Expressionist movement had reached its fullest expression.

The art of Cole in the nineteenth century and that of Gorky and Hofmann in the twentieth fused the major conceptual polarities of style pursued by their respective schools. In Cole's work it was accomplished through his dual attention to the real and the ideal; in Gorky's and Hofmann's, through their combining the pictorial language of autobiographical gesturalism with meditative environments. Yet even though these painters stood as the artistic fountainheads for a succeeding generation, they paralleled one another as well in their acknowledgments of past masters. Cole, for example, wrote that for his understanding of the sublime he had "only to appeal to Claude, G. Poussin, and Salvator Rosa," and proclaimed "Turner as one of the greatest Landscape painters that ever lived."[4] For his part, Hofmann owed an early debt to the work of Delaunay, Kandinsky, and Mondrian, as well as to aspects of Cubism and Fauvism. Gorky even more consciously served an apprenticeship with European masters, admitting in his

ARSHILE GORKY. *The Plough and the Song.* 1947
Oil on canvas, 50¾ x 62¾ in. (128.9 x 159.4 cm.)
Allen Memorial Art Museum, Oberlin College, Oberlin, Ohio

familiar statement that "I was *with* Cezanne for a long time, and then naturally I was *with* Picasso."[5]

Paradoxically, the American vision has been sometimes explosive, sometimes contemplative; although that paradox has usually reflected the larger struggles of the country divided within itself or uneasy about its relationships abroad. Both Luminism and Abstract Expressionism have two aspects: the dynamic and the calm, the exclamatory and the reflective. Historians have regularly referred to these polarities, but for the most part have neglected to elaborate why they coexisted in each movement.[6] Also, traditional discussions (much more so in the case of Abstract Expressionism) have tended to define the dualism primarily in formal terms, often at the expense of probing meaning and content.

Although Barbara Novak has pioneered in the philosophical and metaphysical interpretation of Hudson River and Luminist painting, she continually returns to formal issues:
For luminist light largely derives its special quality from its containment within clearly defined geometries and sometimes, too, from the opposition of its brilliance to the ultraclarification of foreground detail. . . . the stepped-back planes so characteristic of luminist space are retained, and the small impastos of stroke are carefully aligned so as not to disturb the mensuration.[7]
James Thomas Flexner evidently fears outright any effort to probe the iconographical and ideational substructure of American art, when he writes: "As for iconography: the most useful study for analyzing the content of Hudson River School landscapes would be a subject outside the usual scope of art historians. It would be forestry."[8] This is like asserting that discussion of still-life painting should be confined to cooks.

Discussions of Abstract Expressionism have devoted comparable attention to formalist aspects, owing both to the influential criticism of Clement Greenberg and to the popular assumption that abstraction cannot possess precise or comprehensible, if any, meaning. We generally think of Abstract Expressionism's foremost significance residing in its formal inventions of new pictorial space, line, and figure-ground relationship. In title and explication Greenberg's important essay, "The Crisis of the Easel Picture," focused on these elements:
This tendency appears in the all-over, "decentralized," "polyphonic" picture that relies on a surface knit together of identical or closely similar elements which repeat themselves without marked variation from one edge of the picture to the other. It is a kind of picture that dispenses, apparently, with beginning, middle, end.[9]

On one level the literal or implied panoramic scale of canvases from both periods surely recalls the continuing American association of its vast landscape with the national identity. The pulsing surges of energy, seemingly uncontainable within the picture's framing edges, characterize equally the view of nature described in Frederic Church's *Niagara Falls* of 1857 (page 94) and embodied in Jackson Pollock's *Autumn Rhythm* (opposite) almost a century later. The latter, of course, is no actual landscape, although it is very much an American environment. The title "New York School" given to Pollock and his colleagues refers prosaically to the place of their gathering as well as suggestively to this new American landscape of density, monumentality, and dynamism.

One of the central and significant features of pictures in these two movements is their conscious emphasis on horizontality of format. Church pioneered in this new expansiveness with *Niagara Falls,* whose proportions attenuated the traditional ratio of width to height in order to express a specifically American sensibility of geographic and pictorial space. David Huntington quotes the experience of a contemporary observer of Church's work: "Here there is room to breathe. Here the soul expands."[10] Martin Johnson Heade was strongly affected by this example, as Theodore E. Stebbins, Jr., has shown, in his landscape paintings of the next decade.[11] Pollock similarly exploited emphatic lateral proportions for many of his canvases, to which Barnett Newman responded by pushing towards a ratio of even more than two to one (page 54). Thomas Hess has argued that Newman's extra-wide canvases

43

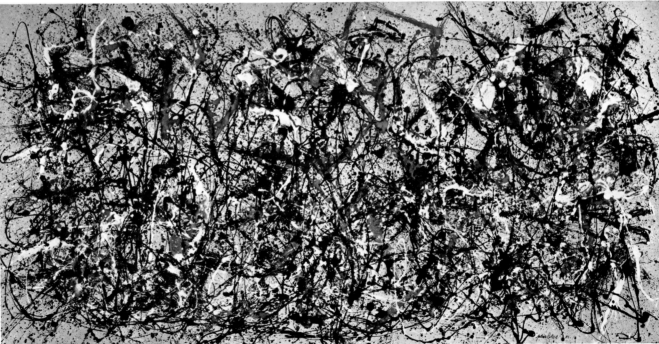

above:
MARTIN JOHNSON HEADE
Approaching Storm: Beach near Newport
c. 1865–70
Oil on canvas,
28 x 58¼ in. (71.1 x 148 cm.)
Museum of Fine Arts, Boston
M. and M. Karolik Collection

below:
JACKSON POLLOCK
Autumn Rhythm (Number 30, 1950). 1950
Oil and enamel on canvas,
106½ x 212 in. (270.5 x 538.6 cm.)
The Metropolitan Museum
of Art, New York
George A. Hearn Fund, 1957

not only attain a greater dynamism but also possess suggestive metaphysical and mystical associations.[12]

Still, we must explore the reasons for such expressions dominating the artistic imagination in the mid-nineteenth and again in the mid-twentieth century, as well as for the contrasting stylistic modes running parallel through each school. On a deeper, more shadowy level there lies the important context of internal national tension combined with divisive foreign involvements dominating both periods in American life. Certainly one of the crucial events in the middle of the nineteenth century was the Civil War—preceded by the contentious forces of Westward expansion and issues of national union, as well as by engagement in the Mexican War—succeeded by the exacerbating effort and failure of Reconstruction.

It is this larger atmosphere and reality of anxious division in the national psyche which helps to explain the growing shrillness and sense of conflict, even a hint of artistic schizophrenia, in the culminating period of Luminist painting just around 1870. Some have been unsure how to define exactly what seem to be the shifting edges and center of the Luminist movement: who precisely is to be included and excluded, when it began and ended, why most paintings of Lane, Heade, and Gifford surely belong within the canon, while others by their colleagues Church and Bierstadt appear problematic.[13] Many identify Church's splendid *Twilight in the Wilderness* of 1860 (page 38) as quintessentially Luminist for its incandescent red and yellow light and its heroic spiritual message, but remain uncertain about classifying *Cotopaxi* of 1862 (page 51) and his other, similar canvases of the erupting South American volcano. Yet the explosive violence of this series seems to be an equally revealing index of its time—and indeed very much a part of the day's cultural consciousness.

When we turn to Church's friend Martin Johnson Heade, we should first acknowledge two significant points about his work and career: that he painted similar visions of threatening forces along side of extraordinarily serene and contemplative marsh scenes, and that he traveled extensively, almost compulsively, throughout the 1860s and 1870s. But the crucial fact is that his few great storm pictures—*Approaching Storm: Beach near Newport* of c. 1865–70 (page 43), *Thunderstorm over Narragansett Bay* of 1868 (page 57), and *Ometepe Volcano, Nicaragua* of 1867—all date from the decade of the Civil War. In this light we also ought to note that even in his beautiful record of *Lake George* in 1862 (opposite) are a dryness of form and stillness of mood that hover on the foreboding. Finally, one has to wonder if it is more than coincidence, more than a shared interest in transient light effects, more than the new availability of hot cadmium colors, that the foremost "twilight" pictures of Heade, Church, and Gifford date from the 1860s, when loss of day may well have seemed to signify the loss of national unity.

In this regard it is worth recalling that the earliest of the Luminist painters, Fitz Hugh Lane, had reached the maturity of his career during the previous decade of the 1850s and died in 1865. He thus never had to face, consciously or unconsciously, the psychic ravages of an America at the close of its Civil War, and his art accordingly is without the apocalyptic or menacing notes sounded by Heade and Church in subsequent years.

Heade was also the prototypical Luminist in his peripatetic wanderings. Even his choice of the marshlands for his most familiar paintings is revealing. They were not only scenes of isolation in a nearly uninhabited landscape, with salt-water streams significantly meandering throughout, but also unstable environments, changing with the tides, in a world between land and sea. Heade painted the marshes up and down the Atlantic Coast, from Newburyport in Massachusetts to the Everglades in Florida. Beyond this he traveled unceasingly around the United States and abroad, from New York to Boston, to the Middle West and the West Coast, to South America and Europe more than once.

The middle decades of the century also found Church on the move

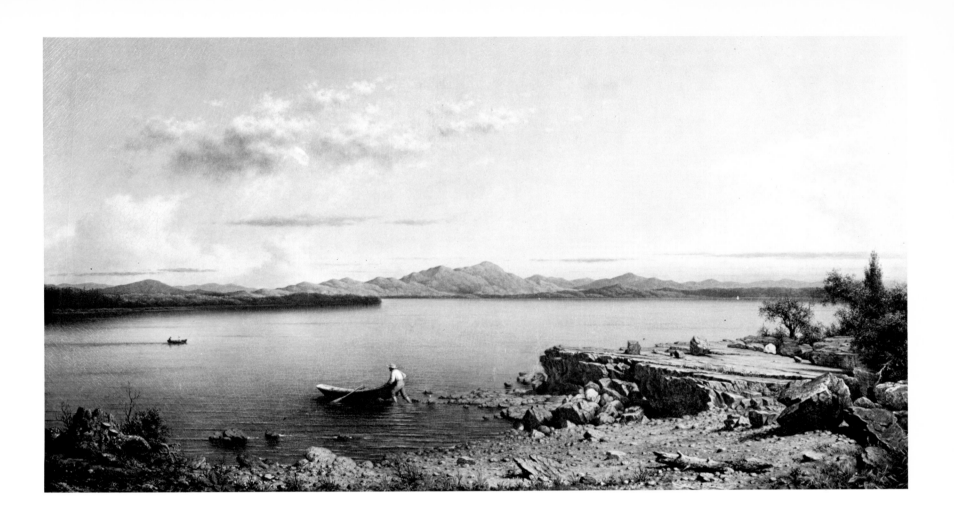

MARTIN JOHNSON HEADE. *Lake George.* 1862
Oil on canvas, 26 x 49¾ in. (66.1 x 120.4 cm.)
Museum of Fine Arts, Boston. Bequest of Maxim Karolik

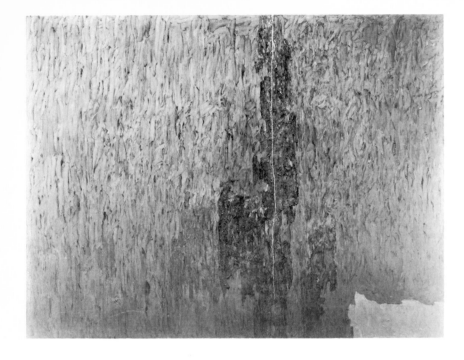

above:
CLYFFORD STILL. *Painting.* 1952
Oil on canvas, 119 x 156 in. (302.3 x 396.2 cm.)
The Art Institute of Chicago
Wirt D. Walker Fund and John Stephan Gift, 1962

opposite above:
MARTIN JOHNSON HEADE. *Newbury Marshes.* c. 1860–69
Charcoal and chalk, 11 x 21 in. (28 x 53.4 cm.)
Private collection

opposite center:
MARTIN JOHNSON HEADE. *Dusk on the Plum Island River.* c. 1860–69
Charcoal and chalk, 11½ x 21⅞ in. (29.2 x 55.6 cm.)
Private collection

opposite below:
MARTIN JOHNSON HEADE. *Twilight, Salt Marshes.* c. 1860–69
Charcoal and colored chalks, 11 x 21⅝ in. (27.9 x 54.1 cm.)
Museum of Fine Arts, Boston
M. and M. Karolik Collection

to South America and the Arctic, while others of his generation such as William Bradford, James Hamilton, and Sanford R. Gifford set off to paint the northern icebergs or sites in the Mediterranean and the Near East. Although such journeying was a pursuit—the pursuit of a wilderness frontier fast disappearing within the continental United States—it was also a flight, the flight from a turbulent and disquieting world at home.

If striking oppositions of mood surface in Luminist painting of the Civil War years, there appears to be an equally deep cleavage within Abstract Expressionist painting between the aggressive gesturalism of Pollock, Kline, and de Kooning and the color-field meditations of Rothko, Still, and Newman. Yet the compulsiveness of the one and brooding calm of the other are fused in their context of a country nominally at peace in the postwar period, but paradoxically engaged in the Cold War, itself a contradiction in terms. We had "brinksmanship" in foreign policy and a "silent generation" in college: open threats of extreme action by the government, and deep repression of feelings by the student population. Emerging from the Cold War years was America's involvement in Korea and Southeast Asia and all its accompanying internal divisiveness. So again in the middle decades of the present century the United States became embroiled in foreign and domestic discord. The stylistic polarities in American painting make an appropriate index to such broader tensions in the national scene.

The Abstract Expressionists were not quite the relentless travelers many of their Luminist predecessors had been; at the same time a measure of wandering and escapism infected their careers, too. From various parts of Europe and the United States they gravitated to New York, often with pauses or ambulations elsewhere. Jackson Pollock and Clyfford Still were typical in coming to New York from Western states with stops in many places along the way. Like their literary contemporaries, the Beat poets and writers, especially Lawrence Ferlinghetti and Jack Kerouac, they were (as the latter's book stated) *On the Road.* They

moved almost without stop from one part of America to another, as if with the pulsating rhythms of a Pollock painting. The Cold War had been issued in by the atomic bomb, which led to the realization that all modern life from then on was to be subject to accident and chance. This was an age with no longer fixed absolutes, with mass equal to energy, with no certain center or finiteness.

Partly out of indefatigable idealism, partly out of a premonition of loss, Americans in both centuries adopted a strongly contemplative and spiritual, occasionally even religious, attitude toward their landscape. The Luminist canvases of the early 1860s by Lane and Heade, for example, moved toward a stillness of mood and balanced harmony of design in recording nature that most evokes Emersonian Transcendentalism. As they distilled the components of landscape before them into lucid unities and translucent suspensions of time, they implicitly addressed nature's higher, spiritual order.

It is possible that in some instances Heade arrived at even more explicit religious associations. Among his most familiar pictures is his extensive sequence of marsh scenes, with their cadenced placement of haystacks and gently curving streams, at their best achieving a gentle air of timelessness. Unusual in this oeuvre is a small group of related charcoal drawings done in the Newbury, Massachusetts, marshes during the 1860s. Like Monet, Heade fixed his view on the haystacks in a particular setting and recorded them in the changing light during the day. But importantly different from the effort by the French artist to capture the instantaneous moment in his shimmering canvases, Heade aspires to a rarefied sense of time enduring beyond the moment.[14]

Almost a dozen charcoals done from the same vantage point looking north on the Plum Island River have been located.[15] In the drawings of the morning hours (for example, *Newbury Marshes,* right, top), he shows the shadows cast by a sun still in the East, while their shift to the opposite direction (as in *Dusk on the Plum Island River,* right, center) marks his work in the later afternoon. The composition remains

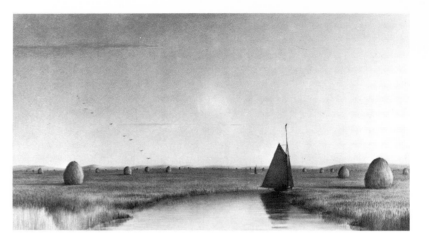

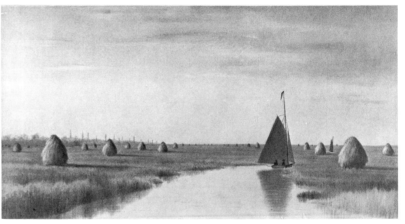

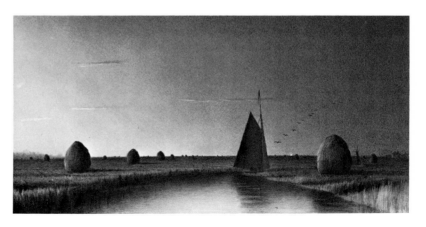

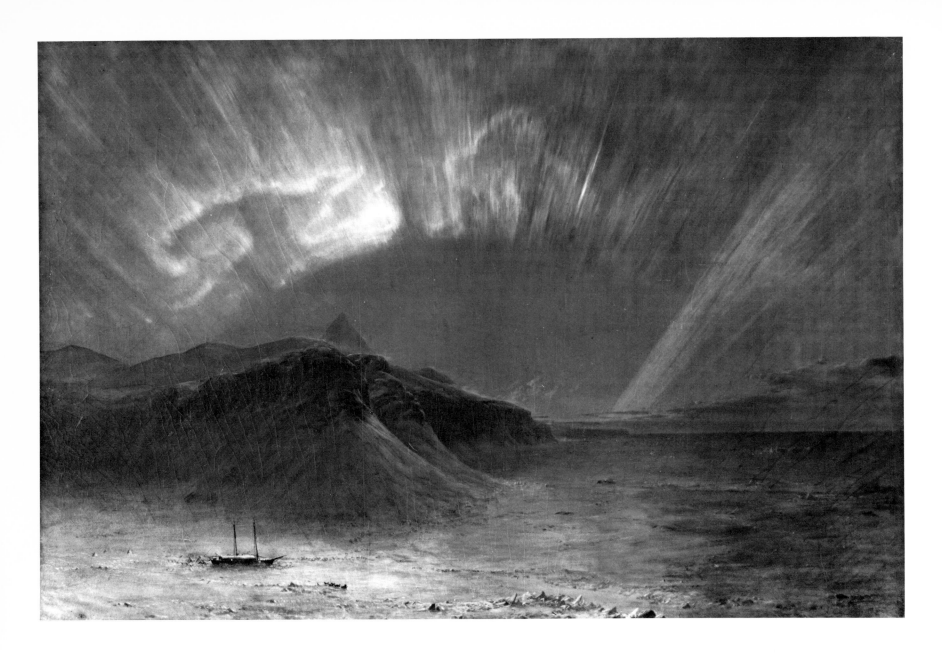

FREDERIC EDWIN CHURCH. *The Aurora Borealis.* 1865
Oil on canvas, 56 x 83 in. (142.3 x 210.9 cm.)
National Collection of Fine Arts,
Smithsonian Institution, Washington, D.C.

carefully consistent throughout: a stream narrows our view from the center foreground into the middle of the scene, with haystacks receding in rows on either side into the distance; just to the right of center the vertical of a small sailboat evenly intersects the flat horizon line. Appearing in the final drawings of the series are thin striations of clouds, a descending arc of ducks, and a speck of light from the distant lighthouse on the Merrimack River. To demonstrate twilight's descent, Heade appropriately shifted to darker paper and charcoal.

As he moved from one sketch to the next, he also introduced tighter order, economy, and refinement into his design. The number of haystacks diminishes; their placement becomes more measured and more evenly centered on the horizon line; the line of descending ducks increasingly complements the foreground contours of the stream. The final drawing of the group, *Twilight, Salt Marshes* (page 47, bottom), includes one other conclusive gesture. Where previously the thin horizontal clouds echoed the flat landscape below, here the one major cloud interlocks with the vertical sailboat mast. In purely formal terms this at last brings a perfect resolution to all of the pictorial elements in a central focusing device, but we cannot help noticing that this delicate intersection also assumes the unobtrusive shape of a cross in the sky.

Such an image of spirituality would have well served the Luminist attitude towards American nature and history at a critical time. We know that Heade's friend Church alluded to the same imagery in his own landscapes of these years. In the 1860s he referred to the salvation of the Union by executing a chromolithograph called *Our Banner in the Sky* (right), which displayed a vision of stars and red-and-white striped clouds across the blue night sky.[16] Persuasive argument already exists demonstrating that most of Church's work broadly alluded to Judaeo-Christian themes. In varying ways his heroic paintings of *Niagara Falls* (page 94), *Twilight in the Wilderness* (page 38), *Rainy Season in the Tropics* (page 84), *The Heart of the Andes,* and *The Aurora Borealis* (opposite) were exemplary national landscapes of regeneration.

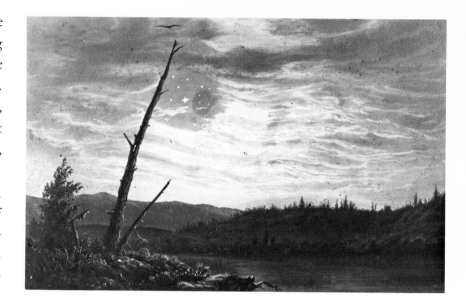

FREDERIC EDWIN CHURCH. *Our Banner in the Sky.* c. 1860–69
Chromolithograph, 7⅜ x 11¼ in. (18.7 x 28.6 cm.)
Olana State Historic Site, Hudson on Hudson, New York
New York State Office of Parks & Recreation

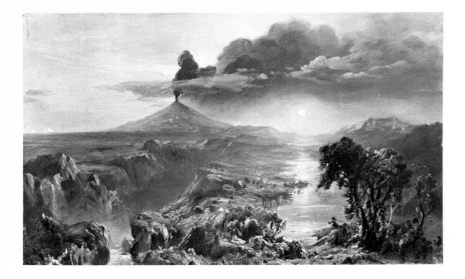

In particular, with some of his 1861 oil and pencil studies for *Cotopaxi* (as in the one to the left), Church deliberately introduced the symbolism of the cross in the dark rising plume of volcanic smoke intersected by a drifting horizontal band of white clouds.[17] Church was intimating that Americans inhabited a new Eden, a new promised land, and in standing before this sublime grandeur one enjoyed the metaphoric presence of Genesis. Yet like Heade, Church alternated in these great wilderness vistas between cool serenity and explosive melodrama, as if obsessed with the inseparable creation *and* the fall of Adam. As Robert Frost reminds us, creation and destruction are related, and the end of the world (as its beginning) will come by fire and ice!

Some say the world will end in fire,
Some say in ice.
From what I've tasted of desire
I hold with those who favor fire.
But if it had to perish twice,
I think I know enough of hate
To say that for destruction ice
Is also great
And would suffice.[18]

Not surprisingly, we encounter in Abstract Expressionism ruminations on the powerful forces of Genesis, on the heroic drama as well as pathos of human mortality. Barnett Newman most notably linked the original creation with all artistic activity. Pointedly, he wrote an article titled: "The First Man Was an Artist," and asserted that "Man's first expression . . . was a poetic outcry. . . . The purpose of man's first speech was an address to the unknowable. . . . [His] hand traced the stick through the mud to make a line before he learned to throw the stick as a javelin."[19] His huge canvases of raw color, then, were voids on which his line or lines were first marks of creative expression, and thereby defined the world of matter around them.

As Gifford before him sought the eternal spiritual past in Italy,

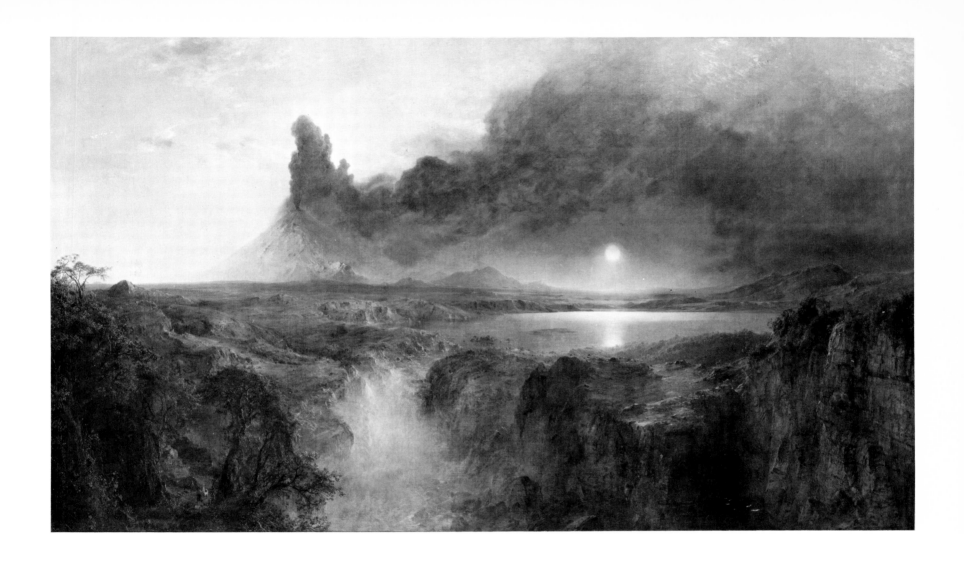

FREDERIC EDWIN CHURCH. *Cotopaxi*. 1862
Oil on canvas, 48 x 85 in. (121.9 x 215.9 cm.)
Collection John Astor, Miami

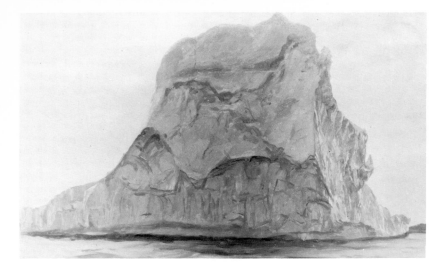

FREDERIC EDWIN CHURCH. *Iceberg.* 1859
Oil on cardboard, 12 x 20⅛ in. (30.6 x 51 cm.)
Cooper-Hewitt Museum of Design, Smithsonian Institution, New York

ALBERT BIERSTADT. *The Conflagration.* c. 1881–89
Oil on paper, 11¼ x 15⅛ in. (28.6 x 38.4 cm.)
Worcester Art Museum, Worcester, Massachusetts

Greece, and Egypt, as Church also went to Jerusalem and Petra, Newman sought spiritual continuity in the Bible, abstracting its content in paintings he titled *Covenant, Day One, Primordial Light,* and *Stations of the Cross.*[20] There are further echoes of Heade and Church in Newman's art—the monumental scale and raw visual power, the measured disposition of forms across luminous spaces, the aspiration toward metaphysical harmony.

In the oils of Pollock and Rothko, as well, we confront a primordial imagery, whether with pagan or sacred connotations. Beyond the well known formal inventions of either artist there exist landscapes of powerful feeling and spiritual associations. Like their nineteenth-century precedents, these paintings embrace similar polarities of exuberance and tragedy. Rothko especially indicated that he was "interested only in expressing the basic human emotions—tragedy, ecstasy, doom, and so on. . . . The people who weep before my pictures are having the same religious experience I had when I painted them."[21]

These sentiments were strong currents through most of his mature career. In his earlier days he had discovered a particularly sympathetic note in Nietzsche's essay, *The Birth of Tragedy,* which included the declaration (as applicable to Rothko's Luminist predecessors as to himself):

There is need for a whole world of torment in order for the individual to produce the redemptive vision and to sit quietly in his rocking rowboat in mid-sea, absorbed in contemplation.[22]

Rothko had also responded fervently on an Italian journey in the 1950s to the frescoes of Fra Angelico in the monastery of St. Mark's.[23] The Abstract Expressionist's large radiant canvases evoke in modern terms the powerful mystery and immanence of spiritual feeling. Rothko recurrently referred to such transcendent terms as tragedy, irony, and fate.

His cosmic reflections informed his art with both religious and philosophical resonances, appropriately introspective for a period so

outwardly secular, materialist, and aggressive. Working in an unsettled and anxious age, Rothko finally took his own life, as others of his artistic generation—Jackson Pollock, Ernest Hemingway, David Smith—also met with tragic or violent deaths. It is fitting that some of Rothko's last works found their place in the so-called Rothko Chapel in Houston, created as a conducive environment for meditation.

At the peak of their powers, neither the Luminists nor the Abstract Expressionists were so somber or introspective. Rather, both chose an exclamatory voice towards their country and time, an America in two periods of ascendancy before the currents of disunion fully surfaced. The literature of both eras bears equally close links. As we gaze upon a Bierstadt or Church, we might well recall the lines from Walt Whitman's *Song of the Open Road:*

The earth expanding right hand and left hand,
The picture alive, every part in its best light. . . .
I inhale great draughts of space,
The east and the west are mine, and the
north and the south are mine.[24]

With full breath and loud voice here was the same language of praise for the breadth and strength of the American continent.

A native of Long Island (named Paumanok by the Indians), Whitman crisscrossed America in person and in poetry. Just as Whitman had announced he was "Starting from fish-shape Paumanok where I was born"[25] to go West, Ferlinghetti a century later titled a volume of his poetry *Starting from San Francisco.* With pulsations of energy as reminiscent of Pollock as of Whitman, he began his own self-song:

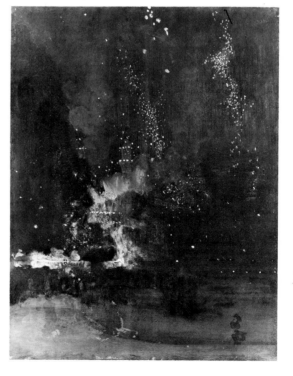

Here I go again
crossing the country in coach trains
(back to my old
lone wandering)
All night Eastward . . .[26]

It remains to be noted that both of these artistic movements, for a

JACKSON POLLOCK
The Flame. c. 1934–38
Oil on composition board,
20 x 30 in. (50.8 x 76.2 cm.)
Collection Lee Krasner Pollock

JAMES ABBOTT MCNEILL WHISTLER
Nocturne in Black and Gold:
The Falling Rocket
c. 1874. Oil on wood panel,
23¾ x 18⅜ in. (60.3 x 46.6 cm.)
The Detroit Institute of Arts
The Dexter M. Ferry, Jr., Fund

time so unified in style (even if polarized within), ultimately yielded to new modes of realism. In the 1870s it was the dark gravity of Homer and Eakins; in the 1970s Pop art and sharp-focus realism. However, in these two succeeding periods we see a new thoughtfulness emerging. In later nineteenth-century art there is the pervasive appearance of elegiac revery; a century later in conceptual art there is artistic expression giving primacy to thought. Yet these successor styles in both instances seem part of new waves of artistic pluralism. Where American art at the mid-point of both centuries projected enormous self-confidence and optimism, the last quarter of each century saw the introduction of a perplexing and often contradictory multiplicity of styles. Artistic insecurity surely reverberated somehow from larger losses in direction. On the occasions of America's two centennials, time, seemingly having been made to stand still, uneasily quickened pace again.

above: BARNETT NEWMAN. *Vir Heroicus Sublimis.* 1950–51
Oil on canvas, 95⅜ x 213¼ in. (242.3 x 541.7 cm.)
The Museum of Modern Art, New York
Gift of Mr. and Mrs. Ben Heller

opposite: MARK ROTHKO. *Number 22.* 1949
Oil on canvas, 117 x 107⅛ in. (297.2 x 272.1 cm.)
The Museum of Modern Art, New York
Gift of the artist

NOTES

56

1. Clement Greenberg, "'American-Type' Painting," in *Art and Culture: Critical Essays* (Boston: Beacon Press, 1961), pp. 209, 228. Sam Hunter echoed the same sentiments in his *American Art of the 20th Century* (New York: Abrams, 1973), p. 229: "The first painting movement to bring American artists world-wide notice after the Second World War was Abstract Expressionism."

2. Barbara Novak, *American Painting of the Nineteenth Century* (New York: Praeger, 1969), p. 95.

3. Two recent publications have made the first significant connections: Robert Rosenblum's *Modern Painting and the Northern Romantic Tradition: Friedrich to Rothko* (New York: Harper and Row, 1975); and *Art in America* (New York), vol. 64, no. 1 (January–February 1976), "American Landscape Issue."

4. Louis Legrand Noble, *The Life and Works of Thomas Cole,* ed. by Elliot S. Vesell (Cambridge, Mass.: Harvard University Press, 1964), pp. 83, 86.

5. Quoted in Julien Levy, *Arshile Gorky* (New York: Abrams, 1966), p. 15.

6. For example, Sam Hunter, *Modern American Painting and Sculpture* (New York: Dell, 1959), and Irving Sandler, *The Triumph of American Painting: A History of Abstract Expressionism* (New York: Praeger, 1970), especially chapters 7 and 11. See also Barbara Novak, "Grand Opera and the Small Still Voice," *Art in America* (New York), vol. 59, no. 2 (March–April 1971), pp. 64–73.

7. Novak, *American Painting,* pp. 122, 131.

8. James Thomas Flexner, *Nineteenth Century American Painting* (New York: Putnam's, 1970), p. 9.

9. Clement Greenberg, "The Crisis of the Easel Picture," in *Art and Culture,* p. 155.

10. David C. Huntington, *The Landscapes of Frederic Edwin Church: Vision of an American Era* (New York: Braziller, 1966), p. 69.

11. See Theodore E. Stebbins, Jr., *The Life and Works of Martin Johnson Heade* (New Haven, Conn.: Yale University Press, 1975), pp. 35, 44, 107.

12. Thomas B. Hess, *Barnett Newman* (New York: The Museum of Modern Art, 1971) pp. 69 ff.

13. See exhibition catalogue *Luminous Landscape: The American Study of Light, 1860–1875* (Fogg Art Museum, Cambridge, Mass., 1966).

14. See Novak, *American Painting,* pp. 129 ff, and John Wilmerding, *The Genius of American Painting* (New York: Morrow, 1973), Introduction, pp. 19 ff.

15. See Stebbins, *Martin Johnson Heade,* pp. 56–63, 283–85.

16. Huntington, *Frederic Edwin Church,* p. 61.

17. *Ibid.,* pp. 17–20. As Huntington further points out (p. 199), Church's teacher and the founder of American landscape painting, Thomas Cole, had himself explicitly used this symbolism earlier in his series on The Cross and the World.

18. *Complete Poems of Robert Frost* (New York: Holt, 1949), p. 268.

19. Barnett Newman, "The First Man Was an Artist," *The Tiger's Eye* (New York), vol. 1, no. 1 (October 1947), pp. 59–60; quoted in Sandler, *Triumph of American Painting,* p. 189.

20. For the fullest discussion and interpretation of these religious themes, see Hess, *Barnett Newman,* passim.

21. Quoted in Seldon Rodman, *Conversations with Artists* (New York: Devin-Adair, 1957), pp. 93–94, and in Rosenblum, *Modern Painting,* p. 215.

22. Quoted in Peter Selz, *Mark Rothko* (New York: The Museum of Modern Art, 1961), p. 14.

23. *Ibid.,* p. 9.

24. Walt Whitman, *Leaves of Grass* (Philadelphia: D. McKay, 1891–1892), pp. 122–23.

25. *Ibid.,* p. 18.

26. Lawrence Ferlinghetti, *Starting from San Francisco* (rev. ed., New York: New Directions, 1967), p. 5.

above: MARTIN JOHNSON HEADE. *Thunderstorm over Narragansett Bay.* 1868
Oil on canvas, 32⅛ x 54¾ in. (81.5 x 139.1 cm.)
Collection Ernest Rosenfeld, New York

overleaf: THOMAS COLE. *Landscape with Tree Trunks.* 1825
Oil on canvas, 26½ x 32½ in. (67.3 x 82.6 cm.)
Museum of Art, Rhode Island School of Design, Providence
Walter H. Kimball Fund

ON DIVERS THEMES FROM NATURE

A Selection of Texts

Edited and Introduced by Barbara Novak

THE dialogues on landscape painting in nineteenth-century America were conducted with great intensity and passion. They concerned the popular "religion" of the period: nature as the unfailing repository of the society's ideals. This amounted to a secular mode of faith—based on a unique interfusion of optimism, transcendentalism, nationalism, and science.

Though this world view was made logically obsolete when Darwin removed the idealism from nature and science, it has taken a long time to die. The community's self-image and self-interest were—and are—involved. Nature's purity could redeem every evil, since nature itself, as the reflection and immanence of God, was without evil. Indeed, Americans have often had considerable difficulty acknowledging the existence of evil. Thus, the dialogues about nature had a certain opacity at their core, and one has to listen to the nineteenth-century voices with an acute ear. The spiritual and moral energies of a Thoreau, for instance, are unmistakable. It is in the popular interpretations of the natural "religion" that the doctrinaire and routine reveal themselves in language and sentiment.

The age was severely pained by the challenges science offered to religion and orthodoxy. It was obsessed with respectability and morality and confused by the idea of progress, which was in effect cancelling nature—the source of its religion. The issue of nature as a last emblem of humanism was forced by the Civil War. Afterwards, nature lacked the spiritual vitality that had placed it at the center of the country's mind and conscience for over forty years. In those years, nature was the common denominator of the society's transactions, subsuming art, philosophy, science, and religion. This must be one of the most impressive fictions to which any society ever subscribed. It bears endless study.

We are now conscious of the assumptions of an age—what implicit beliefs are not perceived, let alone tested. It is of course a conceit of every age that its predecessor is obtuse in ways that it is not.

This is the burden of D. H. Lawrence's remarks. But the following comments on nature and art contain hard thinking that set up wide cultural reverberations. The sentiment and locution of much of this discourse, so antithetical to our current modes, are only a part, and perhaps not the most important part, of their content.

The extracts that follow—a "collage" of contemporary voices—are gathered around certain themes. These "symposia" clarify concerns suggested by a reading of the paintings themselves. Some themes (e.g., morality) are specific to the nineteenth century. Others (e.g., silence) have relevance not only to the present, but to what we may speculate are constant American preoccupations.

ON AMERICAN NATURE AND CULTURE

Towards the end of the American nature adventure, D. H. Lawrence's retrospective eye perceived with pungent irony the myth of the natural paradise. The earlier writers show less insight, because they have less hindsight. For them, American nature is still implicated in the virginal dream generated by an entire culture. Its uniqueness is constantly underlined by comparisons with Europe. Ideas of newness, of fresh, unsullied wilderness are still viable, but there is a wry awareness of the inescapable dilemma of untouched nature counterposed to progress and culture.

HAZLITT, Godwin, Shelley, Coleridge, the English romantics, were of course thrilled by the *Letters from an American Farmer*. A new world, a world of the Noble Savage and Pristine Nature and Paradisal Simplicity and all that gorgeousness that flows out of the unsullied fount of the ink-bottle. Lucky Coleridge, who got no farther than Bristol. Some of us have gone all the way.

I think this wild and noble America is the thing that I have pined for most ever since I read Fenimore Cooper, as a boy. Now I've got it.

Franklin is the real *practical* prototype of the American. Crèvecoeur is the emotional. To the European, the American is first and foremost a dollar-fiend. We tend to forget the emotional heritage of Hector St. John de Crèvecoeur. We tend to disbelieve, for example, in Woodrow Wilson's wrung heart and wet hanky. Yet surely these are real enough. Aren't they? . . .

"On Divers Themes from Nature" © 1976 Barbara Novak

NATURE.

I wish I could write it larger than that.

NATURE.

Benjamin overlooked NATURE. But the French Crèvecoeur spotted it long before Thoreau and Emerson worked it up. Absolutely the safest thing to get your emotional reactions over is NATURE.

Crèvecoeur's *Letters* are written in a spirit of touching simplicity, almost better than Chateaubriand. You'd think neither of them would ever know how many beans make five. This American Farmer tells of the joys of creating a home in the wilderness, and of cultivating the virgin soil. Poor virgin, prostituted from the very start. —D. H. Lawrence, *Studies in Classic American Literature* (1922)[1]

I WILL now venture a few remarks on what has been considered a grand defect in American scenery—the want of associations, such as arise amid the scenes of the old world.

We have many a spot as umbrageous as Vallombrosa, and as picturesque as the solitudes of Vaucluse; but Milton and Petrarch have not hallowed them by their footsteps and immortal verse. He who stands on Mont Albano and looks down on ancient Rome, has his mind peopled with the gigantic associations of the storied past; but he who stands on the mounds of the West, the most venerable remains of American antiquity, *may* experience the emotion of the sublime, but it is the sublimity of a shoreless ocean un-islanded by the recorded deeds of man.

Yet American scenes are not destitute of historical and legendary associations—the great struggle for freedom has sanctified many a spot, and many a mountain, stream, and rock, has its legend, worthy of poet's pen or the painter's pencil. But American associations are not so much of the past as of the present and the future. . . .[2]

. . . looking over the yet uncultivated scene, the mind's eye may see far into futurity. Where the wolf roams, the plough shall glisten; on the gray crag shall rise temple and tower—mighty deeds shall be done in the now pathless wilderness; and poets yet unborn shall sanctify the soil. . . .[3]

. . . to this cultivated state our western world is fast approaching; but nature is still predominant, and there are those who regret that with the improvements of cultivation the sublimity of the wilderness should pass away: for those scenes of solitude from which the hand of nature has never been

above: ASHER B. DURAND. *Kindred Spirits.* 1849
Oil on canvas, 44 x 36 in. (111.8 x 91.4 cm.)
The New York Public Library, Astor, Lenox, and Tilden Foundations

overleaf above: JOHN FREDERICK KENSETT. *Autumn Afternoon on Lake George.* 1864
Oil on canvas, 48¾ x 72½ in. (123.9 x 184.2 cm.)
Corcoran Gallery of Art, Washington, D.C.

overleaf below: GEORGE CALEB BINGHAM. *The Storm.* c. 1850
Oil on canvas, 25⅛ x 30⅛ in. (63.8 x 76.5 cm.)
Wadsworth Atheneum, Hartford. Gift of Henry E. Schnakenberg

lifted, affect the mind with a more deep toned emotion than aught which the hand of man has touched. Amid them the consequent associations are of God the creator—they are his undefiled works, and the mind is cast into the contemplation of eternal things. —Thomas Cole, "Essay on American Scenery" (1835)[4]

WHILE Claude's skies, and the dexterous management of Salvator's pictures continue to retain the admiration they have ever excited, numerous modern artists are distinguished by a feeling for nature which has made landscape, instead of a mere imitation, a vehicle of great moral impressions. As modern poets have struck latent chords in the heart from a deeper sympathy with humanity, recent limners have depicted scenes of natural beauty, not so much in the spirit of copyists as in that of lovers and worshippers; and accordingly, however unsurpassed the older painters are in historical, they are now confessedly outvied in landscape. And where should this kind of painting advance, if not in this country? Our scenery is the great object which attracts foreign tourists to our shores. No blind adherence to authority here checks the hand or chills the heart of the artist. It is only requisite to possess the technical skill, to be versed in the alphabet of painting, and then, under the inspiration of a genuine love of nature "to hold communion with her visible forms," in order to achieve signal triumphs in landscape, from the varied material so lavishly displayed in our mountains, rivers, lakes, and forests—each possessing characteristic traits of beauty, and all cast in a grander mould, and wearing a fresher aspect than any other civilized land. —Henry T. Tuckerman, *Book of the Artists* (1867)[5]

THE FACTS are as certain as if they had already occurred. In but few years these impenetrable forests will have fallen. The noise of civilization and of industry will break the silence of the Saginaw. Its echo will be silent. Embankments will imprison its sides, and its waters, which today flow unknown and quiet through nameless wilds, will be thrown back in their flow by the prows of ships. Fifty leagues still separate this solitude from the great European settlements, and we are perhaps the last travellers who will have been allowed to see it in its primitive splendour, so great is the force that drives the white race to the complete conquest of the New World.

It is this consciousness of destruction, this *arrière-pensée* of quick and inevitable change, that gives, we feel, so peculiar a character and such a

touching beauty to the solitudes of America. One sees them with a melancholy pleasure; one is in some sort of a hurry to admire them. Thoughts of the savage, natural grandeur that is going to come to an end become mingled with splendid anticipations of the triumphant march of civilization. One feels proud to be a man, and yet at the same time one experiences I cannot say what bitter regret at the power that God has granted us over nature. —Alexis de Tocqueville, *Journey to America* (1831)[6]

IN WHAT has been said I have alluded to wild and uncultivated scenery; but the cultivated must not be forgotten, for it is still more important to man in his social capacity—necessarily bringing him in contact with the cultured; it encompasses our homes, and, though devoid of the stern sublimity of the wild, its quieter spirit steals tenderly into our bosoms mingled with a thousand domestic affections and heart-touching associations—human hands have wrought, and human deeds hallowed all around.

And it is here that taste, which is the perception of the beautiful, and the knowledge of the principles on which nature works, can be applied, and our dwelling-places made fitting for refined and intellectual beings. . . .[7]

. . . Yet I cannot but express my sorrow that the beauty of such landscapes are quickly passing away—the ravages of the axe are daily increasing—the most noble scenes are made desolate, and oftentimes with a wantonness and barbarism scarcely credible in a civilized nation. The way-side is becoming shadeless, and another generation will behold spots, now rife with beauty, desecrated by what is called improvement; which, as yet, generally destroys Nature's beauty without substituting that of Art. This is a regret rather than a complaint; such is the road society has to travel; it may lead to refinement in the end, but the traveller who sees the place of rest close at hand, dislikes the road that has so many unnecessary windings. —Thomas Cole, "Essay on American Scenery" (1835)[8]

I HAVE no hostility to nature, but a child's love to it. I expand and live in the warm day like corn and melons. Let us speak her fair. I do not wish to fling stones at my beautiful mother, nor soil my gentle nest. I only wish to indicate the true position of nature in regard to man, wherein to establish man all right education tends; as the ground which to attain is the object of human life, that is, of man's connection with nature. Culture inverts the vulgar view of nature, and brings the mind to call that apparent which it uses to call real, and that real which it uses to call visionary. Children, it is true, believe in the external world. The belief that it appears only, is an afterthought, but with culture this faith will as surely arise on the mind as did the first. —Ralph Waldo Emerson, *Nature* (1836)[9]

ON INFLUENCE: CLAUDE AND SALVATOR

Confronted with primordial landscape, American artists often looked over their shoulders at the traditional paradigms of European art. One influence that particularly stamped itself on the American landscape was that of Claude. His pastoral compositions "acculturated" American nature, bringing it into the precincts of lofty ideals. Once there, the native subject would compete with the works of the masters. Claudian light was as potent a factor as Claudian form. It answered a need for "sentiment"—a faculty that penetrated the inner truth of nature. Generally a single Claudian stamp was enough to telescope the sublime and the beautiful. Claudian influence was sometimes qualified by cues taken from Salvator's repertory of time-ravaged picturesque.

HIS MORNING, evening and noon-day scenery, may be compared to that of Claude Lorrain, more subdued but more true, and his storm scenes to those of Salvator Rosa. . . . Whatever scene he painted, it was nature herself. —Shearjashub Spooner, on Thomas Cole (1853)[10]

THE BEST Claude I have ever seen. The sky and distance of a pearly cool tone may light and assist—the other parts of the picture darker—The clouds are light and beautiful and seem as though they were not painted with brushes but melted into the blue. . . . There are very broad masses of shadow in the picture but all transparent and gradating into the light beautifully—The water in the foreground is exquisitely painted and looks like the purest of water. His touch throughout is mellow melting and appropriate. . . . The sky and distance are smooth as though they had been pummiced—though here and there you may see where the painter has used his hand. —Thomas Cole, on Claude's *Embarkation of the Queen of Sheba* (1829)[11]

THE CLAUDES are still pleasing but Embarkation of the Queen of Sheba is my favourite—the beauty of the atmosphere, the truth, transparency and motion of the water are surprising. —Thomas Cole (1841)[12]

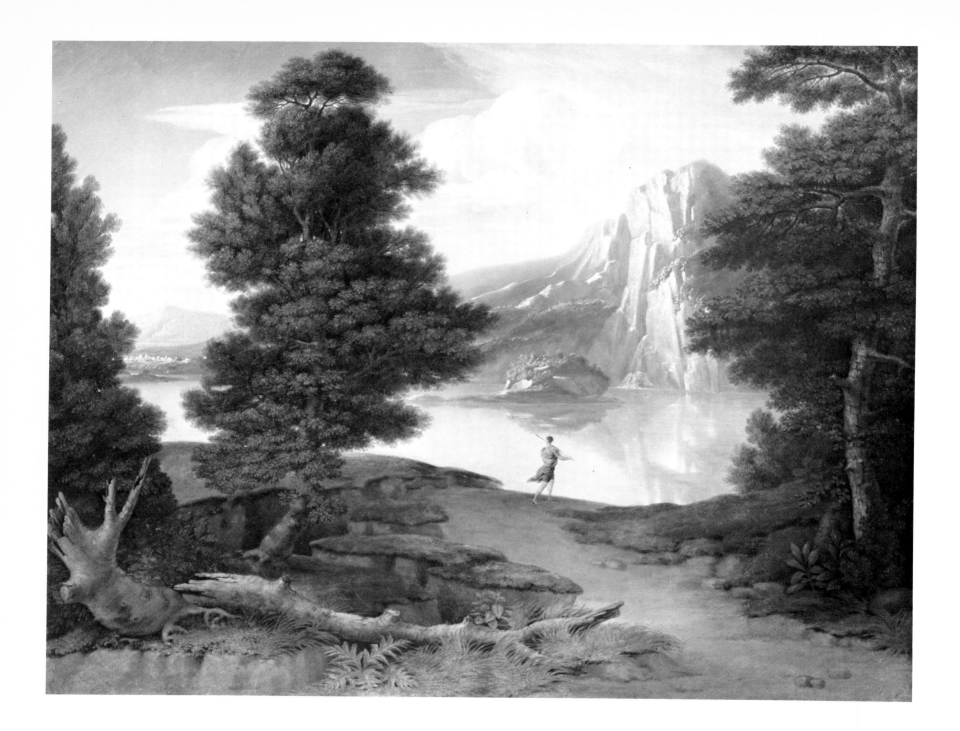

I MAY now say more emphatically I have seen the Old Masters, several of them undoubtedly fine specimens . . . and first and foremost in my thought is Claude . . . There are 10 of his works in this collection, some of them esteemed his very best, I may therefore venture to express my first impressions of Claude—On the whole then, if not disappointed, at the least, I must say he does not surpass my expectations . . . I will not express an opinion in detail until further examination, yet what I have seen of them is worth the passage of the Atlantic. —Asher B. Durand, Journal (1840)[13]

IT MAY be hopeless to expect more perfect light and atmosphere than we find in the seaports and occasionally, other scenes by Claude. Still, I have not felt in contemplating them that I was so completely in the presence of Nature, so absorbed by her loveliness and majesty, as not to feel that the portrait of her might be at least, in some important feature, more expressive of character. —Asher B. Durand, Letter to Thomas Cole (1840)[14]

MANY of the old masters have been praised for their defects, and the blackness of age has been called tone; and there are some whose merits appear to me to be but small. Salvator Rosa's is a great name—his pictures disappointed me—he is *peculiar,* energetic, but of limited capacity, comparatively.—Claude, to me, is the greatest of all landscape painters, and indeed I should rank him with Raphael or Michael Angelo. Poussin I delighted in; and Ruysdael, for his truth, which is equal to Claude, but not so choice. —Thomas Cole, Letter to William Dunlap (c. 1834)[15]

ON INFLUENCE: THE DUTCH

In a direct line from Sir Joshua Reynolds, whose hold on American artists reached far into the nineteenth century, official criticism considered Dutch models inferior. But the artists themselves seem to have found inspiration in the compositions of such artists as Cuyp, Van de Velde, and Van Goyen. The problem of Dutch influence on American landscape painting is still a perplexing one. Archival evidence of the artists' interest is slim. To some extent, the abandonment of Claudian formulas and the direct consideration of American nature per se could have produced the open-edged horizontal compositions that distinguish the "Luminist mode" of Lane, Heade, Kensett, and occasionally other members of the Hudson River group. But at the very least, the Dutch

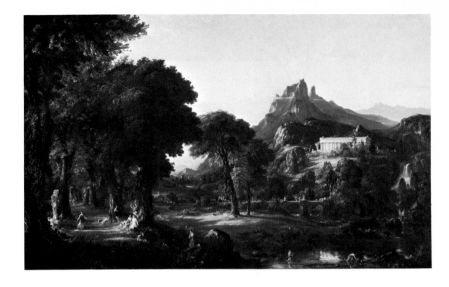

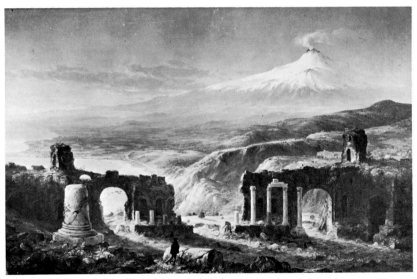

opposite: WASHINGTON ALLSTON. *Landscape with a Lake.* 1804
Oil on canvas, 38 x 51¼ in. (96.5 x 130.2 cm.)
Museum of Fine Arts, Boston. M. and M. Karolik Collection

top: THOMAS COLE. *Dream of Arcadia.* 1838
Oil on canvas, 39 x 63 in. (99.1 x 160 cm.). The Denver Art Museum

bottom: THOMAS COLE. *Mount Etna from Taormina.* 1844
Oil on canvas, 32¼ x 48 in. (81.9 x 121.9 cm.)
Lyman Allyn Museum, New London, Connecticut

works, which were early exhibited in America, seem to have provided paradigms for a more pragmatic observation of what the critic John Neal called the "prose" of nature.

THE PAINTERS of the Dutch school have still more locality. With them, a history-piece is properly a portrait of themselves; whether they describe the inside or outside of their houses, we have their own people engaged in their own peculiar occupations; working or drinking, playing or fighting. The circumstances that enter into a picture of this kind are so far from giving a general view of human life, that they exhibit all the minute particularities of a nation differing in several respects from the rest of mankind. Yet, let them have their share of more humble praise. The painters of this school are excellent in their own way; they are only ridiculous when they attempt general history on their own narrow principles, and debase great events by the meanness of their characters.

Some inferior dexterity, some extraordinary mechanical power is apparently that from which they seek distinction. . . .

The same local principles which characterize the Dutch school extend even to their landscape-painters; and Rubens himself, who has painted many landscapes, has sometimes transgressed in this particular. Their pieces in this way are, I think, always a representation of an individual spot, and each in its kind a very faithful but a very confined portrait. Claude Lorrain, on the contrary, was convinced, that taking nature as he found it seldom produced beauty. His pictures are a composition of the various drafts which he had previously made from various beautiful scenes and prospects. . . . That the practice of Claude Lorrain, in respect to his choice, is to be adopted by landscape-painters in opposition to that of the Flemish and Dutch schools, there can be no doubt, as its truth is founded upon the same principle as that by which the historical painter acquires perfect form. —Sir Joshua Reynolds, *Discourse* (1771)[16]

AMONG the professed landscapists of the Dutch school, we find much dexterous imitation of certain kinds of nature, remarkable usually for its persevering rejection of whatever is great, valuable, or affecting in the object studied. Where, however, they show real desire to paint what they saw as far as they saw it, there is of course much in them that is instructive, as in Cuyp and in the etchings of Waterloo, which have even very sweet and genuine feeling; and so in some of their architectural painters. But the object of the great body of them is merely to display manual dexterities of one kind or another, and their effect on the public mind is so totally for evil, that though I do not deny the advantage an artist of real judgment may derive from the study of some of them, I conceive the best patronage that any monarch could possibly bestow upon the arts, would be to collect the whole body of them into a grand gallery and burn it to the ground. —John Ruskin, *Modern Painters, I* (1843)[17]

INTELLECTUALLY, its choice was low and unrefined. It ignored moral significance, yet its feeling, although common, was not unsound at heart. I should say that it lacked both aesthetic and intellectual sensibility . . . avoiding all thought and priding itself on its mechanical skill and infinite patience. There never was a more purely mechanical, commonplace school of painting, combined with so much minute finish and fidelity to the ordinary aspect of things, heedless of *idealisms* of any sort. If it labored for any special end, it was that of ocular deception. . . . They did not want art to teach them ideas, but to represent things. —James Jackson Jarves, on the Dutch (1869)[18]

BUT DUTCH art is too well-liked and known for me to dwell longer on it. Those whose aesthetics are in sympathy with its mental mediocrity will not desert it for anything I may say. —James Jackson Jarves (1869)[19]

YOU HAVE misunderstood what I said about compositions. I meant not those you refer to. The finest pictures I will allow are compositions, but this they are of experienced artists whose style has been formed, and whose store of natural images are so abundant that they can arrange real views from nature in such a manner as to form a scene desired in its design from the imagination only. Claude's pictures, though compositions, are every one of them real views as to the various parts of the landscape, not only in scenery but in atmospheric appearance, and it is the truth of his scenery which is so much admired. Berghem and Ruysdael are among the best known, and yet their pictures have no appearance of a composition. —Robert Gilmor, Jr., to Thomas Cole (1826)[20]

I HAVE some of my finest [pictures] lying about the house like lumber for want of room to hang them up. My fine Berghem and Ruysdael are still in this situation. —Robert Gilmor, Jr., to Thomas Cole (1828)[21]

Selected Listing of Dutch Paintings in the Collection of Robert Gilmor, Jr.

A scene on the river Wye, at Amsterdam.—Ludolph Backhuysen.
A small Landscape.—Wynants.
A Calm.—William Vandevelde.
View on the Rhine.—J. Vandermeer.
View of Haarlem, his native place.—Jacob Ruysdael.
View of the Leeshore at Scheveling.—Do.
Small Landscape.—Do.
Cattle and Sheep, in a sunny Landscape.—Omegank.
Landscape, with Cattle.—Vander Leeuw.
Moonlight View on a canal in Holland.—Vander Neer.
Evening Scene on a river, with Cattle (engraved).—Albert Cuyp.
Sea-shore at Schevelinge, with numerous figures (engraved).—Van Goyen.
—William Dunlap (1834)[22]

Selected Listing of Dutch Paintings Exhibited at the American Academy of Fine Arts and the Apollo Association

CUYP [probably Aelbert Cuyp]
1817. American Academy of Fine Arts
 40. An Old Man. For Sale.
1821. 99. Landscape, with Cattle.
1822. 87. Cattle.
1828. 42. Landscape with Cow and Figure. Lent by Mr. W. Hall.
1839. May Exhibition, Apollo Association
 72. Landscape—by Albert Cuyp, born at Dort in 1606 (sic) Sketch—morning in a meadow on the sea-shore, attended with its mists and vapours. From the collection of C. La Forest, Esq.
1840. September Exhibition, Apollo Association
 42. The Chase

VANDERVELDE (Vanderveldt)
1817. American Academy of Fine Arts
 18. Sea Piece, with Vessels and Figures. Jumel Collection.
 33. Storm at Sea. For Sale.
1821. 104. Landscape, with shipping.

1822. 70. Shipping.
 101. Sea Port.
 104. Sea View.
 110. Sea View.
1823. 82. Marine View.
 84. Landscape, with Figures and Shipping.
1839. May Exhibition, Apollo Association
 157. Shipping in a gale of wind. For sale, $300.00
1840. February Exhibition, Apollo Association
 57. Landscape and Cattle. Belongs to the collection of M. La Forest, Esq.

VANDERVELDE, Willem, 17th century, Dutch.
1818. American Academy of Fine Arts
 186. A Calm. A pleasing picture by that master. Lent by Mr. P. Flandin

VAN GOYEN, Jan
1818. American Academy of Fine Arts
 22. Landscape, with Fishermen drawing a seine to the banks of a river, distant figure angling. Lent by Mr. Amory.[23]

LIKE his father, the younger Van de Velde designed everything from nature, and his compositions are distinguished by a more elegant and tasteful arrangement of his objects, than is to be found in the productions of any other painter of marines. . . . In his calms the sky is sunny, and brilliant, and every object is reflected in the glassy smoothness of the water, with a luminous transparency peculiar to himself. In his fresh breezes and squalls, the swell and curl of the waves is delineated with a truth and fidelity which could only be derived from the most attentive and accurate study of nature; in his storms, tempests, and hurricanes, the tremendous conflict of the elements and the horrors of shipwreck are represented with a truthfulness that strikes the beholder with terror. —Shearjashub Spooner (1853)[24]

SOME of Cole's figures and [word illegible] have the finish of the Dutch masters. —William Sidney Mount, Notebook (1848)[25]

THE SIMPLEST arrangement and treatment of colours will be found in the style of Cuyp and Both; objects in shadow are relieved against a warm, sunny sky,

THOMAS WORTHINGTON WHITTREDGE. *The Old Hunting Grounds.* 1864
Oil on canvas, 36 x 27 in. (91.4 x 68.6 cm.)
Reynolda House, Inc., Winston-Salem, North Carolina

and do not present much variety of tint. The whole aspect or general tone of the picture is warm. —William Sidney Mount, Notebooks (1844–50)[26]

IN GRANDEUR of conception and knowledge of aerial perspective combined with the utmost glow and warmth of the misty or serene atmosphere, Cuyp stands unrivalled and takes the same place for Dutch scenery as Claude Lorrain for the Italian, so that he might justly be called the Dutch Claude. —*The Crayon* (1855)[27]

MR. DUNLAP, in his notice of Mr. Mount, says, 'I was much pleased to receive the spontaneous eulogium of a much better judge than myself, in a letter of 1834, from Mr. Allston.' He says, 'I saw some pictures in the Athenaeum, (Boston,) by a young man of your city—Mount—which showed great power of expression. . . . If he would study Ostade and Jan Steen, especially the latter, and master their colour and *chiaro scuro,* there is nothing, as I see, to prevent his becoming a great artist in the line he has chosen.' If our great historical painter could see the pictures W. S. Mount exhibits this year with the academy to which he belongs, and of which he was a student, we think Mr. Allston would agree with us, that to study Jan Steen's master, Nature, is doing as much for the Long Island boy, as Jan Steen could do for him. —*The New-York Mirror* (1835)[28]

THIS day has been devoted to visiting the Dulwich Gallery, a collection of nearly four hundred pictures, principally of the old masters . . . the Gallery is open free to the public and consists of a tolerably numerous collection, the majority of which are by the Dutch masters.

 Of the sunny pictures of Cuyp, there are several here, exceedingly luminous . . . his cattle leave nothing to wish for. There are also examples of Wouvermans . . . Both Berchem and Paul Potter. —Asher B. Durand, Journal (1840)[29]

MAGNIFICENT collection of the Dutch masters contained in the Museum of Amsterdam. So that we may now safely conclude that we have seen the chef d'oeuvres of this school of imitative art, and can form, with pretty just estimate, the capacity of colour under the direction of the imitative and skillful merits. —Asher B. Durand, Journal (1840)[30]

On American Nature and American Art

America's raw landscape represented a challenge to create an American art that was not "stamped" with European influence and tradition. Direct encounters with nature played an important role, resulting in observations of light and form that paralleled certain proto-Impressionist developments abroad.

I SOON found myself in working traces but it was the most crucial period of my life. It was impossible for me to shut out from my eyes the works of the great landscape painters which I had so recently seen in Europe, while I knew well enough that if I was to succeed I must produce something new and which might claim to be inspired by my home surroundings. I was in despair. Sure, however that if I turned to nature I should find a friend, I seized my sketch box and went to the first available outdoor place I could find. I hid myself for months in the recesses of the Catskills. But how different was the scene before me from anything I had been looking at for many years! The forest was a mass of decaying logs and tangled brush wood, no peasants to pick up every vestige of fallen sticks to burn in their miserable huts, no well-ordered forests, nothing but the primitive woods with their solemn silence reigning everywhere. I think I can say that I was not the first or by any means the only painter of our country who has returned after a long visit abroad and not encountered the same difficulties in tackling home subjects. Very few independent minds have ever come back home and not been embarrassed with this same problem. And it is to be hoped that none will ever return without being bothered in the same way. . . .

If art in America is ever to receive any distinctive character so that we can speak of an American School of Art, it must come from this new condition, the close intermingling of the peoples of the earth in our peculiar form of government. In this I have some hope for the future of American Art. We are a very young nation to stand as well as we do in art compared with the people of the old world. Our young artists, especially the landscape painters, are experimenting. —Worthington Whittredge, Autobiography (1905)[31]

On God and Nature

The most important aspect of American landscape prior to the Civil War was its status as God's "sensuous image and revelation." The concepts of Design and

ASHER B. DURAND. *In the Woods.* 1855
Oil on canvas, 60¾ x 48 in. (154.3 x 121.9 cm.)
The Metropolitan Museum of Art, New York
Gift in memory of Jonathan Sturges by his children, 1895

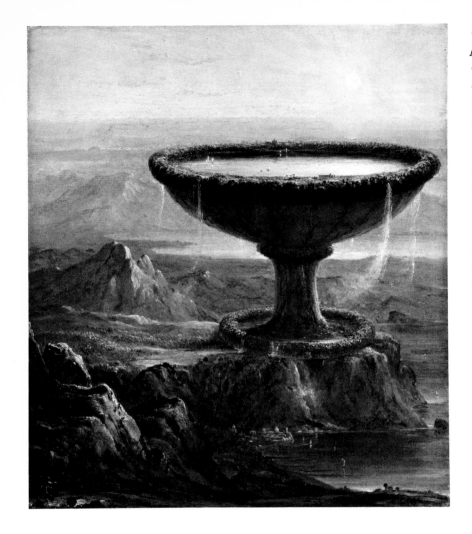

THOMAS COLE. *The Titan's Goblet*. 1833
Oil on canvas, 19⅜ x 16⅛ in. (49.2 x 41 cm.)
The Metropolitan Museum of Art, New York
Gift of Samuel Avery, Jr., 1904

Divine Providence held fast in America. Landscape paintings were votive icons, portraits of God. God in nature and God as nature were virtually interchangeable, despite the uneasiness of orthodox religions at the pantheistic overtones. In this, Transcendental philosophy led the way. Ruskin, who shared many of these attitudes, found an American audience even more receptive than the English.

THERE is yet another motive for referring you to the study of Nature early—its influence on the mind and heart. The external appearance of this our dwelling-place, apart from its wondrous structure and functions that minister to our well-being, is fraught with lessons of high and holy meaning, only surpassed by the light of Revelation. It is impossible to contemplate with right-minded, reverent feeling, its inexpressible beauty and grandeur, forever assuming new forms of impressiveness under the varying phases of cloud and sunshine, time and season, without arriving at the conviction

> *"That all which we behold*
> *is full of blessings"*

that the Great designer of these glorious pictures has placed them before us as types of the Divine attributes, and we insensibly, as it were, in our daily contemplations,

> *"To the beautiful order of his works*
> *Learn to conform the order of our lives."*
>
> —Asher B. Durand, "Letters on Landscape Painting" (1855)[32]

[LANDSCAPE painting] will be great in proportion as it declares the glory of God, by a representation of his works, and not of the works of man. . . . every *truthful* study of near and simple objects will qualify you for the more difficult and complex; it is only thus you can learn to read the great book of Nature, to comprehend it, and eventually transcribe from its pages, and attach to the transcript your own commentaries. —Asher B. Durand, "Letters on Landscape Painting" (1855)[33]

. . . IN GAZING on the pure creations of the Almighty, he [who looks on nature] feels a calm religious tone steal through his mind, and when he has turned to mingle with his fellow men, the chords which have been struck in that sweet communion cease not to vibrate. —Thomas Cole, "Essay on American Scenery" (1835)[34]

WE HAVE the same need to command a view of the religion of the world. We can never see Christianity from the catechism—from the pastures, from a boat in the pond, from amidst the songs of wood-birds we possibly may. —Ralph Waldo Emerson, "Circles" (1841)[35]

IN THE woods is perpetual youth. Within these plantations of God, a decorum and sanctity reign, a perennial festival is dressed, and the guest sees not how he should tire of them in a thousand years. In the woods, we return to reason and faith. There I feel that nothing can befall me in life—no disgrace, no calamity (leaving me my eyes), which nature cannot repair. Standing on the bare ground—my head bathed by the blithe air and uplifted into infinite space—all mean egotism vanishes. I become a transparent eyeball; I am nothing; I see all; the currents of the Universal Being circulate through me; I am part or parcel of God. The name of the nearest friend sounds then foreign and accidental: to be brothers, to be acquaintances, master or servant, is then a trifle and a disturbance. I am the lover of uncontained and immortal beauty. In the wilderness I find something more dear and connate than in streets or villages. In the tranquil landscape, and especially in the distant line of the horizon, man beholds somewhat as beautiful as his own nature. —Ralph Waldo Emerson, *Nature* (1836)[36]

THE WORLD proceeds from the same spirit as the body of man. It is a remoter and inferior incarnation of God, a projection of God in the unconscious. But it differs from the body in one important respect. It is not, like that, now subjected to the human will. Its serene order is inviolable by us. It is, therefore, to us, the present expositor of the divine mind. . . . Is not the landscape, every glimpse of which hath a grandeur, a face of him? —Ralph Waldo Emerson, *Nature* (1836)[37]

AND SO it is with external Nature: she has a body and a soul like man; but her soul is the Deity. —John Ruskin, *Modern Painters, I* (1843)[38]

ONE LESSON, however, we are invariably taught by all, however approached or viewed,—that the work of the Great Spirit of nature is as deep and un-approachable in the lowest as in the noblest objects,—that the Divine mind is as visible in its full energy of operation on every lowly bank and mouldering stone, as in the lifting of the pillars of heaven, and settling the foundations of

THOMAS DOUGHTY. Untitled Landscape (Rowing on a Mountain Lake). c. 1835
Oil on canvas, 17 x 14 in. (43.2 x 35.6 cm.)
Dartmouth College Museum and Galleries, Hanover, New Hampshire
Whittier Fund

72

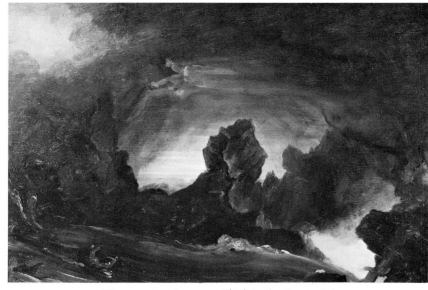

WASHINGTON ALLSTON. *Elijah in the Desert.* 1818
Oil on canvas, 48¾ x 72½ in. (111.2 x 184.2 cm.)
Museum of Fine Arts, Boston. Gift of Mrs. Samuel Hooper and Miss Alice Hooper

THOMAS COLE. Sketch for *Manhood.* c. 1839
Oil on canvas, 11 x 16¾ in. (27.9 x 42.5 cm.)
Munson-Williams-Proctor Institute, Utica, New York

the earth; and that to the rightly perceiving mind, there is the same infinity, the same majesty, the same power, the same unity, and the same perfection, manifest in the casting of the clay as in the scattering of the cloud, in the mouldering of the dust as in the kindling of the day-star. —John Ruskin, *Modern Painters, I* (1843)[39]

ON MORALITY AND NATURE

Morality and concepts of God-in-nature often proceeded in tandem. Landscape lovers were, presumably, more moral than city lovers, and viewing nature, or a painting of nature, was a moral act. Morality sometimes had overtones of cloying piety, but often there were deep spiritual resonances.

. . . THE MOUNTAINS and the ocean, the forest and the river, the blooming clover and the waving grain, the wondrous forms of animals and of man and women, touch us with the same emotions as the perception of intellectual truth and the contemplation of virtuous deeds. They are manifestations of the moral and inner life of the world, of the Eternal Mind whose thoughts are constant laws, and which is revealed alike by the small and the great, in each as in all. —*North American Review* (1855)[40]

HAVE MOUNTAINS, and waves, and skies, no significance but what we consciously give them when we employ them as emblems of our thoughts? The world is emblematic. Parts of speech are metaphors, because the whole of nature is a metaphor of the human mind. The laws of moral nature answer to those of matter as face to face in a glass.

. . . A life in harmony with Nature, the love of truth and of virtue, will purge the eyes to understand her text.

. . . All things are moral; and in their boundless changes have an unceasing reference to spiritual nature. Therefore is nature glorious with form, color, and motion; that every globe in the remotest heaven, every chemical change from the rudest crystal up to the laws of life, every change of vegetation from the first principle of growth in the eye of a leaf, to the tropical forest and antediluvian coal-mine, every animal function from the sponge up to Hercules, shall hint or thunder to man the laws of right and wrong and echo the Ten

Commandments. Therefore is Nature ever the ally of Religion: lends all her pomp and riches to the religious sentiment. . . . It has already been illustrated, that every natural process is a version of a moral sentence. The moral law lies at the centre of nature and radiates to the circumference. . . . All things with which we deal, preach to us. What is a farm but a mute gospel? . . . Nor can it be doubted that this moral sentiment which thus scents the air, grows in the grain, and impregnates the waters of the world, is caught by man and sinks into his soul. The moral influence of nature upon every individual is that amount of truth which it illustrates to him. —Ralph Waldo Emerson, *Nature* (1836)[41]

OF ALL our artists, he [Kensett] has the most thoroughly amiable disposition, is wholly superior to envy, and pursues his vocation in such a spirit of love and kindliness, that a critic must be made of very hard material who can find it in his heart to say a severe, inconsiderate, or careless word about John F. Kensett. Perhaps some of our readers will think all this is quite irrelevant to the present object, which is to define Kensett's position in art, wherewith personal qualities, it may be argued, have nothing to do. But we are of a contrary opinion. The disposition or moral nature of an artist directly and absolutely influence his works. —Henry T. Tuckerman, *Book of the Artists* (1867)[42]

WHAT IS the beauty of nature, but a beauty clothed with moral associations? What is the highest beauty of literature, poetry, fiction, and the fine arts, but a moral beauty which genius has bodied forth, for the admiration of the world? And what are those qualities of the human character which are treasured up in the memory and heart of nations—the objects of universal reverence and exultation, the themes of celebration, of eloquence, and the festal of song, the enshrined idols of human admiration and love? Are they not patriotism, heroism, philanthropy, disinterestedness, magnanimity, martyrdom? —*The New-York Mirror* (1837)[43]

DARK PASSION and debasing crimes, destroy the fine edge of the soul, and eat into it, like a corroding canker. Assuming, therefore, that a pure taste is one of the tests of a healthful moral condition, we shall prize it, not only as a source of pleasure, but as an adjunct to virtue, an ally of religion. . . . The fragrant flower, the whitening harvest, the umbrageous grove, the solemn

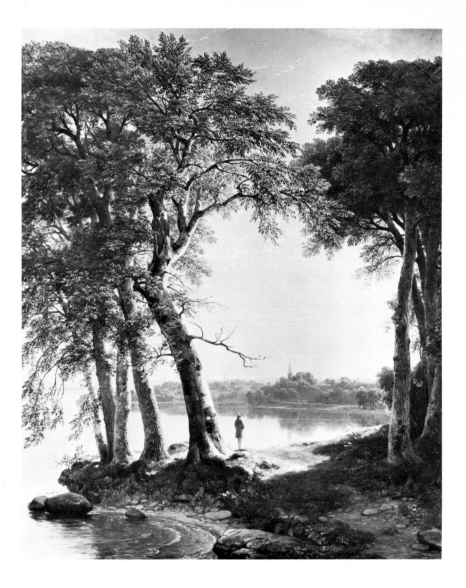

ASHER B. DURAND. *Early Morning at Cold Spring.* 1850
Oil on canvas, 59 x 47½ in. (149.9 x 120.6 cm.)
Montclair Art Museum, Montclair, New Jersey
Lang Acquisition Fund, 1945

73

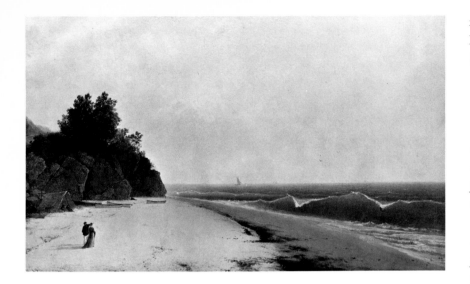

JOHN FREDERICK KENSETT. *Coast Scene with Figures.* 1869
Oil on canvas, 36¼ x 60¼ in. (92.1 x 153 cm.)
Wadsworth Atheneum, Hartford
The Ella Gallup Sumner and Mary Catlin Sumner Collection

mountain, the mighty cataract, are they not all teachers? or text-books, in the hand of the Great Teacher? —Mrs. Lydia H. Sigourney, *Godey's Lady's Book* (1840)[44]

ON THE SUBLIME

The awesome sublime celebrated by Edmund Burke continued into the nineteenth century, but with some modifications. Sublimity took on more transcendent and Christian overtones, becoming almost apocalyptic in fervor, and paralleling certain aspects of revivalist belief. A new kind of sublimity, characterized by silence and stillness, also emerged. Defined by Emerson and Thoreau, this "new sublime" was even more mystically Christian, touching on the "central silence" of Meister Eckhart. The quietism of the Luminist paintings of Lane, Heade, and Kensett can be contrasted with the more historionic "sounds" of the works of Frederic Church, who achieved transcendence largely in terms of the "older sublime." Nineteenth-century painting and literature frequently show a profound sensitivity to the aesthetic of silence.

THE PASSION caused by the great and sublime in *nature,* when those causes operate most powerfully, is astonishment; and astonishment is that state of the soul, in which all its motions are suspended, with some degree of horror. In this case the mind is so entirely filled with its object, that it cannot entertain any other, nor by consequence reason on that object which employs it. Hence arises the great power of the sublime, that far from being produced by them, it anticipates our reasonings, and hurries us on by an irresistible force. Astonishment, as I have said, is the effect of the sublime in its highest degree; the inferior effects are admiration, reverence, and respect. . . .

The eye is not the only organ of sensation, by which a sublime passion may be produced. Sounds have a great power in these as in most other passions. . . . Excessive loudness alone is sufficient to overpower the soul, to suspend its action, and to fill it with terror. The noise of vast cataracts, raging storms, thunder or artillery, awake a great and awful sensation in the mind, though we can observe no nicety or artifice in those sorts of music. —Edmund Burke, *On the Sublime and Beautiful* (1757)[45]

THE FACT is, that sublimity is not a specific term,—not a term descriptive of the effect of a particular class of ideas. Anything which elevates the mind is

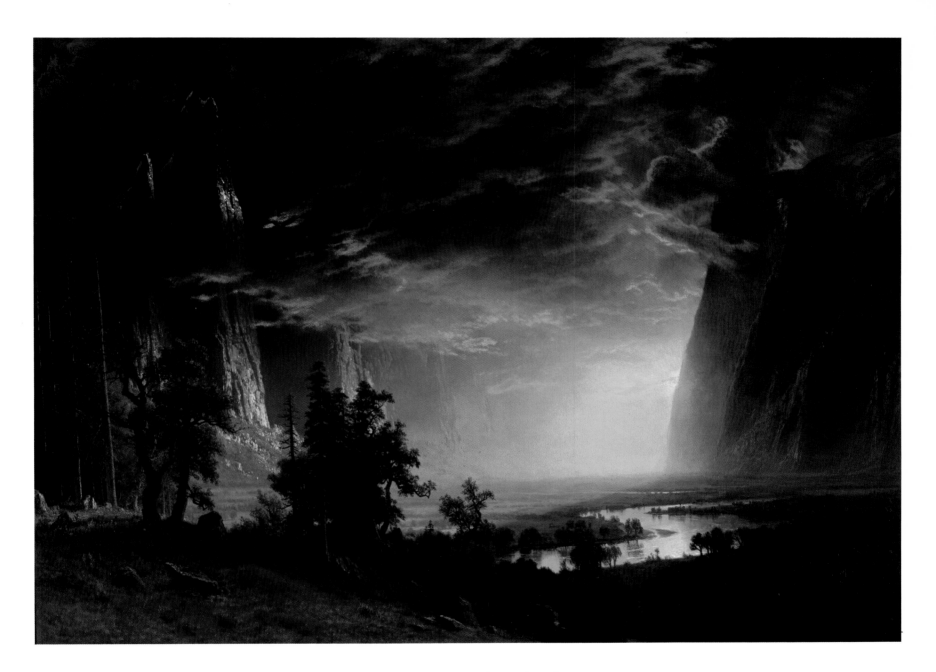

ALBERT BIERSTADT. *Sunset in the Yosemite Valley.* 1868
Oil on canvas, 35½ x 51½ in. (90.2 x 130.8 cm.)
Pioneer Museum and Haggin Galleries, Stockton, California

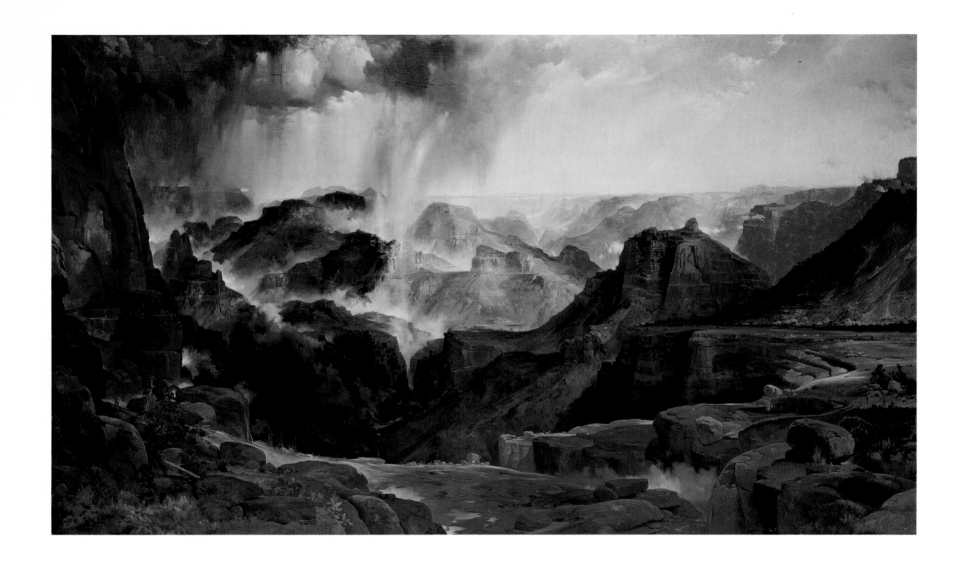

Thomas Moran. *The Chasm of the Colorado.* 1873–74
Oil on canvas, 84⅜ x 144¾ in. (214.4 x 367.7 cm.)
The United States Department of the Interior, Washington, D.C.

sublime, and elevation of mind is produced by the contemplation of greatness of any kind; but chiefly, of course, by the greatness of the noblest things. Sublimity is, therefore, only another word for the effect of greatness upon the feelings. Greatness of matter, space, power, virtue, or beauty, are thus all sublime; and there is perhaps no desirable quality of a work of art, which in its perfection is not, in some way or degree, sublime. —John Ruskin, *Modern Painters, I* (1843)[46]

[CHURCH] has dealt with South American cascades as faithfully as with the flushed horizon of his native country, and we find a new mine of the picturesque, opened by his graphic hand. Seldom has a more grand effect of light been depicted than the magnificent sunshine on the mountains of a tropical clime, from his radiant pencil. It literally floods the canvas with celestial fire, and beams with glory like a sublime psalm of light. —Henry T. Tuckerman, *Book of the Artists* (1867)[47]

WE DISTINGUISH the announcements of the soul, its manifestations of its own nature, by the term *Revelation*. These are always attended by the emotion of the sublime. For this communication is an influx of the Divine mind into our mind. —Ralph Waldo Emerson, "The Over-Soul" (1841)[48]

THERE ARE two lakes . . . situated in a wild mountain gorge called the Franconia Notch, in New Hampshire. . . . Shut in by stupendous mountains which rest on crags that tower more than a thousand feet above the water, whose rugged brows and shadowy breaks are clothed by dark and tangled woods, they have such an aspect of deep seclusion, of utter and unbroken solitude, that, when standing on their brink a lonely traveller, I was overwhelmed with an emotion of the sublime, such as I have rarely felt. It was not that the jagged precipices were lofty, that the encircling woods were of the dimmest shade, or that the waters were profoundly deep; but that over all, rocks, wood, and water, brooded the spirit of repose, and the silent energy of nature stirred the soul to its inmost depths.

I would not be understood that these lakes are always tranquil; but that tranquillity is their great characteristic. There are times when they take a far different expression; but in scenes like these the richest chords are those struck by the gentler hand of nature. —Thomas Cole, "Essay on American Scenery" (1835)[49]

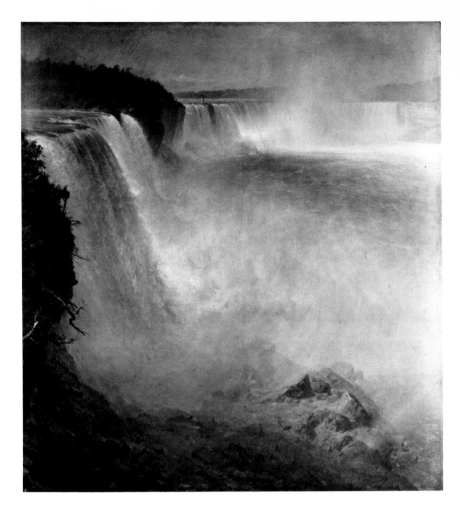

FREDERIC EDWIN CHURCH. *Niagara from the American Side.* 1867
Oil on canvas, 114 x 90 in. (289.6 x 228.6 cm.)
National Gallery of Scotland, Edinburgh

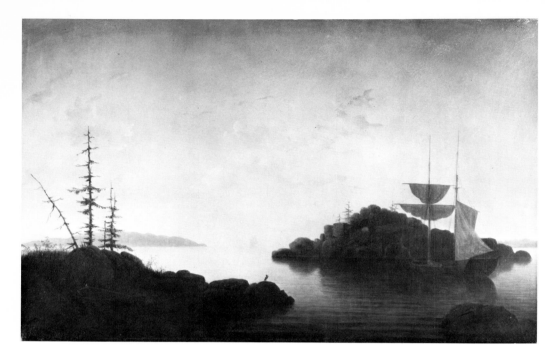

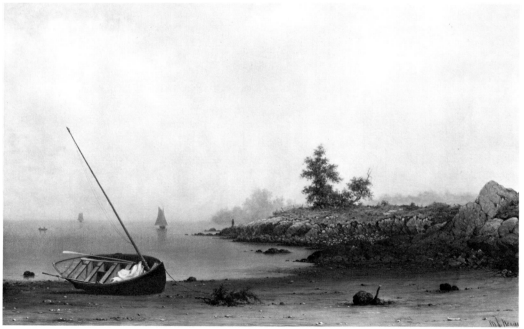

Fitz Hugh Lane. *Christmas Cove, Maine.* 1859
Oil on canvas, 15½ x 24 in. (39.4 x 61 cm.)
Private collection

Martin Johnson Heade. *The Stranded Boat.* 1863
Oil on canvas, 22¾ x 36½ in. (57.8 x 92.7 cm.)
Museum of Fine Arts, Boston
M. and M. Karolik Collection

. . . YET IT IS not in the broad and fierce manifestations of the elemental energies, not in the clash of the hail, nor the drift of the whirlwind, that the highest characters of the sublime are developed. God is not in the earthquake, nor in the fire, but in the still small voice. —John Ruskin, *Modern Painters, I* (1843)[50]

THERE ARE times when the gentle influences of the country more strongly impress us; there are days, and this was one, when the woods and fields possess a hallowing, tranquillizing power, which banishes every unholy thought, obliterates care, subdues the passions, and as it throws a Sabbath over the mind, causes us to bless with gratitude the love that made the earth so fair. —*The New-York Mirror* (1837)[51]

TO BE CALM, to be serene! There is the calmness of the lake when there is not a breath of wind; there is the calmness of a stagnant ditch. So is it with us. Sometimes we are clarified and calmed healthily, as we never were before in our lives, not by an opiate, but by some unconscious obedience to the all-just laws, so that we become like a still lake of purest crystal and without an effort our depths are revealed to ourselves. All the world goes by us and is reflected in our deeps. Such clarity! obtained by such pure means! by simple living, by honesty of purpose. —Henry David Thoreau, Journal (1851)[52]

GOOD AS IS discourse, silence is better, and shames it. —Ralph Waldo Emerson, "Circles" (1841)[53]

THE CENTRAL silence is there, where no creature may enter, nor any idea, and there the soul neither thinks nor acts, nor entertains any idea, either of itself or of anything else. —Meister Eckhart, "The Sermons" (c. 1300–28)[54]

IF WITH closed ears and eyes I consult consciousness for a moment, immediately are all walls and barriers dissipated, earth rolls from under me, and I float, by the impetus derived from the earth and the system, a subjective, heavily laden thought, in the midst of an unknown and infinite sea, or else heave and swell like a vast ocean of thought, without rock or headland, where are all riddles solved, all straight lines making there their two ends to meet, eternity and space gambolling familiarly through my depths. I am from the beginning, knowing no end, no aim. No sun illumines me, for I dissolve all lesser lights in my own intenser and steadier light. I am a restful kernel in the magazine of the universe. —Henry David Thoreau, Journal (1838)[55]

WHO WILL ever paint a true picture of those rare moments in life when physical well-being prepares the way for calm of soul, and the universe seems before your eyes to have reached a perfect equilibrium; then the soul, half asleep, hovers between the present and the future, between the real and the possible, while with natural beauty all around and the air tranquil and mild, at peace with himself in the midst of universal peace, man listens to the even beating of his arteries that seems to him to mark the passage of time flowing drop by drop through eternity. —Alexis de Tocqueville, *Journey to America* (1831)[56]

WE HAVE often admired one of those calm and serene evenings on the ocean when the sails flap quietly by the mast, leaving the sailor doubtful whence the breeze will rise. This response of all nature is no less impressive in the solitudes of the New World than on the immensity of the sea. At midday, when the sun darts its beams on the forest, one often hears in its depths something like a long sigh, a plaintive cry lingering in the distance. It is the last stir of the dying wind. Then everything around you falls back into a silence so deep, a stillness so complete, that the soul is invaded by a kind of religious terror. . . .

More than once in Europe we have found ourselves lost deep in the woods, but always some sound of life came to reach our ears. Perhaps the distant tinkle of the nearest village bell, a traveller's footstep, the woodcutter's axe, a gunshot, the barking of a dog, or just that confused sound that pervades a civilised country. Here not only is man lacking, but no sound can be heard from the animals either. The smallest of them have left these parts to come close to human habitations, and the largest have gone to get even farther away. Those that remain stay hidden from the sun's rays. So all is still in the woods, all is silent under their leaves. One would say that for a moment the Creator had turned his face away and all the forces of nature are paralyzed. —Alexis de Tocqueville, *Journey to America* (1831)[57]

. . . A SILENCE which, gratefully contrasting with the surrounding tumult of form, conveyed to me a new sentiment. I have lain and listened through the heavy calm of a tropical voyage, hour after hour, longing for a sound; and in desert nights the dead stillness has many a time awakened me from sleep. For

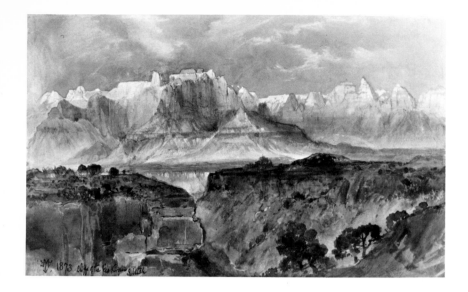

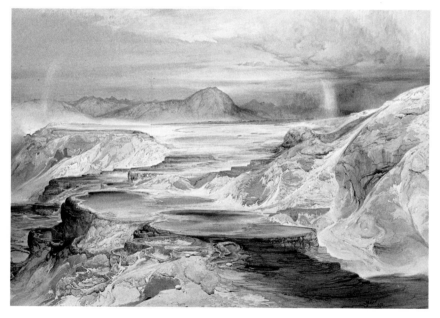

THOMAS MORAN. *Cliffs of the Rio Virgin.* 1873. Watercolor, 8⅝ x 14 in. (21.9 x 35.6 cm.)
Cooper-Hewitt Museum of Design, Smithsonian Institution, New York

Hot Springs of Gardiner River, Yellowstone National Park, Wyoming Territory. 1872
Watercolor, 20¼ x 28⅝ in. (51.4 x 72.7 cm.)
Reynolda House, Inc., Winston-Salem, North Carolina

moments, too, in my forest life, the groves made absolutely no breath of movement; but there is round these summits the soundlessness of a vacuum. The sea stillness is that of sleep. The desert of death, this silence is like the waveless calm of space. —Clarence King, on Mount Tyndall, in *Mountaineering in the Sierra Nevada* (1872)[58]

. . . WHILE I know the standard claim is that Yosemite, Niagara Falls, the upper Yellowstone and the like afford the greatest natural shows, I am not so sure but the prairies and the plains, while less stunning at first sight, last longer, fill the esthetic sense fuller, precede all the rest, and make North America's characteristic landscape. Indeed, through the whole of this journey, what most impressed me, and will longest remain with me, are these same prairies. Day after day, and night after night, to my eyes, to all my senses—the esthetic one most of all—they silently and broadly unfolded. Even their simplest statistics are sublime. —Walt Whitman, *Specimen Days* (1879)[59]

THOSE divine sounds which are uttered to our inward ear—which are breathed in with the zephyr or reflected from the lake—come to us noiselessly, bathing the temples of the soul, as we stand motionless amid the rocks.

The halloo is the creature of walls and masonwork; the whisper is fitted in the depths of the wood, or by the shore of the lake, but silence is best adapted to the acoustics of space. —Henry David Thoreau, Journal (1838)[60]

ON ADVENTURE

The landscape artists fulfilled a painterly "manifest destiny" of their own. As God's continent opened up before them, these artist-explorers followed quickly, either traveling with the topographical expeditions or close behind them. As curates of God's nature, they felt a special obligation to experience the widest range of natural aspects and climates. In these circumstances, physical hardship and difficulty were simple tests of devotion.

ARTISTS are now scattered, like leaves or thistle blossoms, over the whole face of the country, in pursuit of some of their annual study of nature and necessary recreation. Some have gone far toward the North Pole, to invade the haunts of the iceberg with their inquisitive and unsparing eyes—some have gone to the far West, where Nature plays with the illimitable and grand—some have

become tropically mad, and are pursuing a sketch up and down the Cordilleras, through Central America and down the Andes. If such is the spirit and persistency of American art, we may well promise ourselves good things for the future. —*The Cosmopolitan Art Journal* (1859)[61]

THE INDOMITABLE explorative enterprise of the New England mind Church has carried into landscape art, the infinite possibilities whereof, as accessory to and illustrative of natural science, were long ago foreseen by Humboldt, into whose views the young American painter entered with ardor and intelligence. It seems to us a most pleasing coincidence that, when Church sojourned in the vicinity of Quito, in order to study tropical landscape, he lodged beneath the roof and shared the hospitality of the same family with whom Humboldt found a home fifty years before, while making his scientific researches in the same region. . . . Half a century later, the artist who was to do for South America in art what the *savant* had done in science, like him came wearied at night, to repose in the same apartment. . . .

Enterprise is, indeed, a prominent characteristic of Church; he has had the bravery to seek and the patience to delineate subjects heretofore scarcely recognized by art, one of whose benign missions it is to extend the enjoyment which time and space limit, and bring into mutual and congenial acquaintance the most widely separated glories of the universe. —Henry T. Tuckerman, *Book of the Artists* (1867)[62]

ADVENTURE is an element in American artist-life which gives it singular zest and interest. From Audubon's lonely forest wanderings and vigils, to Church's pilgrimage among the Andes, or Bradford's chase after icebergs off the coast of Labrador, its record abounds with pioneer enterprise and hardy exploration. —Henry T. Tuckerman, *Book of the Artists* (1867)[63]

CHURCH'S travels in South America were not without fatigues and hazards. On one of these occasions, after twenty days passed on board a small brig, and suffering much from heat and sea-sickness, he disembarked at the mouth of the Magdelena river, which he tediously ascended in a canoe. Traversing the woods on mules, the artist and his companion endured all the privations, and enjoyed all the wonders of a tropical journey. They were tormented by insects, and passed hours in making their way through the dense undergrowth. One dark night an accident separated them. The bridle-paths were dangerous without a

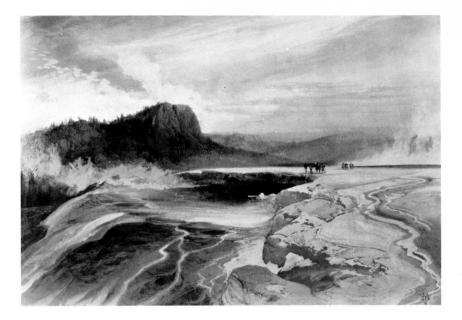

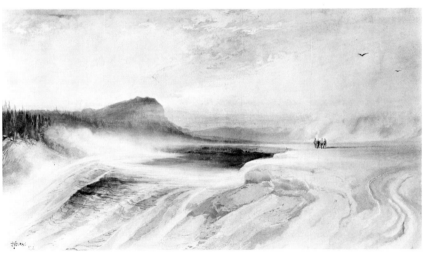

THOMAS MORAN
Two views of *Great Blue Spring of the Lower Geyser Basin, Fire Hole River, Yellowstone.* 1872.
Watercolor; *above:* 9½ x 13¾ in. (24.2 x 34.9 cm.)
Collection Mr. and Mrs. James Biddle, Washington, D.C.
below: 9 x 16 in. (22.9 x 40.6 cm.)
The Dietrich Corporation, Reading, Pennsylvania

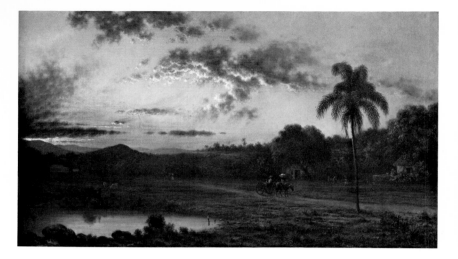

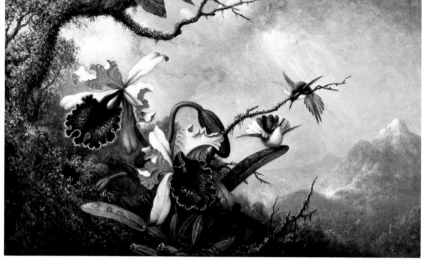

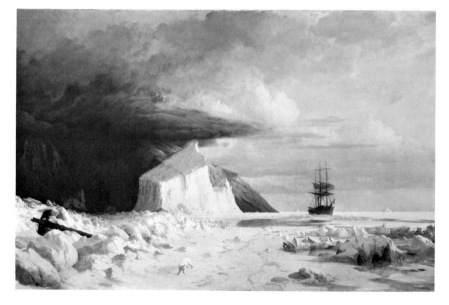

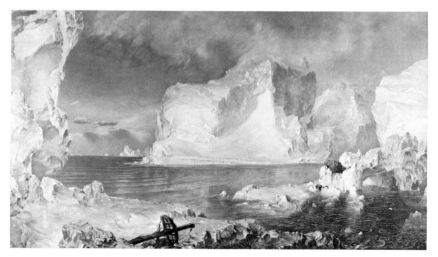

MARTIN JOHNSON HEADE. *Sunset: A Scene in Brazil.* c. 1864–65
Oil on canvas, 19¼ x 34 in. (48.9 x 86.4 cm.)
Collection Mr. and Mrs. Edmund J. Bowen, Delray Beach, Florida

WILLIAM BRADFORD. *An Arctic Summer, Boring through the Pack Ice in Melville Bay.* 1871
Oil on canvas, 51¾ x 78 in. (131.5 x 198.2 cm.)
Collection Mr. and Mrs. Erving Wolf, Houston

MARTIN JOHNSON HEADE. *Yellow Orchid and Two Hummingbirds.* c. 1870–79
Oil on canvas, 14 x 22 in. (135.6 x 155.8 cm.). Collection David Rust

FREDERIC EDWIN CHURCH. *The Icebergs (The North).* 1863
Chromolithograph by C. Risdon after a lost painting of 1861,
20¾ x 35½ in. (52.7 x 90.2 cm.)
Olana State Historic Site, Hudson on Hudson, New York
New York State Office of Parks & Recreation

guide; not a sign of human dwellings was visible; the hootings of owls and the howlings of beasts increased the horrors of darkness. Wearied with penetrating the interminable brushwood, now up to his knees in a morass, and now entangled amid the vine-covered trees, the intrepid limner climbed a tree and long shouted in vain. The mules had slipped away, his companion was ill, and worn out by fatigue, he found temporary repose on an ant-hill. After many disappointments, he succeeded at length in finding the track of his guides, and resuming his journey under more favorable auspices. —Henry T. Tuckerman, *Book of the Artists* (1867)[64]

FROM SAN JUAN we went to Mendis and after crossing the River Magdalena we took a peon and mules for Guaduas. The road was very bad, but we advanced more than the peon, who was on foot. We arrived at the apex of the mountains which looks toward the high Guaduas . . . and began to descend without a guide. . . . Suddenly, the mules left the road and took us to a point filled with thorns and vines, and after being very scratched by the thorns and caught by the vines, we naturally decided that it could not be the right road to Guaduas. —Frederic E. Church, Journal (1853)[65]

THE PICTURE altogether is a noble example of that application of the landscape-painter's art to the rendering of the grand, beautiful, and unfamiliar aspects of nature, only accessible at great cost of fatigue and exposure, and even at peril of life and limb, which seems to be one of the walks in which this branch of the art is destined to achieve new triumphs in our time. —Anonymous English critic, on Church's *The Icebergs* (1863)[66]

ON SCIENCE AND ART

For the early nineteenth century, both science and art were routes to God. Landscape artists were especially aware of the important advances of geology, which replaced biblical time with primordial time around 1830, just as the pictorial discovery of nature as subject was taking place. Each scientific advance brought with it the problem of reconciliation with Design. In the period prior to and immediately succeeding the publication of Darwin's On the Origin of Species *(1859), when evolutionary ideas were gaining force, American artists, like the scientists, devoted considerable energy to maintaining the idea of Deity.*

FREDERIC EDWIN CHURCH. Two studies of Icebergs. 1859
Pencil and white gouache on colored paper,
both, 4½ x 8¼ in. (11.5 x 20.9 cm.)
Cooper-Hewitt Museum of Design,
Smithsonian Institution, New York

FREDERIC EDWIN CHURCH. *Rainy Season in the Tropics.* 1866
Oil on canvas, 56¼ x 84¼ in. (142.9 x 214 cm.)
The Fine Arts Museums of San Francisco, California Palace of the Legion of Honor
Mildred Anna Williams Collection

[THE LANDSCAPE painter always has] companions, who entertain and instruct. . . . Each stone bears upon its surface characters so plainly legible that he "who runs may read." The particolored lichens add grace and symmetry to the massive boulders, which have journeyed from the Polar seas, as they reposed upon the breast of some crystal iceberg. These the artist sees and enjoys, and when the last touch is given to his sketch and the pencil is laid aside, his thoughts revert to those old times, when fauna and flora existed supreme, since breath had not yet given life to man. . . . It is for his own interest and reputation as an artist, to understand what will conduce to the adornment of his work and what will detract from its perfection, and consequently, although perhaps unintentionally, he is a geologist. . . .

Continually meeting with different strata, the query naturally arises, why this diversity? He meets with immense fissures and volcanoes and he asks himself whence did they originate and by what convulsion were they produced? To him, therefore, properly belongs the study of geology, as he more thoroughly than any other can imitate what nature has produced. —"The Relation between Geology and Landscape Painting," *The Crayon* (1859)[67]

A MINUTE examination of the works of creation as they now exist, discloses the infinite perfection of its Author, when they were brought into existence; and geology proves Him to have been unchangeably the same, through the vast periods of past duration, which that science shows to have elapsed since the original formation of our earth. . . . Geology furnishes many peculiar proofs of the benevolence of the Deity. —Edward Hitchcock, *Elementary Geology* (1842)[68]

THE PREVAILING opinion, until recently, limits the duration of the globe to man's brief existence, which extends backward and forward only a few thousand years. But geology teaches us that this is only one of the units of a long series in its history. It develops a plan of the Deity respecting its preparation and use, grand in its outlines, and beautiful in its execution; reaching far back into past eternity, and looking forward, perhaps indefinitely, into the future. . . .

It appears that one of the grand means by which the plans of the Deity in respect to the material world are accomplished, is constant change; partly mechanical, but chiefly chemical. In every part of our globe, on its surface, in its crust, and we have reason to suppose, even in its deep interior these changes are in constant progress: and were they not, universal stagnation and death would be the result. We have reason to suspect also, that changes analogous to those which the earth has undergone, or is now undergoing, are taking place in other worlds; in the comets, the sun, the fixed stars, and the planets. In short, geology has given us a glimpse of a great principle of *instability,* by which the *stability* of the universe is secured; and at the same time, all these movements and revolutions in the forms of matter essential to the existence of organic nature, are produced. Formerly the examples of decay so common everywhere, were regarded as defects in nature: but they now appear to be an indication of wise and benevolent design:—a part of the vast plans of the Deity for securing the stability and happiness of the universe. —Edward Hitchcock, *Elementary Geology* (1842)[69]

THE BOTANIST and geologist can find work in his rocks and vegetation. He seizes upon natural phenomena with naturalistic eyes. —James Jackson Jarves, on Bierstadt (1864)[70]

HIS TASTE in reading suggests a scientific bias; he has long been attracted by the electrical laws of the atmosphere, and has improved every opportunity to study the Aurora Borealis. . . . The proof of the scientific interest of such landscapes as have established Church's popularity, may be found in the vivid and authentic illustrations they afford of descriptive physical geography. —Henry T. Tuckerman, *Book of the Artists* (1867)[71]

LANDSCAPE painting . . . requires for its development a large number of various and direct impressions, which when received from external contemplation, must be fertilized by the powers of the mind, in order to be given back to the senses of others as a free work of art. The grander style of heroic landscape painting is the combined result of a profound appreciation of nature and of this inward process of the mind. —Alexander von Humboldt, *Cosmos, II* (1847)[72]

I FORMERLY admired Humboldt, I now almost adore him; he alone gives any notion of the feelings which are raised in the mind on entering the tropics. —Charles Darwin (1832)[73]

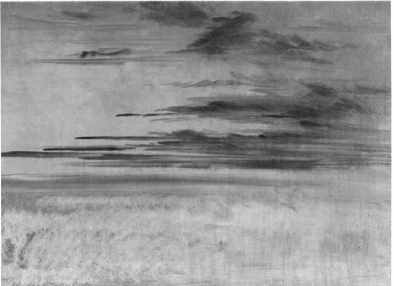

GEORGE CATLIN. Landscape backgrounds for *An Indian Council, Sioux* and
Elk and Buffalo Grazing among Flowers. c. 1846–48
Oil on canvas; *above:* 19¼ x 26⅝ in. (48.9 x 67.8 cm.)
below: 19½ x 27⅝ in. (49.5 x 70.2 cm.)
National Collection of Fine Arts, Smithsonian Institution, Washington, D.C.

I KNEW him only by his great works and noble character but the news touched me as if I had lost a friend. —Frederic E. Church, on Humboldt's death (1859)[74]

BY UNFOLDING the laws of being [science] carries thought into the infinite, and creates an inward art, so perfect and expanded in its conceptions that material objects fashioned by the artist's hand become eloquent only as the feeling which dictated them is found to be impregnated with, and expressive of, the truths of science. The mind indignantly rejects as false all that the imagination would impose upon it not consistent with the great principles by which God manifests himself in harmony with creation. As nature is His art, so science is the progressive disclosure of His soul, or that divine philosophy which, in comprehending all knowledge, must include art as one of its forms. —James Jackson Jarves, *The Art-Idea* (1864)[75]

ON SKIES

Landscape was broken down by commentators into its various components. Skies, clouds, mountains, forests, waterfalls, and still pools all evoked literary, philosophical, critical, and artistic comment. God's infinite firmament was the perfect locus for the landscapists' strongest spiritual affirmations. Cole, Cropsey, Church, and Bierstadt did endless cloud studies. In American paintings, skies can be read both philosophically and meteorologically.

THE SKY will next demand our attention. The soul of all scenery, in it are the fountains of light, and shade, and color. Whatever expression the sky takes, the features of the landscape are affected in unison, whether it be the serenity of the summer's blue, or the dark tumult of the storm. It is the sky that makes the earth so lovely at sunrise, and so splendid at sunset. In the one it breathes over the earth the crystal-like ether, in the other the liquid gold. . . .

Look at the heavens when the thunder shower has passed, and the sun stoops behind the western mountains—there the low purple clouds hang in festoons around the steps—in the higher heaven are crimson bands interwoven with feathers of gold, fit for the wings of angels—and still above is spread the interminable field of ether, whose color is too beautiful to have a name. —Thomas Cole, "Essay on American Scenery" (1835)[76]

TWENTY minutes after seven, I sit at my window to observe the sun set. The lower clouds in the north and southwest grow gradually darker as the sun goes down, since we now see the side opposite to the sun, but those high overhead, whose under sides we see reflecting the day, are light. The small clouds low in the western sky were at first dark also, but, as the sun descends, they are lit up and aglow all but their cores. . . . A roseate redness, clear as amber, suffuses the low western sky about the sun, in which the small clouds are mostly melted, only their golden edges still revealed. The atmosphere there is like some kinds of wine, perchance, or molten cinnabar, if that is red, in which also all kinds of pearls and precious stones are melted. Clouds generally near the horizon, except near the sun, are now a dark blue. (The sun sets.) It is half past seven. . . . —Henry David Thoreau, Journal (1852)[77]

". . . THE HEAVENS declare the glory of God and the firmament showeth his handiwork." . . . look out on the widespread horizon, and study some of its phenomena and laws. Here we have, first of all, the canopy of blue; not opaque, hard, and flat, as many artists conceive it, and picture patrons accept it; but a luminous, palpitating air, in which the eye can penetrate infinitely deep, and yet find depth, nor is it always the same monotonous blue; it is constantly varied, being more deep, cool, warm or grey—moist or dry, passing by the most imperceptible gradations from the zenith to the horizon—clear and blue through the clouds after rain—soft and hazy when the air is filled with heat, dust and gaseous exhalations—golden, rosy, or green when the twilight gathers over the landscape; thus ever presenting new phases for our admiration at each change of light or circumstance. —Jasper F. Cropsey, "Up among the Clouds" (1855)[78]

THE SKY is the daily bread of the eyes. What sculpture in these hard clouds; what expression of immense amplitude in this dotted and rippled rack, here firm and continental, there vanishing into plumes and auroral gleams. No crowding; boundless, cheerful, and strong. —Ralph Waldo Emerson, Journal (1843)[79]

WE NEVER tire of the drama of sunset. I go forth each afternoon and look into the west a quarter of an hour before sunset, with fresh curiosity, to see what new picture will be painted there, what new panorama exhibited, what new

ELIHU VEDDER. *Memory.* 1870
Oil on mahogany panel, 21 x 16 in. (53.3 x 40.6 cm.)
Los Angeles County Museum of Art
Mr. and Mrs. William Preston Harrison Collection

ALBERT BIERSTADT. *Beach Scene.* c. 1871–73. Oil on paper mounted on fiberboard, 13¼ x 18½ in. (33.7 x 47 cm.)
Seattle Art Museum. Gift of Mrs. John McCone in memory of Ada E. Piggott

dissolving views, can Washington Street or Broadway show anything as good? Every day a new picture is painted and framed, held up for half an hour, in such lights as the Great Artist chooses, and then withdrawn, and the curtain falls. —Henry David Thoreau, Journal (1852)[80]

. . . IF ARTISTS were more in the habit of sketching clouds rapidly, and as accurately as possible in the outline, from nature, instead of daubing down what they call "effects" with the brush, they would soon find there is more beauty about their forms than can be arrived at by any random felicity of invention, however brilliant, and more essential character than can be violated without incurring the charge of falsehood,—falsehood as direct and definite, though not as traceable as error in the less varied features of organic form. —John Ruskin, *Modern Painters, I* (1843)[81]

. . . THE SKY is for all; bright as it is, it is not "too bright, nor good, for human nature's daily food;" it is fitted in all its functions for the perpetual comfort and exalting of the heart, for the soothing it and purifying it from its dross and dust. Sometimes gentle, sometimes capricious, sometimes awful, never the same for two moments together; almost human in its passions, almost spiritual in its tenderness, almost divine in its infinity, its appeal to what is immortal in us, is as distinct, as its ministry of chastisement or of blessing to what is mortal is essential. —John Ruskin, *Modern Painters, I* (1843)[82]

EVEN IN nature, these [cumulus] clouds are comparatively uninteresting, scarcely worth raising our heads to look at; and on canvas, valuable only as a means of introducing light, and breaking the monotony of blue; yet they are, perhaps, beyond all others the favorite clouds of the Dutch masters. . . . quite good enough for cattle to graze, or boors to play at nine-pins under—and equally devoid of all that could gratify, inform, or offend. —John Ruskin, on the Central Cloud Region (1843)[83]

. . . GRAND masses of dreamy forms floating by each other, sometimes looking like magic palaces, rising higher and higher, and then topling (sic) over in deep valleys, to rise again in ridges like snowy mountains, with lights and shadows playing amid them, as though it were a spirit world of its own. . . . In boyhood, we have often watched this dream-world, and peopled it with

angels; in manhood, from the cares of life we have turned, and been refreshed by the glimpses of its "silver lining." —Jasper F. Cropsey, on cumulus clouds (1855)[84]

ON TREES

The American forest was not only a special symbol of wilderness. Insofar as the trees were perceived as "patriarchal," the axe's destruction carried with it overtones of patricide. American trees embodied American age and represented the primordial time that was America's oldest and strongest claim to "tradition."

IL N'Y A de vieux en Amérique que les bois. —Chateaubriand (1836)[85]

IT IS WORSE than boorish, it is criminal, to inflict an unnecessary injury on the tree that feeds or shadows us. Old trees are our parents, and our parents' parents, perchance. If you would learn the secrets of Nature, you must practice more humanity than others. The thought that I was robbing myself by injuring the tree did not occur to me, but I was affected as if I had cast a rock at a sentient being—with a duller sense than my own, it is true, but yet a distant relation. Behold a man cutting down a tree to come at the fruit! What is the moral of such an act? —Henry David Thoreau, Journal (1855)[86]

BELOW this damp and immoving vault the look of things changes. . . . Majestic order reigns above your head. But near the ground there is a general picture of confusion and chaos. Trunks that can no longer support the weight of their branches are split half-way up and left with pointed and torn tops. Others, long shaken by the wind, have been thrown all complete on the ground; torn out of the soil, their roots form so many natural ramparts behind which several men could easily take cover. Immense trees, held up by the surrounding branches, stay suspended in the air and fall to dust without touching the ground. . . . In the solitudes of America nature in all her strength is the only instrument of ruin and also the only creative force. As in forests subject to man's control, death strikes continually here; but no one is concerned to clear the debris away. Every day adds to the number; they fall and pile up one on top of the other; time cannot reduce them quickly enough

to dust and make fresh places ready. . . . In the midst of all this debris the work of new creation goes ceaselessly forward. Offshoots, creepers, and plants of every sort press across every obstacle to the light. They ramp along the trunks of fallen trees, they push their way into the rotten wood, and they lift and break the bark still covering them. Life and death meet here face to face, as if they wished to mingle and confuse their labours. —Alexis de Tocqueville, *Journey to America* (1831)[87]

THE FOREST, as usual, had little to intercept the view below the branches, but the tall straight trunks of trees. Everything belonging to vegetation had struggled toward the light, and beneath the leafy canopy one walked, as it might be, through a vast natural vault, that was upheld by myriads of rustic columns. —James Fenimore Cooper, *The Pathfinder* (1840)[88]

IN THE American forest we find trees in every stage of vegetable life and decay—the slender sapling rises in the shadow of the lofty tree, and the giant in his prime stands by the hoary patriarch of the wood—on the ground lie prostrate decaying ranks that once waved their verdant heads in the sun and wind. These are circumstances productive of great variety and pictur-esqueness—green umbrageous masses—lofty and scathed trunks—contorted branches thrust athwart the sky—the mouldering dead below, shrouded in moss of every hue and texture, from richer combinations than can be found in the trimmed and planted grove. . . . Trees are like men, differing widely in character; in sheltered spots, or under the influence of culture, they show few contrasting points; peculiarities are pruned and trained away, until there is a general resemblance. But in exposed situations, wild and uncultivated, battling with the elements and with one another for the possession of a morsel of soil, or a favoring rock to which they may cling—they exhibit striking peculiarities, and sometimes grand originality. —Thomas Cole, "Essay on American Scenery" (1835)[89]

MARK THE spreading boughs of that black birch, the gnarled trunk of this oak, the tufts on yonder pine, the drooping sprays of the hemlock, and the relief of the dead tree—is it not exactly such a woodland nook as you have often observed in a tramp through the woods? Not a leaf or flower on the ground, not an opening in the umbrageous canopy, not a mouldering stump beside the

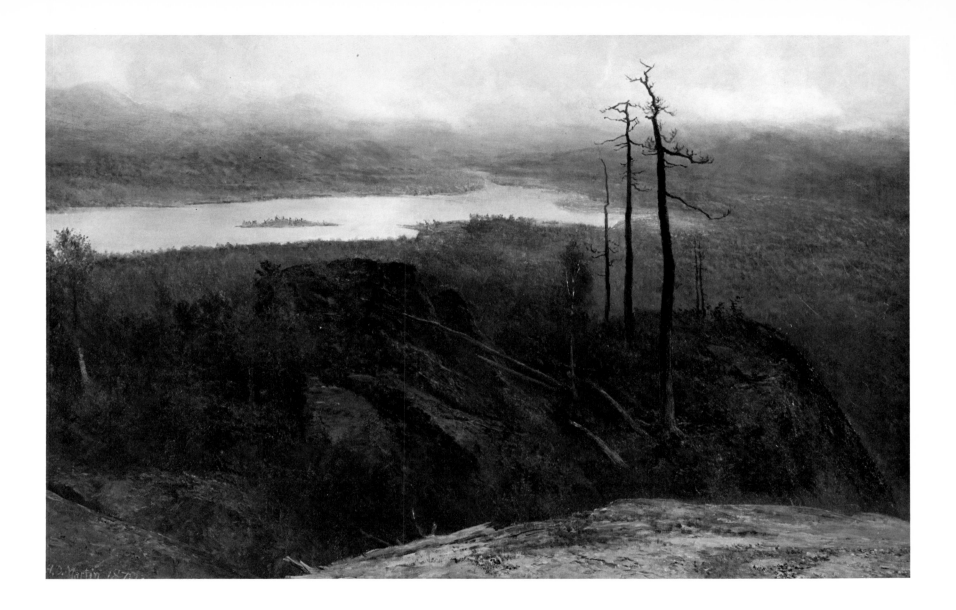

opposite: ALBERT BIERSTADT. *The Great Trees, Mariposa Grove, California.* c. 1875
Oil on canvas, 118⅜ x 59¼ in. (299.7 x 150 cm.)
Hirschl and Adler Galleries, New York

above: HOMER DODGE MARTIN. *Lake Sanford.* 1870
Oil on canvas, 24½ x 39½ in. (62.2 x 100.4 cm.)
The Century Association, New York

pool, but looks like an old friend; it is a fragment of the most peculiar garniture that decks the uncleared land of this continent. In an English gallery it would proclaim America. —Henry T. Tuckerman, on Durand's trees (1867)[90]

On Mountains

Geological awareness enhanced nineteenth-century concern with mountains, which offered to the landscape artist a solid central focus and a "stepping-stone to heaven."

Mr. Lyell opened his Lecture by saying that he had been invited to give a short course of Lectures upon one of the most extensive branches of Natural Science; and as he was to have but a few meetings, he should lose no time in prefatory remarks, but would proceed at once to the subject and endeavor as well as he could to enable his class to comprehend the objects of Geology. . . . I shall go, said he, up this magnificent river—the Hudson—and point you first to the Palisades, which you can see from this City; I would show you the natural rock, called Basalt, with its columnar structure, and explain the reasons why we conclude that these rocks thus piled up have existed in a melted state in the interior of the Earth. I would show you the other rocks—as the Sandstone, which was once sand until it was consolidated—deposited, one above another, under the water until a flood of melted matter flowed over and made it solid. Going still farther up, I would show you the gneiss and granite of the Highlands; or I might come back to this very island on which New-York is situated. —Mr. Lyell's Lectures (1840)[91]

. . . one recognizes in his [Gifford's] best studies a remarkably true representation of the gradual rise and fall, the successive grades and the apparent distances in the summits, gorges, slopes and swells. . . . Two remarkable instances of Gifford's skill and feeling, in this special phase of mountain scenery, are his "Mansfield Mountain" and "Catskill Clove"; the latter is a deep gorge, tufted with trees and thickets; its proportions and profundity are made wonderfully sensible to the eye, and over them broods a flood of that peculiar yellow light born of mist and sunshine. The individual trees and the local geology of the region have been more effectively rendered as regards fidelity in detail; but the

opposite above: JASPER FRANCIS CROPSEY
Indian Summer Morning in the White Mountains. 1857
Oil on canvas, 39¼ x 61¼ in. (99.7 x 155.6 cm.)
The Currier Gallery of Art, Manchester, New Hampshire

opposite below: WILLIAM LOUIS SONNTAG
Misty Rocky Mountains. 1868
Oil on canvas, 34½ x 36½ in. (87.6 x 92.8 cm.)
M. Knoedler & Co., Inc., New York

right: RALPH ALBERT BLAKELOCK
The Poetry of Moonlight. c. 1880–90
Oil on canvas, 30 x 25¼ in. (76.2 x 64.1 cm.)
Heckscher Museum, Huntington, New York
August Heckscher Collection

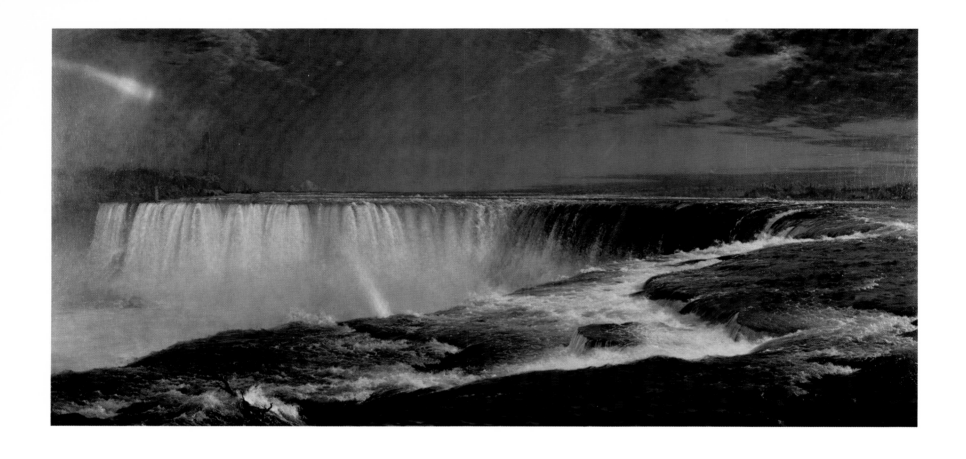

Frederic Edwin Church. *Niagara Falls.* 1857
Oil on canvas, 42½ x 90½ in. (108 x 229.9 cm.)
Corcoran Gallery of Art, Washington, D.C.

general effect is grand, true, and singularly attractive to the imagination; the artist has caught the very tint and tone of the hour, and bathed this sublime gorge therewith, so that, like a suggestive and emphatic expression in a poem, the key-note of a boundless scene is struck—the associations of a vast mountain range pensively glorified by the dying day, are awakened by this splendid revelation of one characteristic feature thereof. —Henry T. Tuckerman, *Book of the Artists* (1867)[92]

. . . IN THE mountains of New Hampshire there is a union of the picturesque, the sublime, and the magnificent; there the bare peaks of granite, broken and desolate, cradle the clouds; while the vallies and broad bases of the mountains rest under the shadow of noble and varied forests; and the traveller who passes the Sandwich range on his way to the White Mountains, of which it is a spur, cannot but acknowledge, that although in some regions of the globe nature has wrought on a more stupendous scale, yet she has nowhere so completely married together grandeur and loveliness—there he sees the sublime melting into the beautiful, the savage tempered by the magnificent. —Thomas Cole, "Essay on American Scenery" (1835)[93]

As YOU ascend, the near and low hills sink and flatten into the earth; no sky is seen behind them; the distant mountains rise. The truly great are distinguished. Vergers, crests of the waves of earth, which in the highest break at the summit into granitic rocks over which the air beats. A part of their hitherto concealed base is seen blue. You see, not the domes only, but the body, the facade, of these terrene temples. You see that the foundation answers to the superstructure. Moral structures. . . .

It will be worth the while to observe carefully the direction and altitude of the mountains from the Cliffs. The value of the mountains in the horizon—would not that be a good theme for a lecture? The text for a discourse on real values, and permanent; a sermon on the mount. They are stepping-stones to heaven—as the rider has a horse-block at his gate—by which to mount when we would commence our pilgrimage to heaven; by which we gradually take our departure from earth, from the time when our youthful eyes first rested on them—from this bare actual earth, which has so little of the hue of heaven. They make it easier to die and easier to live. They let us off. —Henry David Thoreau, Journal (1853)[94]

MANY A man, when I tell him that I have been on to a mountain, asks if I took a glass with me. No doubt, I could have seen further with a glass, and particular objects more distinctly—could have counted more meeting-houses; but this has nothing to do with the peculiar beauty and grandeur of the view which an elevated position affords. It was not to see a few particular objects, as if they were near at hand, as I had been accustomed to see them, that I ascended the mountain, but to see an infinite variety far and near in their relation to each other, thus reduced to a single picture. The facts of science, in comparison with poetry, are wont to be as vulgar as looking from the mountain with a telescope. —Henry David Thoreau, Journal (1852)[95]

MOUNTAINS are, to the rest of the body of the earth, what violent muscular action is to the body of man. The muscles and tendons of its anatomy are, in the mountain, brought out with fierce and convulsive energy, full of expression, passion, and strength; . . . But there is this difference between the action of the earth, and that of a living creature, that while the exerted limb marks its bones and tendons through the flesh, the excited earth casts off the flesh altogether, and its bones come out from beneath. —John Ruskin, *Modern Painters, I* (1843)[96]

WE WANT the pure and holy hills, treated as a link between heaven and earth. —John Ruskin, *Modern Painters, I* (1843)[97]

ON WATER

The waterfall and the still lake—the visual symbols of sound and silence—often signaled the oppositions of old and new sublimity. As in Christian symbolism, water, a medium poised between transparency and reflection, touched upon central spiritual profundities that engaged the age.

AND NOW I must turn to another of the beautifiers of the earth—the Waterfall; which in the same object at once presents to the mind the beautiful, but apparently incongruous idea, of fixedness and motion—a single existence in which we perceive unceasing change and everlasting duration. The waterfall may be called the voice of the landscape, for, unlike the rocks and woods which utter sounds as the passive instruments played on by the elements, the

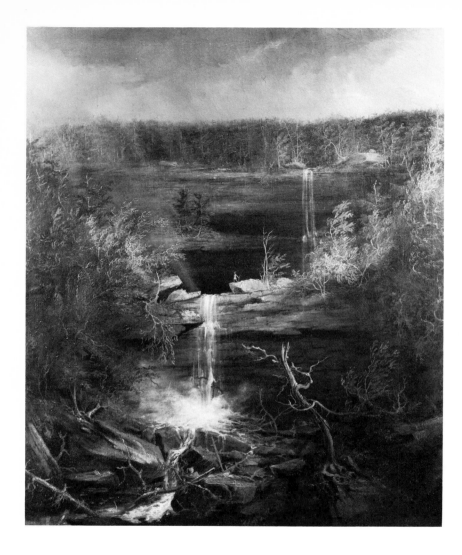

THOMAS COLE. *Kaaterskill Falls.* 1826
Oil on canvas, 43 x 36 in. (109.2 x 91.4 cm.)
The Warner Collection of
Gulf States Paper Corporation, Tuscaloosa, Alabama

waterfall strikes its own chords, and rocks and mountains re-echo in rich unison. And this is a land abounding in cataracts; in these Northern States where shall we turn and not find them? Have we not Kaaterskill, Trenton, the Flume, the Genesee, stupendous Niagara, and a hundred other named and nameless ones, whose exceeding beauty must be acknowledged when the hand of taste shall point them out? —Thomas Cole, "Essay on American Scenery" (1835)[98]

AND NIAGARA! that wonder of the world!—where the sublime and beautiful are bound together in an indissoluble chain. In gazing on it we feel as though a great void had been filled in our minds—our conceptions expand—we become a part of what we behold! At our feet the floods of a thousand rivers are poured out—the contents of vast inland seas. In its volume we conceive immensity; in its course, everlasting duration; in its impetuosity, uncontrollable power. These are the elements of its sublimity. Its beauty is garlanded around in the varied hues of the water, in the spray that ascends the sky, and in that unrivalled bow which forms a complete cincture round the unresting floods. —Thomas Cole, "Essay on American Scenery" (1835)[99]

DANTE might have got some grand ideas for his Inferno had he seen these rapids. As I looked at them I could not help comparing them to waters of the infernal regions, water that is in general so softly beautiful here takes a dreadful and terrifying character. —Thomas Cole, Journal, on a trip to Niagara (1829)[100]

YOU MIGHT suppose that, if we find the remains of a Mastodon in a fresh water deposite so lately laid dry as that near the village of Niagara and only twelve feet below the surface, the Mastodon had lived in the country at a modern period; you might think that perhaps a few centuries would have been sufficient for the accumulation of twelve feet of shelly sandstone and limestone, and that it may have been recently that this Mastodon was buried when the barrier was at the whirlpool before this twelve feet of fluviatile strata were deposited. Yet these strata are older than the whirlpool. . . . If it recedes one foot in a year, then in about five thousand years it would recede a mile; and as the upward slope of the bed of the river is about fifteen feet in a mile, and as the bed's dip to the South is about twenty-five feet in a mile, we must have

JOHN TRUMBULL
Niagara Falls from Two Miles below Chippawa (above)
and *Niagara Falls from under Table Rock* (below). 1808
Each panorama, oil on canvas, 29 x 168½ in. (73.7 x 428 cm.)
The New-York Historical Society

above: JASPER FRANCIS CROPSEY. *Niagara Falls.* 1860
Oil on canvas, 30 x 25¼ in. (76.2 x 64.1 cm.)
Hirschl and Adler Galleries, New York

opposite above: FREDERIC EDWIN CHURCH. *Niagara.* c. 1856–57
Oil on paper, 12 x 35 in. (31 x 88.9 cm.). Private collection

about forty feet for the loss in higth of the Falls by the receding of one mile. Another 5,000 years would cause the loss of another forty feet, and then eighty feet would have disappeared, and the cataract would fall over a solid mass of limestone only eighty feet high. Thus, at the end of 10,000 years, when the Falls shall have receded two miles, they would be eighty feet high. The recession then would be extremely slow, as the base would be of solid limestone.

But all these calculations would be easily vitiated by disturbing causes. Thus, by interfering with the body of water above the fall—by carrying them away, as is now done by the Erie Canal and the Welland Canal in Canada, we should have a different state of affairs. All the water taken from the upper lakes, as by the Illinois Canal &c. cheats the Niagara of its waters and acts as a disturbing force. Every mill-race built above the Falls has the same effect: and though this may seem to be a trifling matter, still, in the progress of population and civilization, such things may be frequently perpetrated, and thus, in the end, have a serious influence. —Sir Charles Lyell (1840)[101]

AS I CAME nearer the Fall a feeling of disappointment came over me. I had imagined Niagara a vast body of water, descending as if from the clouds. The approach to most *Falls* is *from below,* and we get an idea of them as of rivers pitching down to the plain from the brow of a hill or mountain. Niagara River, on the contrary, comes out from Lake Erie, through a flat plain. The top of the cascade is ten feet, perhaps, below the level of the country around, consequently invisible from any considerable distance. You walk to the bank of a broad and rapid river, and look over the edge of a rock, where the outlet flood of an inland sea seems to have broken through the crust of the earth by its mere weight, and plunged with an awful leap into an immeasurable and resounding abyss. It seems to strike and thunder upon the very centre of the world, and the ground beneath your feet quivers with the shock until you feel unsafe upon it.

Other disappointment than this I cannot conceive at Niagara. It is a spectacle so awful, so beyond the scope and power of every other phenomenon in the world, that I think people who are disappointed there, mistake the incapacity of their own conception for the want of grandeur in the scene. . . .

"How exquisitely," said Job, soliloquizing, "that small green island divides the Fall! What a rock it must be founded on, not to have been washed away in the ages that these waters have split against it!"

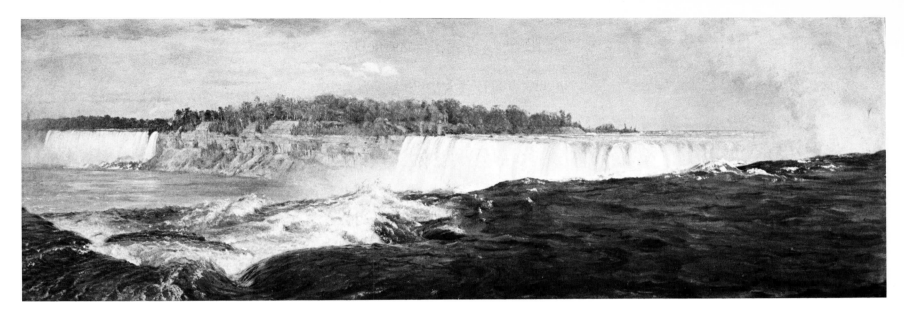

left: JOHN FREDERICK KENSETT. *Whirlpool, Niagara.* c. 1851
Oil on canvas, 13½ x 22 in. (34.3 x 55.9 cm.)
Museum of Fine Arts, Boston
M. and M. Karolik Collection

right: JOHN VANDERLYN. *Double-View Oil Study of Niagara Falls.* c. 1827
Oil on canvas, 18⅞ x 26½ in. (48 x 67.4 cm.)
Senate House State Historic Site, Kingston, New York
New York State Office of Parks & Recreation

ALBERT BIERSTADT. *Niagara Falls.* 1869
Oil on canvas, 14¼ x 19¼ in. (36.2 x 48.9 cm.)
Collection Mr. and Mrs. John D. Rockefeller 3rd, New York

"I'll lay you a bet it is washed away before the year two thousand—payable in any currency with which we may then be conversant."

"Don't trifle."

"With time or geology do you mean? Isn't it perfectly clear, from the looks of that ravine, that Niagara has *backed up* all the way from Lake Ontario. These rocks are not adamant, and the very precipice* you stand on has cracked, and looks ready for the plunge. It must gradually wear back to Lake Erie, and then there will be a sweep I should like to live long enough to see. The instantaneous junction of two seas, with a difference of two hundred feet in the level, will be a spectacle, eh, Job?"

"Tremendous!"

"Do you intend to wait and see it, or will you come to breakfast?"

* It has since fallen into the abyss—fortunately, in the night, as visitors were always upon it during the day. The noise was heard at an incredible distance. —From *London Court Magazine,* in *The New-York Mirror* (1834)[102]

MY IMAGINATION had been so impressed by the vast height of the Falls, that I was constantly looking in an upward direction, when, as we came to the brow of a hill, my companion suddenly checked the horses, and exclaimed, "The Falls!"

I was not, for an instant, aware of their presence; we were yet at a distance, looking *down* upon them; and I saw at once glance a flat extensive plain; the sun having withdrawn its beams for the moment, there was neither light, nor shade, nor color. In the midst were seen the two great cataracts, but merely as a feature in the wide landscape. The sound was by no means overpowering, and the clouds of spray, which Fanny Butler called so beautifully the "everlasting incense of the waters," now condensed ere they rose by the excessive cold, fell round the base of the cataracts in fleecy folds, just concealing that furious embrace of the waters above and the waters below. All the associations which in imagination I had gather round the scene, its appalling terrors, its soul-subduing beauty, power and height, and velocity and immensity, were all diminished in effect, or wholly lost.

I was quite silent—my very soul sunk within me. On seeing my disappointment (written, I suppose, most legibly in my countenance) my companion began to comfort me, by telling me of all those who had been

disappointed on the first view of Niagara, and had confessed it. I *did* confess; but I was not to be comforted. —Anna Brownell Jameson (1838)[103]

ON HIS return from his second expedition to South America, Church painted a large view of Niagara Falls; it is an oblong, seven feet by three, and represents the Horseshoe Fall, as seen from the Canadian shore, near Table Rock. This was immediately recognized as the first satisfactory delineation by art of one of the greatest natural wonders of the western world; . . . the complete possession of the grand theme by his mind was memorably evidenced years after the execution of his famous picture, by a view of the main fall, dashed off in seven hours, from memory, and exhibited with the title of, "Under Niagara"; . . . it seems to move, a solid, vast mass of water, in altitude sublime, rushing with luminous vapor, and so full of power as to give the sensation of a continuous roar, as well as a sublime rush. —Henry T. Tuckerman, *Book of the Artists* (1867)[104]

RUSKIN, when he first saw Church's "Niagara," pointed out an effect of light upon water which he declared he had often seen in nature, especially among the Swiss waterfalls, but never before on canvas; and so perfect is the optical illusion of the iris in the same marvellous picture, that the circumspect author of the Modern Painters went to the window and examined the glass, evidently attributing the prismatic bow to the refraction of the sun. —Henry T. Tuckerman, *Book of the Artists* (1867)[105]

OF ALL inorganic substances, acting in their own proper nature, and without assistance or combinations, water is the most wonderful. If we think of it as the source of all the changefulness and beauty which we have seen in clouds; then as the instrument by which the earth we have contemplated was modelled into symmetry, and its crags chiselled into grace; then, as in the form of snow, it robes the mountains it has made, with that transcendent light which we could not have conceived if we had not seen; then as it exists in the foam of the torrent—in the iris which spans it, in the morning mist which rises from it, in the deep crystalline pools which mirror its hanging shore, in the broad lake and glancing river; finally, in that which is to all human minds the best emblem of unwearied, unconquerable power, the wild, various, fantastic, tameless unity of the sea; what shall we compare to this mighty, this universal element, for glory and for beauty? or how shall we follow its eternal change-

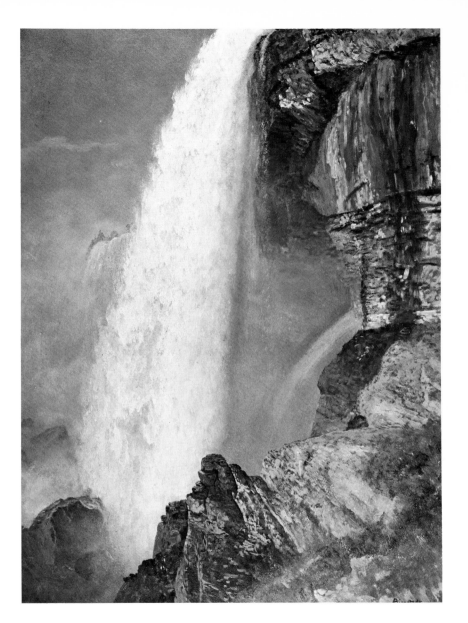

ALBERT BIERSTADT. *Niagara Falls.* c. 1869–70
Oil on canvas, 25 x 20 in. (63.5 x 50.8 cm.)
The Thomas Gilcrease Institute of American History and Art, Tulsa, Oklahoma

fulness of feeling? It is like trying to paint a soul. —John Ruskin, *Modern Painters, I* (1843)[106]

CONSTANT and eager watchfulness, and portfolios filled with actual statements of water-effect, drawn on the spot and on the instant, are worth more to the painter than the most extended optical knowledge; without these all his knowledge will end in a pedantic falsehood. With these it does not matter how gross or how daring here and there may be his violations of this or that law; his very transgressions will be admirable. —John Ruskin, *Modern Painters, I* (1843)[107]

I WILL now speak of another component of scenery, without which every landscape is defective—it is water. Like the eye in the human countenance, it is a most expressive feature: in the unrippled lake, which mirrors all surrounding objects, we have the expression of tranquillity and peace—in the rapid stream, the headlong cataract, that of turbulence and impetuosity.

In this great element of scenery, what land is so rich? I would not speak of the Great Lakes . . . but of those smaller lakes, such as Lake George, Champlain, Winipisiogee, Otsego, Seneca, and a hundred others, that stud like gems the bosom of this country. There is one delightful quality in nearly all these lakes—the purity and transparency of the water. In speaking of scenery it might seem unnecessary to mention this; but independent of the pleasure that we all have in beholding pure water, it is a circumstance which contributes greatly to the beauty of landscape; for the reflections of surrounding objects, trees, mountains, sky, are most perfect in the clearest water; and the most perfect is the most beautiful.

. . . Embosomed in the primitive forest, and sometimes overshadowed by huge mountains, they are the chosen places of tranquillity; and when the deer issues from the surrounding woods to drink the cool waters, he beholds his own image as in a polished mirror. —Thomas Cole, "Essay on American Scenery" (1835)[108]

A LAKE is the landscape's most beautiful and expressive feature. It is earth's eye; looking into which the beholder measures the depth of his own nature. The fluviatile trees next the shore are the slender eyelashes which fringe it, and the wooded hills and cliffs around are its overhanging brows. . . .

It is like molten glass cooled but not congealed, and the few motes in it are pure and beautiful like the imperfections in glass. . . .

In such a day, in September or October, Walden is a perfect forest mirror, set round with stones as precious to my eye as if fewer or rarer. Nothing so fair, so pure, and at the same time so large, as a lake, perchance, lies on the surface of the earth. Sky water. It needs no fence. Nations come and go without defiling it. It is a mirror which no stone can crack, whose quicksilver will never wear off, whose gilding Nature continually repairs; no storms, no dust, can dim its surface ever fresh;—a mirror in which all impurity presented to it sinks, swept and dusted by the sun's hazy brush,—this the light dust-cloth,—which retains no breath that is breathed on it, but sends its own to float as clouds high above its surface, and be reflected in its bosom still. —Henry David Thoreau, *Walden* (1854)[109]

THE LEAVES were fallen, and I mounted a tree and sat for an hour looking on the silent wilderness. Not an opening was to be seen in the boundless forest, except where the lake lay like a mirror of glass. —James Fenimore Cooper, *The Pioneers* (1823)[110]

"HOW BEAUTIFULLY tranquil and glassy the lake is! Saw you it ever more calm and even than at this moment, Natty?" . . . "It must have been a sight of melancholy pleasure indeed . . . to have roamed over these mountains, and along this sheet of beautiful water, without a living soul to speak to or to thwart your humor."

"Haven't I said it was cheerful?" said Leatherstocking. "Yes, yes; when the trees began to be covered with leaves, and the ice was out of the lake, it was a second paradise." —James Fenimore Cooper, *The Pioneers* (1823)[111]

THOMAS DOUGHTY. *In Nature's Wonderland.* 1835
Oil on canvas, 24¼ x 30 in. (61.6 x 76.2 cm.). The Detroit Institute of Arts. Gibbs-Williams Fund

NOTES

DATES FOLLOWING textual quotations correspond as closely as possible to the date of writing and in some instances differ from the date of publication cited below.

1. D. H. Lawrence, *Studies in Classic American Literature* (Garden City, N.Y.: Doubleday Anchor, 1951), pp. 32–33.

2. Thomas Cole, "Essay on American Scenery," *The American Monthly Magazine,* New Series 1 (January 1836), p. 11.

3. *Ibid.,* p. 12.

4. *Ibid.,* p. 5.

5. Henry T. Tuckerman, *Book of the Artists* (1867; reprint, New York: James F. Carr, 1966), pp. 187–88.

6. Alexis de Tocqueville, *Journey to America* (Garden City, N.Y.: Doubleday Anchor, 1971), p. 399.

7. Cole, "Essay on American Scenery," p. 3.

8. *Ibid.,* p. 12.

9. *The Selected Writings of Ralph Waldo Emerson,* ed. Brooks Atkinson (New York: Modern Library, 1950), p. 33.

10. Shearjashub Spooner, *Biographical and Critical Dictionary of Painters, Engravers, Sculptors and Architects* (New York: Putnam's, 1853), p. 213.

11. After a visit to the National Gallery in London, July 29, 1829; Cole papers, Ms. New York State Library (NYSL), Albany, N.Y.: photo copies The New-York Historical Society, New York City.

12. *Ibid.,* August 24, 1841.

13. Journal entry of June 22, 1840, Asher B. Durand papers, Ms. New York Public Library (NYPL), New York City.

14. John Durand, *The Life and Times of Asher B. Durand* (New York: Scribner's, 1894), p. 160.

15. William Dunlap, *A History of the Rise and Progress of the Arts of Design in the United States* (1834; reprint, New York: Dover, 1969), vol. 2, part 2, p. 365.

16. Discourse IV, December 10, 1771, in Sir Joshua Reynolds, *Fifteen Discourses* (New York: Dutton, 1928), p. 53.

17. [John Ruskin], *Modern Painters by a Graduate of Oxford* (1843; reprint, New York: John Wiley and Son, 1868), vol. 1, p. 90.

18. James Jackson Jarves, *Art Thoughts* (New York: Hurd and Houghton, 1869), pp. 181, 180. Quoted in Lois Engelson, "The Influence of Dutch Landscape Painting on the American Landscape Tradition" (Master's essay, Columbia University, 1966, written under the author's direction), p. 39.

19. Jarves, *Art Thoughts,* pp. 181–82.

20. Cole papers, Ms. NYSL, December 27, 1826.

21. *Ibid.,* May 24, 1828.

22. Dunlap, pp. 459–61.

23. Mary Bartlett Cowdrey, ed., *American Academy of Fine Arts and American Art-Union Exhibition Records, 1816–1852* (New York: The New-York Historical Society, 1953), pp. 100, 364–65, 366.

24. Shearjashub Spooner, *Anecdotes of Painters, Engravers, Sculptors and Architects, and Curiosities of Art* (New York: A. W. Lovering, 1853), vol. 3, pp. 146–47.

25. Undated entry in Mount Notebook following May 4, 1848. Ms. The Museums at Stony Brook, L.I., N.Y.

26. Undated entry in Notebooks of 1844–50, *ibid.*

27. H. Waagen, "Cuyp," *The Crayon* (New York), vol. 1, no. 23 (June 6, 1855), p. 361.

28. "The Fine Arts," *The New-York Mirror,* vol. 12, no. 48 (May 30, 1835), p. 379.

29. Durand papers, Ms. NYPL, July 13, 1840. Quoted in Engelson (see note 18), p. 61.

30. *Ibid.,* August 20, 1840. Quoted in Engelson, p. 62.

31. "The Autobiography of Worthington Whittredge, 1820–1910," ed. John I. H. Baur, *The Brooklyn Museum Journal,* 1942, pp. 42, 54.

32. Letter II, *The Crayon* (New York), vol. 1, no. 3 (January 17, 1855), p. 34.

33. Letter III, *The Crayon* (New York), vol. 1, no. 5 (January 31, 1855), p. 66.

34. Cole, "Essay on American Scenery," p. 3.

35. *Emerson,* ed. Atkinson, pp. 285–86.

36. *Ibid.,* pp. 6, 7.

37. *Ibid.,* p. 36.

38. Ruskin, p. 57.

39. *Ibid.,* p. 320.

40. *North American Review,* LXXXI (1855), p. 221.

41. *Emerson,* ed. Atkinson, pp. 18, 20, 23–24.

42. Tuckerman, p. 514.

43. "Moral Beauty," *The New-York Mirror,* vol. 14, no. 32 (February 4, 1837), p. 251.

44. "Taste," *Godey's Lady's Book* (Philadelphia), vol. 20 (February 1840), p. 88.

45. Edmund Burke, *On the Sublime and Beautiful* (New York: Hurst & Co., undated), pp. 40, 60.

46. Ruskin, p. 41.

47. Tuckerman, p. 378.

48. *Emerson,* ed. Atkinson, p. 269.

49. Cole, "Essay on American Scenery," p. 7.

50. Ruskin, p. 202.

51. "Description of the Engraving, A Poet's Grave, Engraved by Adams," *The New-York Mirror,* vol. 14, no. 36 (March 4, 1837), p. 281.

52. Entry for June 22, 1851, in Henry David Thoreau, *Selected Journals,* ed. Carl Bode (New York: Signet Classic, 1967), p. 114.

53. *Emerson,* ed. Atkinson, p. 285.

54. Quoted in *Meister Eckhart: A Modern Translation,* ed. Raymond B. Blakney (New York: Harper & Row, 1941), p. 96.

55. Entry for August 13, 1838, in Thoreau, *Selected Journals,* pp. 33, 34.

56. De Tocqueville, p. 398.

57. *Ibid.,* p. 383.

58. Clarence King, *Mountaineering in the Sierra Nevada* (Boston: James R. Osgood, 1872), p. 80.

59. Walt Whitman, *Specimen Days* (1882; reprint, Boston: David R. Godine, 1971), p. 94.

60. Entry for December 15, 1838, in *The Journal of Henry D. Thoreau,* ed. Bradford Torrey and Francis H. Allen (New York: Dover, 1962), vol. 1, p. 34.

61. *The Cosmopolitan Art Journal,* vol. 3 (September 1859), p. 183.

62. Tuckerman, p. 370.

63. *Ibid.,* p. 389.

64. *Ibid.,* p. 377.

65. Ms. at Olana State Historic Site, Hudson, N.Y.

66. Tuckerman, pp. 382–83.

67. *The Crayon* (New York), vol. 6, part 8 (August 1859), pp. 255–56.

68. Edward Hitchcock, *Elementary Geology* (New York: Dayton and Newman, 1842), pp. 275–76.

69. *Ibid.,* p. 279.

70. James Jackson Jarves, *The Art-Idea* (New York: Hurd and Houghton, 1864; reprint, ed. Benjamin Rowland, Jr., Cambridge, Mass.: Harvard University Press, 1960), p. 192.

71. Tuckerman, p. 371.

72. Alexander von Humboldt, *Cosmos,* trans. by E. C. Otté (New York: Harper & Brothers, 1849), vol. 2, pp. 94–95. First printed in 1847.

73. From a letter to J. S. Henslow, in Alan Moorehead, *Darwin and the Beagle* (New York: Harper & Row, 1969), p. 57.

74. Letter of June 13, 1859, to Bayard Taylor. Typescript, Olana; original, Rare Manuscripts Division, Cornell University Library, Ithaca, N.Y.

75. Jarves, *Art-Idea,* p. 40.

76. Cole, "Essay on American Scenery," pp. 10–11.

77. Entry for July 23, 1852, in Thoreau, *Selected Journals,* p. 166.

78. Jasper F. Cropsey, "Up among the Clouds," *The Crayon* (New York), vol. 2, no. 6 (August 8, 1855), p. 79.

79. Journal VI, in *Journals of Ralph Waldo Emerson* (Boston and New York: Houghton Mifflin, 1911), p. 410.

80. Entry for January 7, 1852, in *Thoreau,* ed. Torrey and Allen, p. 319.

81. Ruskin, p. 213.

82. *Ibid.,* p. 202.

83. *Ibid.,* pp. 223–24.

84. Cropsey, "Up among the Clouds," p. 79.

85. Chateaubriand, "Voyage en Amérique," *Oeuvres* (1836), XII, p. 18, quoted in Hans Huth, "The American and Nature," *The Journal of the Warburg and Courtauld Institutes* (London), vol. 13 (January 1950), p. 127.

86. Entry for October 23, 1855, in Thoreau, *Selected Journals,* pp. 220–21.

87. De Tocqueville, p. 382.

88. James Fenimore Cooper, *The Leatherstocking Saga,* ed. Allan Nevins (New York: Modern Library, 1966), p. 473.

89. Cole, "Essay on American Scenery," pp. 9–10.

90. Tuckerman, pp. 189–90.

91. Sir Charles Lyell, *Lectures on Geology Delivered at the Broadway Tabernacle in the City of New York* [1840] (New York: Greeley and McElrath, 1843), p. 9.

92. Tuckerman, pp. 526–27.

93. Cole, "Essay on American Scenery, p. 6.

94. Entry for May 10, 1853, in Thoreau, *Selected Journals,* pp. 178–79.

95. Entry for October 20, 1852, *ibid.,* p. 171.

96. Ruskin, pp. 267–68.

97. *Ibid.,* p. 285.

98. Cole, "Essay on American Scenery," pp. 7–8.

99. *Ibid.,* p. 8.

100. Cole papers, Ms. NYSL, 1829.

101. Lyell, *Lectures,* pp. 46–47.

102. "Niagara and So On," *The New-York Mirror,* vol. 2, no. 15 (October 11, 1834), p. 114.

103. Anna Brownell Jameson, *Winter Studies and Summer Rambles in Canada* (Toronto: McClelland and Stewart, 1965), pp. 43–44.

104. Tuckerman, p. 376.

105. *Ibid.,* p. 371.

106. Ruskin, p. 321.

107. *Ibid.,* p. 333.

108. Cole, "Essay on American Scenery," pp. 6, 7.

109. Henry David Thoreau, *Walden* (1854; reprint, New York: Mentor, 1942), pp. 128–29.

110. Cooper, p. 672.

111. *Ibid.,* p. 687.

ALBERT PINKHAM RYDER. *Moonlit Cove.* c. 1890–1900
Oil on canvas, 14 x 17 in. (35.5 x 43.1 cm.). The Phillips Collection, Washington, D.C.

TOWARD THE ABSTRACT SUBLIME

A Selection of Twentieth-Century Artists' Texts

Edited by Kynaston McShine

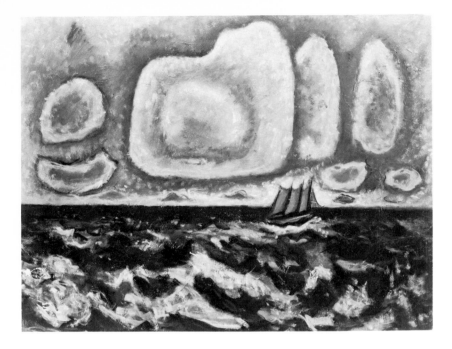

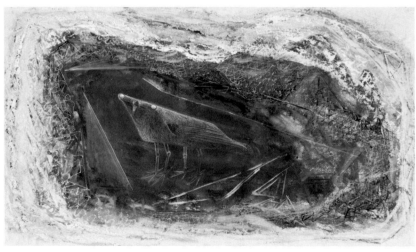

MARSDEN HARTLEY. *Off to the Banks.* 1936
Oil on composition board, 18 x 24 in. (46.4 x 61 cm.). Private collection

MORRIS GRAVES. *Little-Known Bird of the Inner Eye.* 1941
Gouache, 20¾ x 36⅝ in. (52.7 x 93.1 cm.), irregular
The Museum of Modern Art, New York

THE twentieth-century American artist, faced with a world increasingly more urban and secularized, found in nature an inspiration which illuminated his art as it had that of his nineteenth-century counterpart. However, his attitude was more interiorized. Nature was perceived as a reflection of self rather than a manifestation of immanent divinity. For the twentieth-century artist nature was no longer an end but an intellectual means. Given his identification of self with nature and his perception of the developments of twentieth-century European art and philosophy, it was inevitable that he should eventually state his work in abstract terms.

The excerpts from artists' writings that follow are diverse, arising from the imagination, freedom, and individuality found in the twentieth-century artistic endeavor. Nevertheless, the artists speak with a sensitivity to and awareness of timeless concepts such as the primordial and the infinite. Their affirmation of being in America and their acts of creation within this context lead to an immensely sublime and triumphant expression of abstraction. For them, the natural paradise is within.

ON CREATION

UNDOUBTEDLY the first man was an artist. . . .

Man's first expression, like his first dream, was an aesthetic one. . . . Even the animal makes a futile attempt at poetry. . . . The loon gliding lonesome over the lake, with whom is he communicating? The dog, alone, howls at the moon. . . . The purpose of man's first speech was an address to the unknowable. . . . What is the *raison d'être,* what is the explanation of the seemingly insane drive of man to be painter and poet if it is not an act of defiance against man's fall and an assertion that he return to the Adam of the Garden of Eden? For the artists are the first men. —Barnett Newman[1]

ON NATURE AS IDEA

I PAINT to rest from the phenomena of the external world—to pronounce it—and to make notations of its essences with which to verify the inner eye. —Morris Graves[2]

I HAVE MADE the complete return to nature, and nature is, as we all know, primarily an intellectual idea. I am satisfied that painting also is, like nature, an intellectual idea, and that the laws of nature as presented to the mind through the eye—and the eye is the painter's first and last vehicle—are the means of transport to the real mode of thought; the only legitimate source of aesthetic experience for the intelligent painter. . . . —Marsden Hartley[3]

A PICTURE must have a sound structure, with all parts co-ordinated. This inner structure must be the result of the close study of nature's laws, and not of human invention. The artist must come to nature, not with a ready-made formula, but in humble reverence to learn. The work of an artist is superior to the surface appearance of nature, but not its basic laws. —Charles Burchfield[4]

MY AIM in painting has always been the most exact transcription possible of my most intimate impressions of nature. If this end is unattainable, so, it can be said, is perfection in any other ideal of painting or in any other of man's activities. —Edward Hopper[5]

MY CONCERN is with the rhythms of nature . . . the way the ocean moves. . . . The ocean is what the expanse of the west was for me. . . . I work from the inside out, like nature. —Jackson Pollock[6]

WHY NOT MAKE things look like nature? Because I do not consider that important and it is my nature to make them this way. To me it is perfectly natural. They exist in themselves, as an object does in nature. —Arthur G. Dove[7]

I DO NOT paint in front of, but from within nature. —Arshile Gorky[8]

ON NATURE AND EXPERIENCE

HOW MANY of our American painters have given real attention to Ryder? I find him so much the legend among professional artists, this master of arabesque, this first and foremost of our designers, this real creator of pattern, this first of all creators of tragic landscape, whose pictures are sacred to those that revere distinction and power in art. He had in him that finer kind of reverence for the element of beauty which finds all things somehow lovely. He

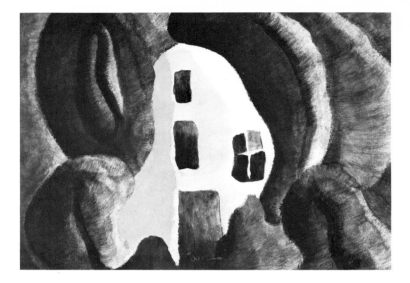

ARTHUR G. DOVE. *Willows.* 1940
Oil on gesso on canvas, 25 x 35 in. (63.5 x 88.9 cm.)
The Museum of Modern Art, New York. Gift of Duncan Phillips

CHARLES BURCHFIELD. *The First Hepaticas.* 1917–18
Watercolor, 21½ x 27½ in. (54.6 x 69.9 cm.)
The Museum of Modern Art, New York. Gift of Abby Aldrich Rockefeller

above: JOHN MARIN. *Study of the Sea.* 1917
Watercolor, 16 x 19 in. (40.6 x 48.2 cm.)
Columbus Gallery of Fine Arts, Columbus, Ohio. Gift of Ferdinand Howald

opposite: MARSDEN HARTLEY. *Evening Storm, Schoodic, Maine.* 1942
Oil on composition board, 30 x 40 in. (76.2 x 101.6 cm.)
The Museum of Modern Art, New York
Acquired through the Lillie P. Bliss Bequest

understood best of all the meaning of the grandiose, of everything that is powerful. . . .

Ryder gave us first and last an incomparable sense of pattern and austerity of mood. He saw with an all too pitiless and pitiful eye the element of helplessness in things, the complete succumbing of things in nature to those elements greater than they that wield a fatal power. Ryder was the last of the romantics, the last of that great school of impressive artistry, as he was the first of our real painters and the greatest in vision. He was a still companion of Blake in that realm of the beyond, the first citizen of the land of Luthany. He knew the fine distinction between drama and tragedy, the tragedy which nature prevails upon the sensitive to accept. He was the painter poet of the immanent in things. —Marsden Hartley[9]

I DON'T LIKE titles for these pictures, because they should tell their own story. You can see that forms repeat themselves in various phases of light, and that convolutions of form are the results of reflections in nature. Yes, I could paint a cyclone . . . I would show repetitions and convolutions of the rage of the tempest. I would paint the wind, not a landscape chastized by the cyclone. —Arthur G. Dove[10]

I WOULD SAY to a person who thinks he wants to paint, Go and look at the way a bird flies, a man walks, the sea moves. There are certain laws, certain formulae. You have to know them. They are nature's laws and you have to follow them just as nature follows them. You find the laws and you fill them in in your pictures and you discover that they are the same laws as in the old pictures. You don't create the formulae. . . . You see them. —John Marin[11]

I FEEL THAT the broad effect, the truth of nature's mood attempted, is the most important, has more appeal than the kind of subject. "Broad effect" is a rather vague term, but what is meant is that those qualities which delight us in nature—the sense of freedom, pure air and light, the magic of distance, and the saturated beauty of color, must be convincingly stated. . . . If these abstract qualities are not in a painting it is a flat failure. . . . —Maxfield Parrish[12]

I AM BREACHING the static barrier, penetrating rigidity. I am destroying confinement of the inert wall to achieve fluidity, motion, warmth in expressing feelingness, the pulsation of nature as it throbs. . . .

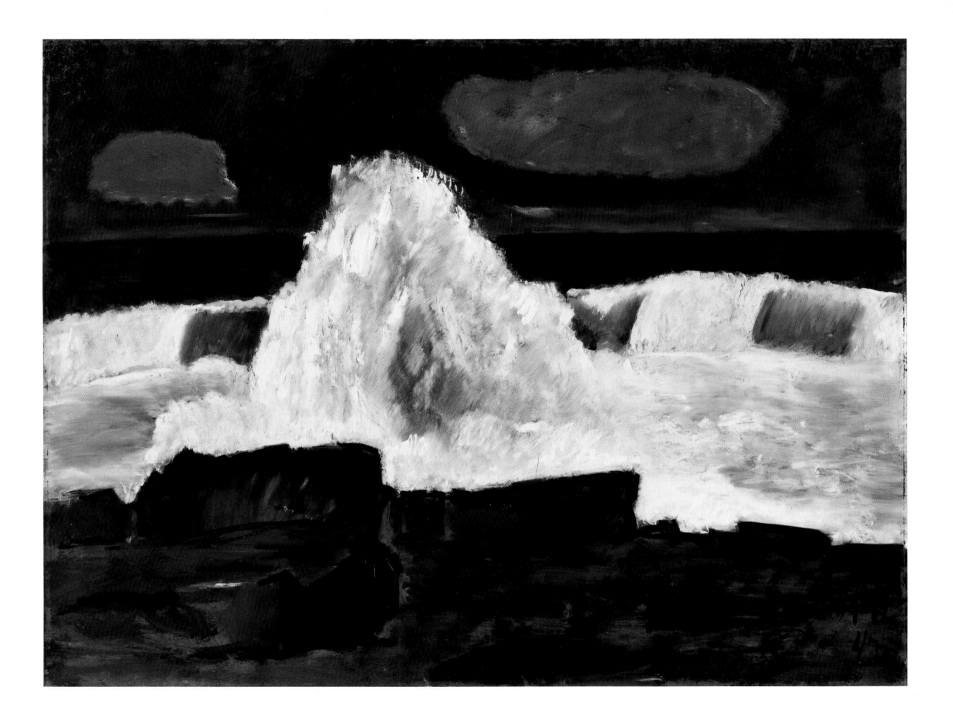

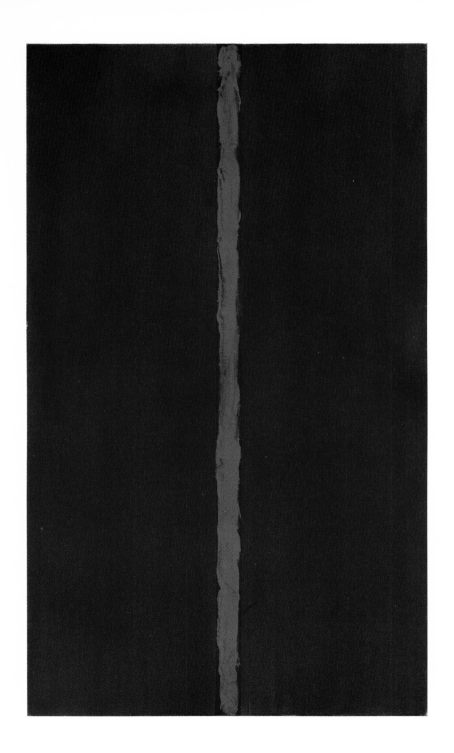

left: BARNETT NEWMAN. *Onement I.* 1948
Oil on canvas, 27 x 16 in. (68.6 x 40.7 cm.)
Collection Annalee Newman, New York

opposite: MARK TOBEY. *Edge of August.* 1953
Casein on composition board, 48 x 28 in. (121.9 x 71.1 cm.)
The Museum of Modern Art, New York

I am using divisions on a two dimensional surface—my canvas—so as to reflect the life pattern that exists in the universe, its tensions, oppositions, actions and counteractions, and to explore the cosmic pattern by the way I move the planes back and forth in all directions to form the complete living unit. —Arshile Gorky[13]

MY AIM IN PAINTING is always, using nature as the medium, to try to project upon canvas my most intimate reaction to the subject as it appears when I like it most; when the facts are given unity by my interest and prejudices. Why I select certain subjects rather than others, I do not exactly know, unless it is that I believe them to be the best mediums for a synthesis of my inner experience. —Edward Hopper[14]

TO UNDERSTAND painting one must live with it. The speed of today leaves very few time to really live with anything, even ourselves. That too painting has to meet.

Then there was the search for a means of expression which did not depend upon representation. It should have order, size, intensity, spirit, nearer to the music of the eye.

If one could paint the part that goes to make the spirit of painting and leave out all that just makes tons and tons of art.

There was a long period of searching for a something in color which I then called "a condition of light." It applied to all objects in nature, flowers, trees, people, apples, cows. These all have their certain condition of light, which establishes them to the eye, to each other, and to the understanding.

To understand that clearly go to nature, or to the Museum of Natural History and see the butterflies. Each has its own orange, blue, black; white, yellow, brown, green, and black, all carefully chosen to fit the character of the life going on in that individual entity. —Arthur G. Dove[15]

THREADING LIGHT: White lines symbolize light as a unifying idea which flows through compartmented units of life, bringing a dynamic to men's minds ever expanding their energies toward a larger relativity. —Mark Tobey[16]

FOR US TO contribute to art, we must grasp our experience, understand that it involves the relationship of man to man—happy, sad, melancholy, suffering,

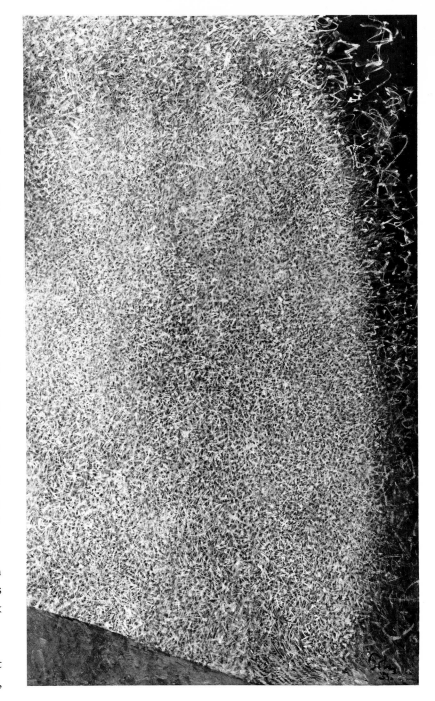

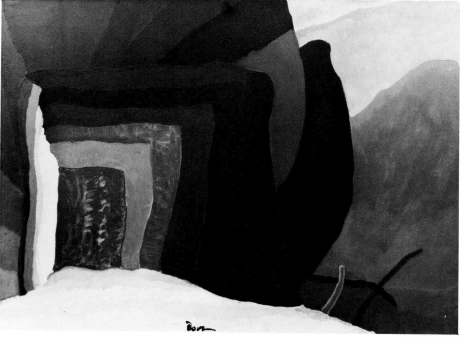

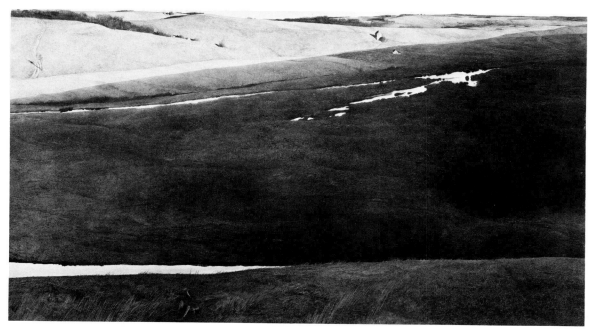

above left: JOHN MARIN
Camden Mountain across the Bay. 1922
Watercolor, 17¼ x 20½ in. (43.8 x 52.1 cm.)
The Museum of Modern Art, New York
Gift of Abby Aldrich Rockefeller (by exchange)

above right: ARTHUR G. DOVE
Holbrook's Bridge to the Northwest. 1938
Wax emulsion on canvas, 25 x 35 in. (63.5 x 88.9 cm.)
Collection Roy R. Neuberger, New York

left: ANDREW WYETH
Hoffman's Slough. 1947
Tempera, 29¾ x 55 in. (75.5 x 139.8 cm.)
Collection Mr. and Mrs. Charles Mayer, New York

beautiful, creative man—and of man to the primordial poetry of nature. Nature which feels in its very unfeelingness. —Arshile Gorky[17]

ON NATURE AND SENSIBILITY

COMMUNION WITH nature, so strongly advocated by the theorists as the touchstone of art, the primal aesthetic root, has almost always been confused with a love of nature. And the artist falling in love with the trees and the sea, the beast and the bird, has not so much been in love with them as with his own feelings about them. That is why the historic attitude of the artist toward nature has been, in nonprimitive peoples, one of sensibility. The concept of communion became a *reaction to* rather than a *participation with,* so that a concern with nature, instead of doing what it was supposed to do—give man some insight into himself as an object in nature—accomplished the opposite and excluded man: setting him apart to make nature the object of romantic contemplation.

The work of Theodoros Stamos, subtle and sensuous as it is, reveals an attitude toward nature that is closer to true communion. His ideographs capture the moment of totemic affinity with the rock and the mushroom, the crayfish and the seaweed. He re-defines the pastoral experience as one of participation with the inner life of the natural phenomenon. One might say that instead of going to the rock, he comes out of it. In this Stamos is on the same fundamental ground as the primitive artist who never portrayed the phenomenon as an object of romance and sentiment, but always as an expression of the original noumenistic mystery in which rock and man are equal. —Barnett Newman[18]

ON THE SENSE OF PLACE

IF WHAT I'M trying to do has any value at all, it's because I've managed to express the quality of the country which I live in. Not the historical quality, I don't mean that, but rather such things as the color of these walls in the wintertime for example. All this has had a strong influence on me as a painter, not looking at Cézanne or going to Paris, but actually having been born here and having spent all my life around these hills. . . . So what is important about my pictures, I feel, is a sort of organic thing of country . . . being able

to find something which expresses it symbolically, not just a scene of a beautiful countryside with a rainbow effect or a storm coming up. —Andrew Wyeth[19]

SEEMS TO ME the true artist must perforce go from time to time to the elemental big forms—Sky, Sea, Mountain, Plain,—and those things pertaining thereto, to sort of nature himself up, to recharge the battery. For these big forms have everything. But to express these, you have to love these, to be a part of these in sympathy. One doesn't get very far without this love, this love to enfold too the relatively little things that grow on the mountain's back. —John Marin[20]

ART IS A very personal, poetic vision or interpretation conditioned by environment. —Arshile Gorky[21]

THE AMERICAN SCENE, in its more limited aspect, has no more significance than any other subject matter. While I feel strongly the personality of a given scene, its "genius loci" as it were, my chief aim in painting it is the expression of a completely personal mood. —Charles Burchfield[22]

IF YOU HAVE lived by the sea, you have learned the significance of the bravery of sea people, and you learn to understand and excuse the sharpness of them which is given them from battle with the elemental facts they are confronted with at all times. That is the character of Homer, that is the quality of his painting. That is what makes him original in the American sense, and so recognizable in the New England sense. —Marsden Hartley[23]

RYDER HAS for once transcribed all outer semblances by means of a personality unrelated to anything other than itself, an imagination belonging strictly to our soil and specifically to our Eastern geography. In his autographic quality he is certainly our finest genius, the most creative, the most racial. For our genius, at its best, is the genius of the evasive; we are born lovers of the secret element, the mystery in things. —Marsden Hartley[24]

I LIVED on the plains of North Texas for four years. . . . That was my country—terrible winds and a wonderful emptiness. —Georgia O'Keeffe[25]

WINSLOW HOMER. *Winter Coast.* 1890
Oil on canvas, 36 x 31⅝ in. (91.9 x 80.3 cm.)
John G. Johnson Collection, Philadelphia

WHAT WAS Avery's repertoire? His living room, Central Park, his wife Sally, his daughter March, the beaches and mountains where they summered; cows, fish heads, the flight of birds; his friends and whatever world strayed through his studio: a domestic, unheroic cast. But from these there have been fashioned great canvases, . . . far from the casual and transitory implications of the subjects. —Mark Rothko[26]

I REMEMBER years ago shocking my friends by saying I would rather go to Churchill, Canada, to walk the tundra than go to Paris. For me space is where I can feel all four horizons, not just the horizon in front of me and in back of me because then the experience of space exists only as volume. —Barnett Newman[27]

Q. WHY DO YOU prefer living here in New York to your native West? A. LIVING is keener, more demanding, more intense and expansive in New York than in the West; the stimulating influences are more numerous and rewarding. At the same time, I have a definite feeling for the West: the vast horizontality of the land, for instance; here only the Atlantic Ocean gives you that. —Jackson Pollock[28]

THE ANDROSCOGGIN, the Kennebec, and the Penobscot flow down to the sea as solemnly as ever, and the numberless inland lakes harbour the loon, and give rest to the angles of geese making south or north according to season, and the black bears roam over the mountain tops as usual.

If the Zeppelin rides the sky at night, and aeroplanes set flocks of sea gulls flying, the gulls remain the same and the rocks, pines, and thrashing seas never lose their power and their native tang.

Nativeness is built of such primitive things, and whatever is one's nativeness, one holds and never loses no matter how far afield the traveling may be. . . .

Those pictures which are not scenes, are in their way portraits of objects—which relieves them from being still-lives, objects thrown up with the tides on the shores of the island where I have been living of late, the marine vistas to express the seas of the north, the objects at my feet everywhere which the tides washed by representing the visible life of place, such as fragments of rope thrown overboard out on the Grand Banks by the fisher-

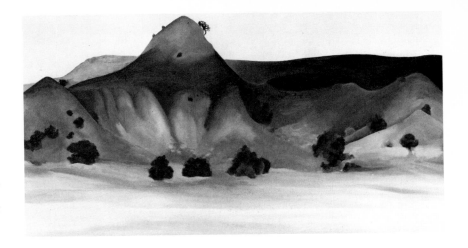

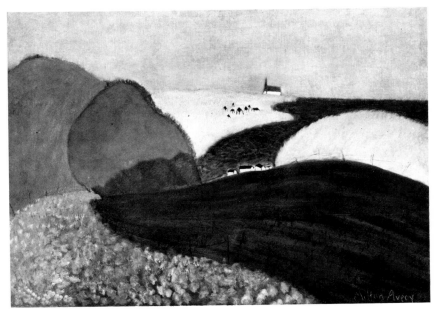

GEORGIA O'KEEFFE. *Hills and Mesa to the West.* 1945
Oil on canvas, 19 x 36 in. (48.2 x 91.4 cm.)
Private collection

MILTON AVERY. *Gaspé—Pink Sky.* 1940
Oil on canvas, 32 x 44 in. (81.3 x 111.8 cm.)
Collection Mr. and Mrs. Samuel H. Lindenbaum, New York

men, or shells and other crustacea driven in from their moorings among the matted seaweed and the rocks, given up even as the lost at sea are sometimes given up.

This quality of nativeness is coloured by heritage, birth, and environment, and it is therefore for this reason that I wish to declare myself the painter from Maine.

We are subjects of our nativeness, and are at all times happily subject to it, only the mollusk, the chameleon, or the sponge being able to affect dissolution of this aspect. —Marsden Hartley[29]

On Nature and Imagination

I LIKE THE heat, the tenderness, the edible, the lusciousness, the song of a single person, the bathtub full of water to bathe myself beneath the water. . . .

I like the wheatfields, the plough, the apricots, the shape of apricots, those flirts of the sun. And bread above all. —Arshile Gorky[30]

I USED TO go, in my earliest school days, into a little strip of woodland not far from the great ominous red brick building in a small manufacturing town, on the edge of a wonderful great river in Maine, from which cool and quiet spot I could always hear the dominant clang of the bell, and there I could listen with all my very boyish simplicity to the running of the water over the stones, and watch—for it was spring, of course—the new leaves pushing up out of the mould, and see the light-hued blossoms swinging on the new breeze. I cared more for these in themselves than I did for any legendary presences sitting under them, shaking imperceptible fingers and waving invisible wands with regality in a world made only for them and for children who were taught mechanically to see them there.

I was constantly confronted with the magic of reality itself, wondering why one thing was built of exquisite curves and another of harmonic angles. It was not a scientific passion in me, it was merely my sensing of the world of visible beauty around me, pressing in on me with the vehemence of splendor, on every side.

I feel about the world now precisely as I did then, despite all the reasons that exist to encourage the change of attitude. I care for the magic of

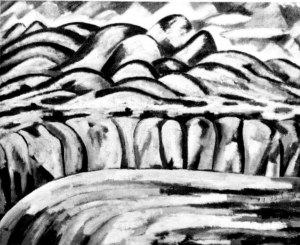

GEORGIA O'KEEFFE
Summer Days. 1936
Oil on canvas,
36 x 30 in.
(91.4 x 77.2 cm.)
Collection Doris Bry,
New York,
for Georgia O'Keeffe

MARSDEN HARTLEY
Landscape, New Mexico
c. 1918
Oil on canvas,
28 x 36 in.
(71.1 x 91.4 cm.)
Washburn Gallery,
New York

experience still, the magic that exists even in facts, though little or nothing for the objective material value. —Marsden Hartley[31]

I'VE BEEN up on the roof watching the moon come up—the sky very dark—the moon large and lopsided—and very soft—a strange white light creeping across the far away to the dark sky—the cliffs all black—it was weird and strangely beautiful. —Georgia O'Keeffe[32]

VALLEY . . . walled in by an amphitheater of mountains as colossal as to seem an adequate setting for the Last Judgment, glacial lakes lay like jewels on the breast of the world—malachite and jade—greens of every variation. Battlements and pinnacles of rock close to the clouds and on the mountain slopes great white glaciers seem motionless and slumbering, but terrible in their potentialities. —Augustus Vincent Tack[33]

I DO AN awful lot of thinking and dreaming about things in the past and the future—the timelessness of the rocks and the hills—all the people who have existed there. I prefer winter and fall, when you feel the bone structure in the landscape—the loneliness of it—the dead feeling of winter. Something waits beneath it—the whole story doesn't show. —Andrew Wyeth[34]

EVERYONE of us finds water either a symbol of peace or fear. I know I never feel better than when I gaze for a long time at the bottom of a still pond. —William Baziotes[35]

WHILE IN Japan sitting on the floor of a room and looking over an intimate garden with flowers blooming and dragonflies hovering in space, I sensed that this small world almost underfoot, shall I say, had a validity all its own . . . which must be realized and appreciated from its own level in space. —Mark Tobey[36]

SOME FABULOUS Northland unlike any on earth—a land of deep water-filled gashes in the earth; old lichen-colored cliffs and mesas, with black spruce forests reflected in the pools, against which white swans gleam miraculously. This romantic land of the imagination, the mysterious North that has haunted me since I was a boy—it does not really exist, but how did it come into being? —Charles Burchfield[37]

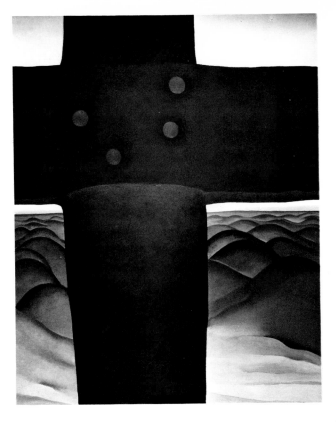

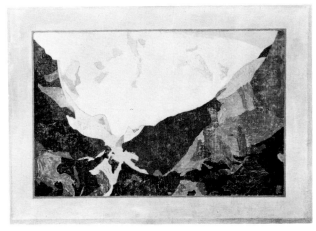

GEORGIA O'KEEFFE
Black Cross, New Mexico
1929
Oil on canvas,
39 x 30⅛ in.
(99.1 x 76.5 cm.)
The Art Institute
of Chicago
Art Institute
Purchase Fund

AUGUSTUS VINCENT
TACK
Canyon. c. 1924
Oil on canvas,
29 x 40 in.
(73.6 x 101.6 cm.)
The Phillips Collection,
Washington, D.C.

above: CHARLES BURCHFIELD. *The Night Wind.* 1918
Watercolor and gouache, 21½ x 21⅞ in. (54.6 x 55.6 cm.)
The Museum of Modern Art, New York
Gift of A. Conger Goodyear

opposite: JACKSON POLLOCK. *The Deep.* 1953
Oil and enamel on canvas, 86¾ x 59⅛ in. (220.3 x 150.2 cm.)
Centre National d'Art et de Culture Georges Pompidou,
Musée National d'Art Moderne, Paris
Given in memory of John de Menil by his children,
the Menil Foundation and Samuel J. Wagstaff, Jr.

ON THE SELF AS NATURE

THE FACT that I grew up on the prairies has nothing to do with my paintings, with what people think they find in them. I paint only myself, not nature. —Clyfford Still[38]

I AM Nature. —Jackson Pollock[39]

MAYBE the world is a dream and everything in it is your self. —Arthur G. Dove[40]

MY IMAGINATION, it would seem, has its own geography. —Mark Tobey[41]

I HELD IT imperative to evolve an instrument of thought which would aid in cutting through all cultural opiates, past and present, so that a direct, immediate, and truly free vision could be achieved, and an idea be revealed with clarity. . . .

It was as a journey that one must make, walking straight and alone. No respite or short-cuts were permitted. And one's will had to hold against every challenge of triumph, or failure, or the praise of Vanity Fair. Until one had crossed the darkened and wasted valleys and come at last into clear air and could stand on a high and limitless plain. Imagination, no longer fettered by the laws of fear, became as one with Vision. And the Act, intrinsic and absolute, was its meaning, and the bearer of its passion. —Clyfford Still[42]

ON THE SUBLIME

THE QUESTION that now arises is how, if we are living in a time without a legend or mythos that can be called sublime, if we refuse to admit any exaltation in pure relations, if we refuse to live in the abstract, how can we be creating a sublime art?

We are reasserting man's natural desire for the exalted, for a concern with our relationship to the absolute emotions. We do not need the obsolete props of an outmoded and antiquated legend. We are creating images whose reality is self-evident and which are devoid of props and crutches that evoke associations with outmoded images, both sublime and beautiful. We are freeing

ourselves of the impediments of memory, association, nostalgia, legend, myth, or what have you, that have been the devices of Western European painting. Instead of making *cathedrals* out of Christ, man, or "life," we are making it out of ourselves, out of our own feelings. The image we produce is the self-evident one of revelation, real and concrete, that can be understood by anyone who will look at it without the nostalgic glasses of history.
—Barnett Newman[43]

THE SUBLIME? A paramount consideration in my studies and work from my earliest student days. In essence, it is most elusive of capture or definition—only surely found least in the lives and works of those who babble of it the most. The dictator types have made a cliche of "sublime" concepts throughout the centuries to impress and subjugate the ignorant and desperate.
—Clyfford Still[44]

I SEEK that moment when my picture suddenly echoes to me, when it seems breathless, that instant when it is suffocating for love of air and gasps to fulfill its passion to communicate. The torturous second of that throb for life announces its consummation. I lay down my brush. Perfection. —Arshile Gorky[45]

THE MOST important tool the artist fashions through constant practice is faith in his ability to produce miracles when they are needed. Pictures must be miraculous: the instant one is completed, the intimacy between the creation and the creator is ended. He is an outsider. The picture must be for him, as for anyone experiencing it later, a revelation, an unexpected and unprecedented resolution of an eternally familiar need. —Mark Rothko[46]

ON THE INFINITE AND THE UNKNOWN

THE STUFF of thought is the seed of the artist. Dreams form the bristles of the artist's brush. And as the eye functions as the brain's sentry, I communicate my most private perceptions through art, my view of the world. In trying to probe beyond the ordinary and the known, I create an inner infinity. I probe within the confines of the finite to create an infinity. —Arshile Gorky[47]

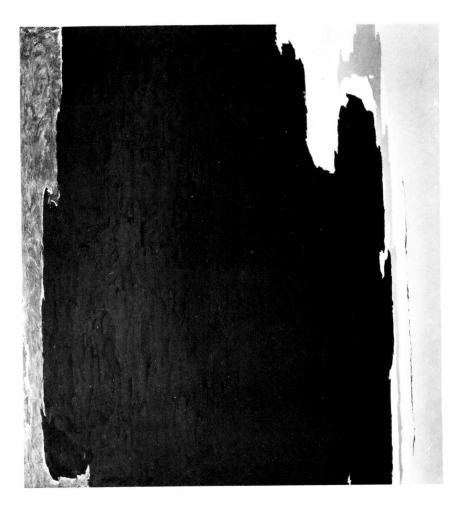

123

opposite: BARNETT NEWMAN. *The Voice.* 1950
Egg tempera and enamel on canvas, 96⅛ x 105½ in. (244.1 x 268 cm.)
The Museum of Modern Art, New York
The Sidney and Harriet Janis Collection

above: CLYFFORD STILL. *Painting.* 1951
Oil on canvas, 94 x 82 in. (238.8 x 208.3 cm.)
The Museum of Modern Art, New York
Blanchette Rockefeller Fund

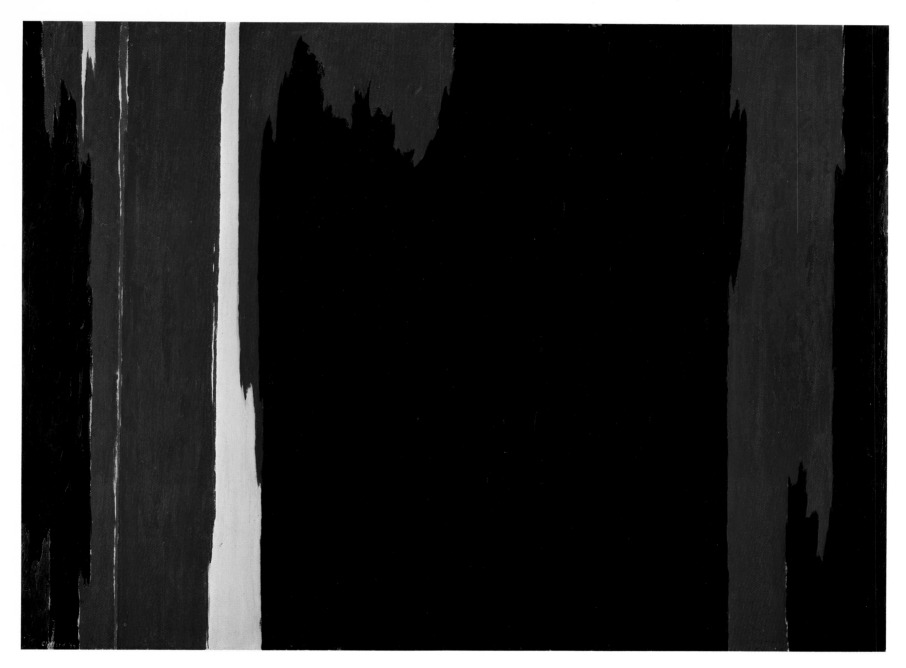

CLYFFORD STILL. *1954.* 1954. Oil on canvas, 113½ x 156 in. (288.3 x 396.2 cm.)
Albright-Knox Art Gallery, Buffalo. Gift of Seymour H. Knox

THE INNER life of a human being is a vast and varied realm and does not concern itself alone with stimulating arrangements of color, form, and design.

The term "life" as used in art is something not to be held in contempt, for it implies all of existence, and the province of art is to react to it and not to shun it. —Edward Hopper[48]

THE CULT of space can become as dull as that of the object. The dimension that counts for the creative person is the Space he creates within himself. This space is closer to the infinite than the other, and it is the privilege of a balanced mind—and the search for an equilibrium is essential—to be as aware of inner space as he is of outer space. If he ventures in one, and neglects the other, man falls off his horse and the equilibrium is broken. —Mark Tobey[49]

I THOUGHT, as I squatted on my heels and gazed into the warm amber-colored water with its teeming life, that if one could but read it aright this little watery world would hold the whole secret of the universe. At least I had the feeling I was gazing into infinity. —Charles Burchfield[50]

THE ARTIST cannot avoid nature and his return to it should not be equated with primitivism but instead a reevaluation of nature based on the new experiences perceived through the complexity of civilization. It is better to be conscientiously troubled and perplexed by the vastness of the unknown, than content with the little that is known. Civilization knows more about complexity whether or not it has been able to solve the problems of it. And this is the key to the advancement of aesthetic art. Perceiving nature through the eyes of civilization brings to great art more authority and strength. Mastery of complexity involves the experience of complexity. It is this clash of opposites, of new and different ideas and experiences that is so important in advancing great art. —Arshile Gorky[51]

CERTAIN people always say we should go back to nature. I notice they never say we should go forward to nature. It seems to me they are more concerned that we should go back, than about nature.

If the models we use are the apparitions seen in a dream, or the recollection of our pre-historic past, is this less part of nature or realism, than a cow in a field? I think not. —Adolph Gottlieb[52]

WE ASSERT that the subject is crucial and only that subject-matter is valid which is tragic and timeless. That is why we profess spiritual kinship with primitive and archaic art. —Adolph Gottlieb and Mark Rothko[53]

I'M NOT interested in illustrating my time. A man's "time" limits him, it does not *truly* liberate him. Our age—it is of science—of mechanism—of power and death. I see no virtue in adding to its mammoth arrogance the compliment of graphic homage. —Clyfford Still[54]

ART IS above nationalism and represents universal man's eye for discerning beauty and knowledge of himself and his environment and transcending pettiness. —Arshile Gorky[55]

FREEDOM doesn't mean freedom from anything, it means freedom toward something. —Arthur G. Dove[56]

TO BE STOPPED by a frame's edge was intolerable; a Euclidean prison; it had to be annihilated, its authoritarian implications repudiated without dissolving one's individual integrity and idea in material and mannerism. —Clyfford Still[57]

THERE WAS a reviewer a while back who wrote that my pictures didn't have any beginning or any end. He didn't mean it as a compliment, but it was. It was a fine compliment. —Jackson Pollock[58]

AFTER ALL it is a great adventure—a great exploration with the infinite beckoning on. —Augustus Vincent Tack[59]

TO US ART is an adventure into an unknown world, which can be explored only by those willing to take the risks. —Adolph Gottlieb and Mark Rothko[60]

ON ABSTRACTION

ABSTRACTION is the key factor of the creative imagination of man. It is an experimental inspection of the hitherto unknown which can facilitate an evaluation of it. Let me explain. The universe is infinite, but nature in which

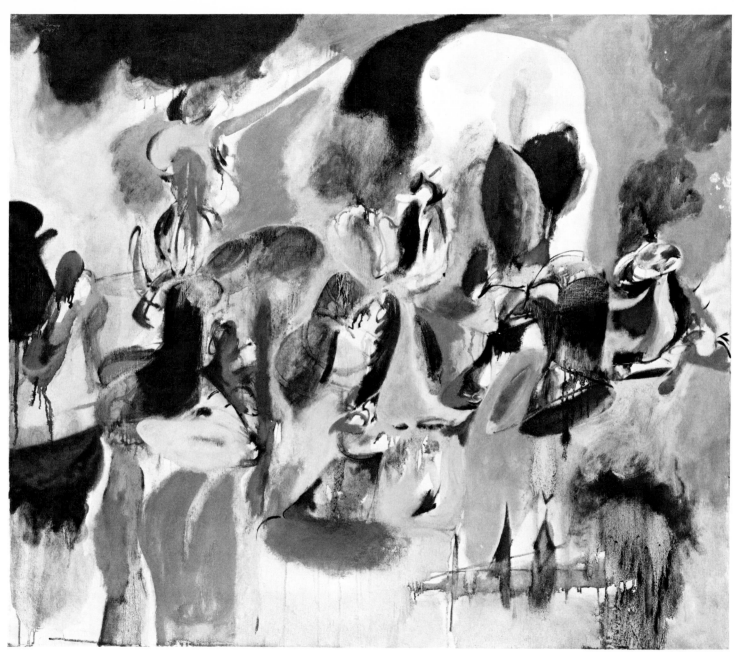

ARSHILE GORKY. *Water of the Flowery Mill.* 1944. Oil on canvas, 42¼ x 48¾ in. (107.4 x 123.8 cm.)
The Metropolitan Museum of Art, New York. George A. Hearn Fund, 1956

man finds himself is, within his recognition at least, finite. It does present him with certain limits. Think of nature as a finite object and all of the plants, animals, rocks, waters, etc., as the cells and skeleton which give it its form and substance. This tangible quality is readily perceived by the human eye. Once so perceived, the human eye is thereby limited by what it can physically see. And so if man is satisfied only with what he sees physically and cannot imagine creatively, he will stagnate.

Abstraction allows man to see with his mind what he cannot see physically with his eyes. Let me give an example. A sculptor can look at a block of wood and if he decides it is the proper type of wood, he can visualize with his mind's eye the plow he will carve out of it. Likewise, as a painter I can have before me an empty canvas, paint tubes and brushes. They are finite in the sense that they are exactly defined. But in my creative imagination I can visualize the painting, or at least the substance of what will eventually become the painting that I will create with them. In other words, I am saying that nature is finite and as such can be a form of confinement to man. Abstraction enables man to break the finite barrier and enter into the actuality of infinity. Abstraction, the ability of man's mind to think of intangibles, to create new mental forms out of previously standardized elements, is what separates us from all other life and lack-of-life. When previous intangibles or earlier infinities are mastered, they become finite and so new infinities must be created so that art can progress.

Beloveds, abstraction is therefore the probing vehicle, the progressive thrust toward higher civilization, toward higher evaluation of the finite by tearing the finite apart, exploding it so as to thereby enter limitless areas. Mere realistic art is therefore finite and limits man only to the perception of his physical eyes, namely that which is tangible. Abstract art enables the artist to perceive beyond the tangible, to extract the infinite out of the finite. It is the emancipator of the mind. It is an exploration into unknown areas.
—Arshile Gorky[61]

NOTES

1. Barnett Newman, "The First Man Was an Artist," *The Tiger's Eye* (New York), vol. 1, no. 1 (October 1947), pp. 59–60.

2. Morris Graves, in exhibition catalogue *Morris Graves: Retrospective Exhibition,* California Palace of the Legion of Honor, San Francisco, May 21–June 29, 1948, p. 3.

3. Marsden Hartley, "Art and the Personal Life," *Creative Art* (New York), vol. 2, no. 6 (June 1928), pp. 31–34.

4. Charles Burchfield, *Charles Burchfield* (New York: American Artists Group, 1945), n.p.

5. From "Notes on Painting," by Hopper, in exhibition catalogue *Edward Hopper,* The Museum of Modern Art, New York, November 1–December 1, 1933, p. 17.

6. Statement of c. 1955–56, quoted in B. H. Friedman, *Jackson Pollock: Energy Made Visible* (New York: McGraw-Hill, 1972), p. 228.

7. Arthur G. Dove, in exhibition catalogue *An Idea,* The Intimate Gallery, New York, December 12, 1927–January 11, 1928.

8. Statement of c. 1941–45, quoted in Julien Levy, *Arshile Gorky* (New York: Abrams, 1966), p. 30.

9. Marsden Hartley, *Adventures in the Arts* (New York: Boni and Liveright, 1921), pp. 40–41.

10. Statement of 1912, quoted in Frederick S. Wight, *Arthur G. Dove* (Berkeley and Los Angeles: University of California Press, 1958), p. 30.

11. John Marin, conversation with Dorothy Norman, in *Magazine of Art* (New York), vol. 30, no. 3 (March 1937), p. 151.

12. From a letter to Brown and Bigelow, St. Paul, dated April 5, 1935, quoted in Coy Ludwig, *Maxfield Parrish* (New York: Watson-Guptill, 1973), p. 175.

13. From a letter dated February 14, 1944, reprinted in K. Mooradian, ed., "A Special Issue on Arshile Gorky," *Ararat* (New York), vol. 12, no. 4 (Fall 1971), p. 31.

14. From a letter to Charles Sawyer dated October 29, 1939, quoted in Lloyd Goodrich, *Edward Hopper* (New York: Abrams, 1971), p. 163.

15. From a letter to Samuel Kootz written c. 1911, quoted in Barbara Haskell, *Arthur Dove* (Boston: New York Graphic Society, 1974), p. 134.

16. Quoted in Sidney Janis, *Abstract and Surrealist Art in America* (New York: Reynal and Hitchcock, 1944), p. 98.

17. From a letter by Gorky dated January 26, 1944, reprinted in *Ararat,* p. 30.

18. From the announcement of an exhibition at the Betty Parsons Gallery, New York, February 1947, quoted in Ralph Pomeroy, *Stamos* (New York: Abrams, 1974), p. 19.

19. From an interview by George Plimpton and Donald Stewart with Wyeth, *Horizon* (New York), vol. 4, no. 1 (September 1961), pp. 88–101.

20. From "John Marin, by Himself," *Creative Art* (New York), vol. 3, no. 4 (October 1928), pp. 35–38. Reprinted in Dorothy Norman, ed., *The Selected Writings of John Marin* (New York: Pellegrini and Cudahy, 1949), p. 127.

21. From a letter by Gorky dated April 22, 1944, reprinted in *Ararat,* p. 32.

22. From the Foreword of *Charles Burchfield,* n.p.

23. Hartley, "Winslow Homer," *Adventures in the Arts,* pp. 48–49.

24. Hartley, "Albert P. Ryder," *Adventures in the Arts,* p. 38.

25. Lloyd Goodrich and Doris Bry, *Georgia O'Keeffe* (New York: Whitney Museum of American Art, 1970), p. 9.

26. From "Commemorative Essay" of January 7, 1965, by Rothko, reprinted in exhibition catalogue *Milton Avery,* National Collection of Fine Arts, Washington, D.C., December 12, 1969–January 25, 1970, n.p.

27. From an interview by Dorothy Seckler with Newman, "Frontiers of Space," *Art in America* (New York), vol. 50 (Summer 1962), pp. 82–87.

28. From "Jackson Pollock," *Arts and Architecture* (Los Angeles), February 1944, p. 14.

29. From "Notes on Painting by the Artist" by Hartley, in *Feininger-Hartley* (New York: The Museum of Modern Art, 1944), p. 65.

30. Arshile Gorky, excerpt from a statement on the painting *Garden in Sochi,* written June 1942, Collections Archives, The Museum of Modern Art, New York.

31. Hartley, "Concerning Fairy Tales and Me," *Adventures in the Arts,* pp. 4–5.

32. From a letter to Alfred Stieglitz from O'Keeffe dated August 26, 1937, reprinted in catalogue of *14th Annual Exhibition of Paintings,* An American Place Gallery, New York, December 27, 1937–February 11, 1938, p. 8.

33. From a letter to Royal Cortissoz dated August 2, 1920, quoted in exhibition catalogue *Augustus Vincent Tack, 1870–1949: Twenty-six Paintings from The Phillips Collection,* University Art Museum, The University of Texas at Austin, August 27–October 3, 1972, p. 17.

34. From an interview by Richard Meryman with Wyeth, *Life,* May 14, 1965. Reprinted in Wanda M. Corn, *The Art of Andrew Wyeth* (Greenwich, Conn.: New York Graphic Society, 1973), p. 60.

35. From a letter by Baziotes to Barnett Newman dated January 22, 1948, quoted in *Location* (New York), vol. 1, no. 2 (Summer 1964), p. 89.

36. From a letter by Tobey dated October 28, 1954, reprinted in *The Art Institute of Chicago Quarterly,* vol. 49, no. 1 (February 1, 1955), p. 9.

37. Excerpt from Burchfield's journals, quoted in John I.H. Baur, *Charles Burchfield* (New York: Whitney Museum of American Art, 1956), p. 11.

38. Benjamin Townsend, "An Interview with Clyfford Still," *Gallery Notes* (Buffalo), vol. 24, no. 2 (Summer 1961), pp. 10–16.

39. Statement of 1942 to Hans Hofmann, quoted in Francis V. O'Connor, *Jackson Pollock* (New York: The Museum of Modern Art, 1967), p. 26.

40. Quoted in Haskell, *Arthur Dove,* p. 136.

41. Mark Tobey, "Reminiscence and Reverie," *Magazine of Art* (New York), vol. 44, no. 6 (October 1951), p. 230.

42. From a letter by Still to Gordon Smith dated January 1, 1959, reprinted in exhibition catalogue *Paintings by Clyfford Still,* Buffalo Fine Arts Academy, Albright Art Gallery, Buffalo, November 5–December 13, 1959, n.p.

43. Barnett Newman, "The Sublime Is Now," *The Tiger's Eye* (New York), vol. 1 (December 15, 1948), pp. 51–53.

44. Quoted by Ti-Grace Sharpless, in exhibition catalogue *Clyfford Still,* Institute of Contemporary Art, University of Pennsylvania, Philadelphia, October 18–November 29, 1963, n.p.

45. From a letter by Gorky dated July 1943, reprinted in *Ararat,* p. 30.

46. Mark Rothko, "The Romantics Were Prompted," *Possibilities* (New York), vol. 1 (Winter 1947–48), p. 84.

47. From a letter by Gorky dated February 9, 1942, reprinted in *Ararat,* p. 29.

48. Statement published in *Reality,* Spring 1953, reprinted in Goodrich, *Edward Hopper,* p. 164.

49. From a statement by Tobey, reprinted in exhibition catalogue *Mark Tobey,* Musée des Arts Décoratifs, Paris, October 18–December 1, 1961, n.p.

50. From Burchfield's journals, quoted in Baur, *Charles Burchfield,* p. 12.

51. From a letter by Gorky dated November 24, 1940, reprinted in *Ararat,* p. 25.

52. From a statement by Gottlieb in "The Ides of Art," *The Tiger's Eye* (New York), vol. 1, no. 2 (December 1947), p. 43.

53. Gottlieb and Rothko, Letter to the Editor, *New York Times,* June 13, 1943.

54. Quoted in Sharpless, *Clyfford Still,* n.p.

55. From a letter by Gorky dated July 1943, reprinted in *Ararat,* p. 30.

56. Quoted in Haskell, *Arthur Dove,* p. 136.

57. Quoted in Sharpless, *Clyfford Still,* n.p.

58. Pollock as quoted in *The New Yorker,* August 5, 1950, p. 16.

59. From a letter to Royal Cortissoz from Tack dated February 2, 1919, quoted in *Augustus Vincent Tack,* p. 17.

60. Gottlieb and Rothko, Letter to the Editor, *New York Times,* June 13, 1943.

61. From a letter by Gorky dated February 17, 1947, reprinted in *Ararat,* p. 39.

THOMAS COLE. *Expulsion from the Garden of Eden.* C. 1827–28
Oil on canvas, 39 x 54 in. (99.1 x 137.2 cm.). Museum of Fine Arts, Boston. M. and M. Karolik Collection

CHRONICLE

Compiled by Mary Davis

THIS CHRONICLE covers the biographies of the artists represented in this book and also includes major artistic and historical events which relate to the period. It begins in 1775, the year of birth of two of the artists, and by coincidence, the year in which the American Revolution begins.

1775

Robert Salmon is born in Scotland (approximate date).
John Vanderlyn is born in Kingston, N.Y.
The American Revolution begins; George Washington assumes command of the Continental Army. Benedict Arnold fails to capture Quebec.
The Second Continental Congress convenes in Philadelphia.
Edmund Burke: *Speech on Conciliation with America.*
Samuel Seabury: *Westchester Farmer,* pamphlets supporting the Loyalist position.
James Watt invents the steam engine.

1776

John Singleton Copley is elected an associate of the Royal Academy in London.
The Revolutionary War: Washington forces the British to evacuate Boston; American troops withdraw from Canada; British occupy Manhattan and Rhode Island; Benedict Arnold is defeated at Lake Champlain; Washington and troops retreat to Pennsylvania.
The Declaration of Independence is signed in Philadelphia.
Thomas Paine: *Common Sense.*

1777

Benjamin West invites Gilbert Stuart to join his studio of American artists working in London.
The Revolutionary War: The British are defeated at Princeton, N.J., and Bennington, Vt.; Lafayette's French volunteers arrive; the Americans are defeated at Germantown, Pa.; the British occupy Philadelphia and control Delaware; General Burgoyne surrenders to the Americans at Saratoga. Washington quarters his Army for the winter at Valley Forge.
The Articles of Confederation, legitimizing the Continental Congress, are submitted to the states for ratification, and are adopted in 1781.
The Stars and Stripes are adopted as the flag of the Continental Congress.

1778

The Revolutionary War: The Americans reject a British offer of peace; American independence is recognized by France and a military alliance is formed; Spain sends aid unofficially. The British evacuate Philadelphia and capture Savannah.

Indian massacres take place at Cherry Valley, N.Y., and Wyoming, Pa.

1779

Washington Allston is born in Georgetown, S.C.
The Revolutionary War: The British are defeated at Vincennes; Spain declares war on Britain; the *Bon Homme Richard,* commanded by John Paul Jones, captures the British ship *Serapis.*

1780

The Revolutionary War: French troops arrive at Newport; British capture Charleston; Benedict Arnold's plot to surrender West Point is revealed, and Major John André is executed; North Carolina and Virginia become major battle areas.
The American Academy of Sciences is founded at Boston.

1781

The Revolutionary War: The British campaign in South ended as Cornwallis surrenders his troops at Yorktown, Va. All land operations end.

1782

The Revolutionary War: Thomas Grenville is sent from London to open peace talks with Benjamin Franklin in Paris. A provisional peace treaty is signed. Spain gains control of Florida.

1783

George Washington proclaims the end of the Revolutionary War. The Treaty of Paris recognizes American Independence and restores Florida to Spain. The British evacuate New York.

1784

John Trumbull returns to London to study with West.
John Singleton Copley is elected a full member of the Royal Academy in London.
An ordinance is signed providing for the survey and sale of public lands in the West, supplemented by the Ordinance of 1785 and the Northwest Ordinance of 1787.

1787

The Constitutional Convention is held at Philadelphia. The Constitution is submitted to the states for ratification, nine votes needed. Delaware ratifies it and becomes the first state, followed by Pennsylvania and New Jersey.
Dollar currency is introduced.
The Northwest Ordinance, adopted for territory north of the Ohio River, provides for admittance of new states and prohibits slavery in the territory.
John Adams: *A Defense of the Constitutions of Government of the United States* (three volumes, 1787–88).
James Madison, Alexander Hamilton, and John Jay: *The Federalist* (1787–88).

1788

New York is declared the federal capital.
Georgia, Connecticut, Massachusetts, Maryland, South Carolina, New Hampshire, Virginia, and New York ratify the Constitution and become states.

1789

The Constitution goes into effect, and the first U.S. Congress meets in New York. George Washington becomes President; John Adams, Vice President; Thomas Jefferson, Secretary of State; Alexander Hamilton, Secretary of the Treasury. John Jay is appointed Chief Justice of the Supreme Court.
The French Revolution begins.

1790

The U.S. Funding Bill is introduced by Alexander Hamilton.
The first U.S. census is taken; the population numbers approximately 4 million.
Benjamin Franklin dies (b. 1706).
First session of the Supreme Court convenes.
Washington, D.C., is founded.

1791

Samuel F. B. Morse, American painter and inventor, is born in Charlestown, Mass.
The first Ten Amendments to the Constitution (Bill of Rights) are passed.
The first Bank of the United States is chartered.
Vermont is admitted to the Union.
Thomas Paine, living in England, becomes enraged by Edmund Burke's attack on the French Revolution and publishes *Rights of Man.* When Burke replies, Paine writes *Rights of Man, Part II* the following year.

1792

Benjamin West, the American-born painter, is named President of the Royal Academy, London, serving until 1820.
George Washington is reelected President.
Two political parties are formed: the Federalist, under Alexander Hamilton and John Adams, and the Republican, under Thomas Jefferson. Kentucky is admitted to the Union, and the Capitol at Washington is begun.
George Vancouver explores the Northwest coast of America.

Mary Wollstonecraft: *Vindication of the Rights of Women* (published in England).

1793

Thomas Doughty is born in Philadelphia.

U.S. law orders escaped slaves to return to their owners.

France declares war on Great Britain, Holland, and Spain; the U.S. proclaims neutrality.

Thomas Paine is arrested in Paris by radicals for deploring terrorist tactics against Louis XVI.

Eli Whitney invents the cotton gin.

1794

Thomas Birch emigrates from England and settles in Philadelphia, where he works with his father, engraving and publishing views of Philadelphia.

Thomas Paine: *The Age of Reason* (Part I), written in a Paris prison; he outlines his Deist beliefs but states his opposition to organized religion.

1795

Thomas Paine: *The Age of Reason* (Part II).

1796

George Catlin is born is born in Wyoming Valley, Pa.

Asher B. Durand is born in Jefferson Village (now Maplewood), N.J.

John Vanderlyn is sent to Paris to study by his patron Aaron Burr.

George Washington refuses a third term, and John Adams is elected the second President of the United States; Thomas Jefferson is elected Vice President. Washington delivers his Farewell Address.

Tennessee is admitted to the Union.

1797

"X.Y.Z. Affair": Talleyrand, foreign minister for the Directory, attempts to bribe American emissaries, increasing anti-French feeling in the U.S.

1798

Alien and Sedition Laws, an expression of Federalist fears of French interference, are passed.

The Virginia and Kentucky Resolutions present Jeffersonian Republicans' states' rights position.

Samuel Taylor Coleridge and William Wordsworth: *Lyrical Ballads.*

Thomas Robert Malthus: *Essay on the Principle of Population.*

1799

Alexander von Humboldt, German naturalist, traveler, and

WASHINGTON ALLSTON
Ship in a Squall
Before 1837
Chalk on canvas,
$47\frac{1}{4}$ x $59\frac{1}{2}$ in.
(120 x 151.1 cm.)
Fogg Art Museum,
Harvard University,
Cambridge, Massachusetts
On loan from the
Washington Allston Trust

ROBERT SALMON
Moonlight Coastal Scene
1836
Oil on panel,
$16\frac{5}{8}$ x $24\frac{1}{4}$ in.
(42.3 x 61.6 cm.)
The St. Louis
Art Museum
Purchase, and
funds given by
Mr. and Mrs.
Duncan C. Dobson,
contributions made
in memory of
Henry B. Pflager
and Eliza K.
McMillan Fund

above: ABBOTT HANDERSON THAYER. *Cornish Headlands.* 1898
Oil on canvas, 30⅛ x 40⅛ in. (76.5 x 101.9 cm.)
National Collection of Fine Arts, Smithsonian Institution, Washington, D.C.
Gift of John Gellatly

opposite above: JOHN SINGER SARGENT. *Mountain Fire.* c. 1903–08
Watercolor, 13¾ x 19¾ in. (39.4 x 50.1 cm.)
The Brooklyn Museum, New York. Purchased by Special Subscription

opposite below: JOHN SINGER SARGENT. *Val d'Aosta (A Stream over Rocks).* c. 1910
Oil on canvas, 22⅛ x 28⅛ in. (55.9 x 71.2 cm.)
The Brooklyn Museum, New York. A. Augustus Healy Fund

statesman, explores Central and South America with French botanist Aimé Bonpland; their travels continue through 1804. His writings of his journey will be read by Frederic Edwin Church and other painters.

1800

Thomas Jefferson is elected third President of the United States.
The U.S. population numbers 5.5 million.
Washington, D.C., becomes the new national capital.

1801

Thomas Cole is born in Bolton-le-Moor (Lancashire), England.
John Vanderlyn returns to New York City after five years of study in Paris.
Washington Allston studies at the Royal Academy in London with Benjamin West.
Thomas Jefferson is inaugurated in Washington, D.C.

1802

The Peace of Amiens ends the war between Britain and France.

1803

John Vanderlyn travels to Europe, where he spends 12 years (2 in Rome, 10 in Paris), during which time he paints the Neo-Classical pictures *Marius amid the Ruins of Carthage* (M. H. de Young Memorial Museum, San Francisco), 1807, and *Ariadne* (Pennsylvania Academy of the Fine Arts), 1814.
Washington Allston moves to Paris.
Congress authorizes the expedition to the Northwest under Meriwether Lewis.
The U.S. purchases Louisiana from France for $15 million.
Ohio is admitted to the Union.

1804

Fitz Hugh Lane is born in Gloucester, Mass.
Alexander Hamilton dies in a duel with Aaron Burr.
Thomas Jefferson is reelected President.
Lewis and Clark expedition departs for the Northwest.

1805

The Pennsylvania Academy of the Fine Arts is founded in Philadelphia.
Washington Allston settles in Rome, where he meets Washington Irving and Samuel Coleridge.

1807

The Athenaeum, an art academy, is founded in Boston.

The Chesapeake Affair, in which seamen are taken off an American man-of-war, provokes anti-British feeling. Thomas Jefferson forbids the entry of British warships to U.S. harbors.

The Embargo Act prohibits all ships from leaving U.S. ports, causing economic problems.

1808

James Madison is elected the fourth President of the United States.

1809

The Embargo Act is repealed and the Non-Intercourse Act is passed, allowing American ships to enter other than English and French harbors.

Washington Irving: *History of New York . . . By Diedrich Knickerbocker.*

1810

The U.S. population numbers 7.2 million.

1811

George Caleb Bingham is born in Augusta County, Va.

Washington Allston and his pupil Samuel F. B. Morse move from Boston to London to paint.

The U.S. breaks off diplomatic relations with England over its failure to recognize the rights of neutral nations; the search of American merchant ships provokes the act.

1812

Asher B. Durand begins his apprenticeship with the engraver Peter Maverick, who later takes Durand into partnership.

Louisiana is admitted to the Union.

The U.S. declares war on Great Britain.

James Madison is reelected President.

1813

War of 1812: The British blockade American ports after Americans win several naval battles.

Oliver Perry commands American fleet victoriously at Put-in-Bay, on Lake Erie.

1814

War of 1812: The British capture Washington and burn the White House.

New England citizens express disapproval of the war at the Hartford Convention late in the year.

The Treaty of Ghent, signed December 24, ends the War of 1812.

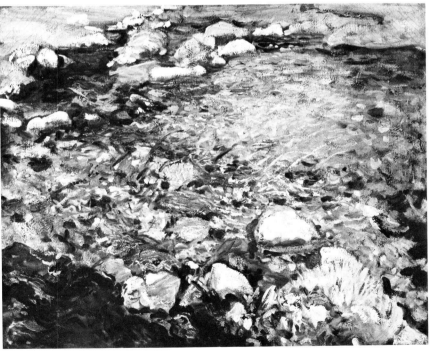

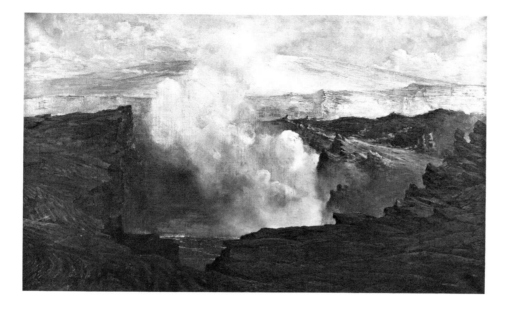

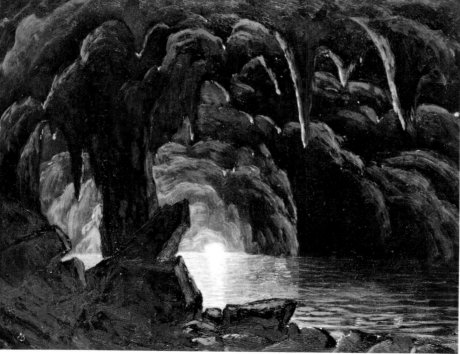

David Howard
Hitchcock
Hawaiian Volcano. 1896
Oil on canvas,
30 x 48½ in.
(76.2 x 123.2 cm.)
Mills College Art Gallery,
Oakland, California
Gift of the Family of
Mr. and Mrs.
Edward M. Walsh

Albert Bierstadt
The Blue Grotto, Capri
c. 1857–58
Oil on cardboard,
6⅞ x 8¾ in.
(17.4 x 22.2 cm.)
Walters Art Gallery,
Baltimore

1815

Word of war's end fails to reach New Orleans. British are defeated in the Battle of New Orleans.
The North American Review is established.

1816

John Frederick Kensett is born in Cheshire, Conn.
Indiana is admitted to the Union.
James Monroe is elected the fifth President of the United States.

1817

Robert S. Duncanson is born in upstate New York.
In London, Washington Allston begins the large Neo-Classical picture *Belshazzar's Feast* (Study, Museum of Fine Arts, Boston.) It occupies him for several years and is never completed.
Mississippi becomes the twentieth state.
William Cullen Bryant: "Thanatopsis," published in the *North American Review.*

1818

Washington Allston returns from London to Boston.
Illinois is admitted to the Union.
The boundary between the United States and Canada is determined.

1819

James Hamilton is born at Entrien, near Belfast, Northern Ireland.
Martin Johnson Heade is born at Lumberville, Bucks County, Pa.
Thomas Cole emigrates to America from England.
George Caleb Bingham moves to Missouri, where he paints for the greater part of his life. Prominent as a politician, Bingham often paints genre scenes of political subjects.
Alabama becomes a state.
The Tallmadge amendment to the bill for the admission of Missouri makes the slavery question a national concern.
Florida is acquired from Spain.
Washington Irving's *The Sketchbook of Geoffrey Crayon, Gent* begins publication. Seven numbers are issued, the last on September 13, 1820. Among the sketches published are "Rip Van Winkle" and "The Legend of Sleepy Hollow."

1820

Thomas Worthington Whittredge is born in Springfield, Ohio.
Thomas Doughty abandons his trade as a leather merchant to begin landscape painting.
Thomas Cole visits the West Indies; he later works as a block engraver in Steubenville, Ohio.

The Missouri Compromise is passed; Maine is admitted to the Union as a free state and Missouri as a slave state (in 1821).
James Monroe is reelected President.
The U.S. population approaches 9.5 million.
James Fenimore Cooper: *Precaution,* his first novel, a treatment of English country life.

1821

Missouri is admitted to the Union.
James Fenimore Cooper: *The Spy.*

1822

William Louis Sonntag is born in Pittsburgh.

1823

William Bradford is born at Fairhaven, near New Bedford, Mass.
Jasper Francis Cropsey is born in Rossville, N.Y.
Sanford R. Gifford is born in Greenfield, N.Y.
Asher B. Durand establishes his reputation as an engraver upon completion of the plate of John Trumbull's *Declaration of Independence.*
James Fenimore Cooper: *Pioneers,* the first of his Leatherstocking Tales.

1824

Eastman Johnson is born in Lovell, Me.
The U.S. House of Representatives elects John Quincy Adams President of the U.S.
The Erie Canal is completed.
Washington Irving: *Tales of a Traveller.*

1825

George Inness is born in Newburgh, N.Y.
The Erie Canal is opened, introducing a new era of economic prosperity.

1826

Frederic Edwin Church is born in Hartford, Conn.
The National Academy of Design is founded in New York.
The Pan American Congress convenes in Panama.
James Fenimore Cooper: *The Last of the Mohicans,* the second of his Leatherstocking Tales.

1828

Robert Salmon emigrates to America, settles in Boston, and becomes a marine and ship painter.
Andrew Jackson is elected seventh President of the United States.
The "Tariff of Abominations," a stiff protective tariff, distresses the South.

Washington Irving: *Life and Voyages of Christopher Columbus.*
Noah Webster: *American Dictionary of the English Language.*

1829

Thomas Cole departs for Europe, where he works in England and the Continent until 1832.
Washington Irving: *Conquest of Granada.*
The Delaware and Hudson locomotive-operated railroad opens.

1830

Albert Bierstadt is born at Solingen, near Düsseldorf, Germany.
Thomas Doughty begins publication of the periodical *Cabinet of Natural History and American Rural Sports,* illustrated with his own hand-colored lithographs.
The settled frontier extends as far as Independence, Mo.
Oliver Wendell Holmes: "Old Ironsides," a poem protesting the destruction of the frigate *Constitution.*

1831

W. L. Garrison establishes *The Liberator,* an anti-slavery journal, in Boston.

1832

Albert Bierstadt's family leaves Germany and arrives in New Bedford, Mass.

1833

William Trost Richards is born in Philadelphia.
George Catlin begins eight-year travels among Indian tribes, recording their lives.
Fitz Hugh Lane works in Boston learning lithography under Pendleton.
Slavery is abolished in the British Colonies.
Cyrus H. McCormick invents the reaper.

1834

James Abbott McNeill Whistler is born in Lowell, Mass.
James Hamilton, aged fifteen, leaves Northern Ireland with his family for Philadelphia.
The U.S. Senate censures President Andrew Jackson for withdrawing deposits from the Bank of the U.S.
Abraham Lincoln begins his political career in the Illinois legislature.

1835

John La Farge is born in New York.
Texas declares its right to secede from Mexico.
The Second Seminole War begins.

Washington Irving: *Tour on the Plains.*
Edgar Allen Poe writes for the *Southern Literary Messenger.*
Alexis de Tocqueville: *La Démocratie en Amérique,* a description of the American political system in the early nineteenth century.
Halley's comet reappears.

1836

Winslow Homer is born in Boston.
Homer Dodge Martin is born in Albany, N.Y.
Elihu Vedder is born in New York.
Arkansas is admitted to the Union as a slave state.
Martin Van Buren is elected eighth President of the United States.
The Alamo falls.
Ralph Waldo Emerson: *Nature.*

1837

Alfred Thompson Bricher is born in Portsmouth, N.H.
Thomas Moran is born in Lancashire, England.
George Caleb Bingham studies art at the Pennsylvania Academy of the Fine Arts.
George Catlin's "Indian Gallery," with a troupe of Indians, tours the U.S., France, and England.
Martin Johnson Heade goes abroad to study art in Italy, France, and England, remaining in Rome for two years.
Fitz Hugh Lane is employed by the Boston publishers Keith and Moore.
John Vanderlyn is commissioned to paint *The Landing of Columbus* for the Capitol Rotunda in Washington.
Financial panic.
Michigan becomes the twenty-sixth state.
The Republic of Texas, led by Sam Houston, is acknowledged by the United States.
Ralph Waldo Emerson: *The American Scholar,* an address to the Phi Beta Kappa Society at Harvard, calling for an American literary man of action who does not rely on European models.
Nathaniel Hawthorne: *Twice-Told Tales.*

1838

John Frederick Kensett works as a bank-note engraver in New York City.
The first steamships cross the Atlantic.
The New York Herald becomes the first U.S. newspaper to employ European correspondents.
Ralph Waldo Emerson: *Address to the Divinity College of Harvard,* asserting the supreme authority of the spiritual intuition of the individual and declaring that his perception of goodness awakens him to the sublime.

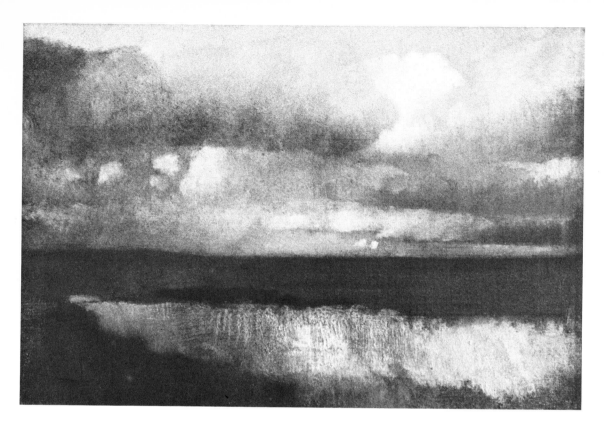

138

JOHN LA FARGE. *Clouds over Sea: From Paradise Rocks, Newport.* 1863
Oil on canvas, 10 x 14 in. (25.4 x 35.6 cm.)
Collection Mrs. John H. Storer, New York

1839

The Apollo Association is founded in New York City to acquire, sell, and distribute by lottery paintings and prints of American landscape and of historical and genre subjects to a popular audience. In 1844 it will be succeeded by the American Art-Union.

Henry Wadsworth Longfellow: *Voices of the Night,* his first volume of poetry.

The Daguerre-Nièpce method of photography is presented to the Académie des Sciences and the Académie des Beaux-Arts, Paris.

1840

Alfred Thompson Bricher moves with his family to New-buryport, Mass., where he attends public schools.

Asher B. Durand departs for Europe, where he studies art for a year. Accompanying Durand are John Frederick Kensett, J. W. Casilear, and T. P. Rossiter.

James Hamilton is shown in exhibition for the first time at the Gallery of the Artists' Fund Society, Philadelphia.

Worthington Whittredge works in Cincinnati as a portrait painter.

Landscape daguerreotypes are made by Samuel Bemis of Crawford's Notch, N.H.

Robert S. Duncanson leaves for Scotland to study art. The Western Freedman's Aid Society raises funds for his trip.

The U.S. population reaches 17 million, of which 2.5 million are slaves and 400,000 are free Negroes.

William Henry Harrison is elected ninth President of the United States.

Charles Henry Dana: *Two Years before the Mast.*

James Fenimore Cooper: *The Pathfinder.*

1841

George Catlin: *Illustrations of the Manners, Customs, and Condition of the North American Indians.*

George Inness is apprenticed to Sherman and Smith, map engravers of New York City.

Eastman Johnson works as a portraitist in Augusta, Me., Cambridge, Mass., Newport, R.I., and Washington, D.C., until 1849.

William Henry Harrison dies; John Tyler succeeds him as tenth President of the United States.

Act is passed enabling settlers to preempt 160 acres of public land at $1.25 per acre. Westward expansion is encouraged.

Ralph Waldo Emerson: *Essays* (first series).

James Fenimore Cooper: *The Deerslayer.*

Henry Wadsworth Longfellow: *Ballads and Other Poems.*

Edgar Allen Poe: "The Murders in the Rue Morgue," in *Graham's Magazine.*

1842

Worthington Whittredge works as a portrait painter in Indianapolis, Ind.

Robert S. Duncanson returns to Cincinnati, where he exhibits in a local art show.

Henry Wadsworth Longfellow: *Poems on Slavery.*

Nathaniel Hawthorne: *Twice-Told Tales* (second edition).

1843

Washington Allston and John Trumbull die.

James Hamilton exhibits at the Pennsylvania Academy of the Fine Arts.

Daniel Webster retires as Secretary of State.

Jefferson Davis, future Confederate leader, enters politics.

Dorothea Dix, social reformer, exposes poor conditions in asylums and prisons.

John Ruskin: *Modern Painters.*

1844

Thomas Eakins is born in Philadelphia.

Frederic Edwin Church studies with Thomas Cole in the Catskills until 1848.

Martin Johnson Heade exhibits at the Pennsylvania Academy and for next two years travels through American countryside painting portraits.

Thomas Moran emigrates from England, settling with his family in Maryland.

James W. Polk is elected the eleventh President of the United States.

Ralph Waldo Emerson: *Essays* (second series).

Samuel F. B. Morse's telegraph is used between Baltimore and Washington.

1845

Asher B. Durand is elected President of the National Academy of Design, New York, which he helped to found in 1826.

Fitz Hugh Lane and John W. A. Scott become partners in a lithography firm in Boston. The latter is also a marine painter.

Sanford R. Gifford studies art in New York with John Rubens Smith.

F. and W. Langenheim daguerreotype Niagara Falls.

Florida and Texas are admitted to the Union (with slavery) as the twenty-seventh and twenty-eighth states. There are 13 free states to 15 slave states.

Edgar Allen Poe: *The Raven and Other Poems.*

1846

Sanford R. Gifford makes a sketching tour of the Berkshires and Catskills.

George Inness studies painting under Régis F. Gignoux in Brooklyn.

James Hamilton exhibits at the National Academy of Design in New York.

Oregon boundary line is determined by treaty with Great Britain.

War with Mexico.

The Wilmot Proviso, prohibiting slavery in any territory acquired from Mexico, passes in the House but not the Senate.

Iowa, the twenty-ninth and free state, is admitted to the Union.

Irish immigration to the United States increases as the great famine strikes Ireland.

Herman Melville: *Typee.*

John Greenleaf Whittier: *Voices of Freedom.*

1847

Ralph Albert Blakelock is born in New York.

Albert Pinkham Ryder is born in New Bedford, Mass.

Jasper Francis Cropsey departs for Europe, where he studies for three years.

George Inness makes the first of several trips to Europe.

John Frederick Kensett returns from Europe after seven years of traveling and painting in England, France, Germany, and Italy.

The Century Association is founded in New York for "intellectuals and men of accomplishment." Asher B. Durand is a founding member.

Henry Wadsworth Longfellow: *Evangeline.*

Karl Marx and Friedrich Engels: *Communist Manifesto* (published in Germany).

1848

Frank Duveneck is born in Covington, Ky.

Thomas Cole dies.

Robert S. Duncanson is commissioned to paint a series of mural landscapes for the home of Nicholas Longworth (now the Taft Museum) in Cincinnati.

The California Gold Rush results in the first "California school" of outdoor daguerreians.

Mexico cedes territory that is now California, Nevada, Arizona, and Utah.

Wisconsin, a free state, is the thirtieth to join the Union. Free and slave states are balanced.

Zachary Taylor is elected twelfth President of the United States.

Year of revolutions in Europe.

1849

Abbot Handerson Thayer is born in Boston.

JOHN LA FARGE. *Berkeley's, or Hanging Rock. Paradise, Newport. North Wind, Autumn.* c. 1869 Oil on panel, 10¾ x 9¼ in. (27.3 x 23.5 cm.) Wellesley College Museum, Wellesley, Massachusetts Gift of Mr. and Mrs. Stanley Feldberg

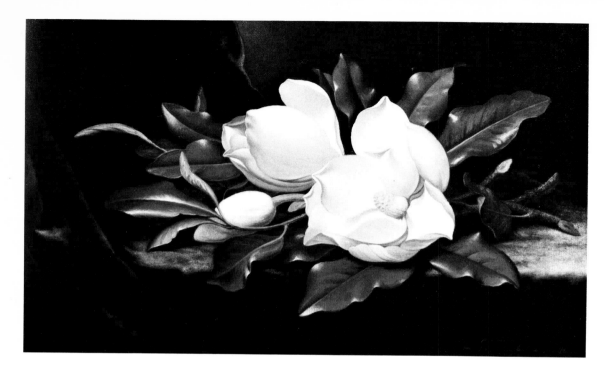

MARTIN JOHNSON HEADE. *Giant Magnolias on a Blue Velvet Cloth.* c. 1885–95
Oil on canvas, 15 x 24 in. (38.1 x 60.9 cm.). Private collection

Fitz Hugh Lane returns to Gloucester, where he lives and paints until his death in 1865.

Worthington Whittredge departs for Europe, where he studies in Düsseldorf and Rome.

Eastman Johnson attends classes at the Royal Academy in Düsseldorf.

Robert S. Duncanson exhibits with the Western Art-Union.

Henry David Thoreau: *Civil Disobedience.*

Herman Melville: *Mardi* and *Redburn.*

John Ruskin: *Seven Lamps of Architecture.*

1850

George Inness departs for Europe.

William Trost Richards studies with Paul Weber, a German landscape and portrait painter.

President Taylor dies; Millard Fillmore succeeds him as the thirteenth President of the United States.

Under the Compromise of 1850, California is admitted to the Union as a free state.

The Fugitive Slave Law is passed.

Land grants made by Congressional act aid in the construction of railroads.

The U.S. population numbers 23 million.

John C. Calhoun: *Speech on the Slavery Question.*

Daniel Webster: *Seventh of March Speech.*

Nathaniel Hawthorne: *The Scarlet Letter.*

1851

Thomas Wilmer Dewing is born in Boston.

Robert Salmon dies (approximate date).

Eastman Johnson works in the Düsseldorf studio of Emanuel Leutze, then painting *Washington Crossing the Delaware* (The Metropolitan Museum of Art, New York). Johnson goes to The Hague, where he studies for four years. Known as the "American Rembrandt," he is offered the position of Court Painter.

James Bogardus constructs a cast-iron frame building.

Cuba declares its independence.

Herman Melville: *Moby Dick.*

Nathaniel Hawthorne: *The House of Seven Gables.*

John Ruskin: *The Stones of Venice.*

The New York Times begins publication.

1852

John Vanderlyn dies.

The American Art-Union is dissolved as an illegal lottery.

William Trost Richards exhibits at the Pennsylvania Academy of the Fine Arts, Philadelphia.

Franklin Pierce is elected fourteenth President of the United States.

Harriet Beecher Stowe: *Uncle Tom's Cabin.*

1853

Accompanied by Cyrus W. Field, Frederic Edwin Church makes his first trip to Colombia and Ecuador after reading the writings of the German naturalist, Alexander von Humboldt.

Albert Bierstadt travels to Düsseldorf to study art.

Robert Vance exhibits daguerreotypes of California.

Robert S. Duncanson travels to France, Italy, and England with William Sonntag.

Nathaniel Hawthorne: *Tanglewood Tales.*

1854

Eastman Johnson works in Paris in the studio of Thomas Couture.

George Inness visits Paris, then moves to Barbizon to study painting.

William Stanley Haseltine travels to Düsseldorf to study and meets Albert Bierstadt and Worthington Whittredge there.

Worthington Whittredge leaves Düsseldorf for a sketching trip to Switzerland and Italy.

James Hamilton travels to England, where he studies the work of Turner, Pyne, and Stanfield.

William Trost Richards studies with Alexander Lawrie in Philadelphia. On a trip to New York he meets John Frederick Kensett, Frederic Edwin Church, and Samuel Coleman. In May he meets Jasper Francis Cropsey; in July his studio burns.

First published photographs in America are sold in Philadelphia by F. and W. Langenheim.

The Kansas-Nebraska Act abrogates the Missouri Compromise and permits the two territories local option on the slavery question.

The Republican Party is organized in protest to the Kansas-Nebraska Act.

Henry David Thoreau: *Walden, or Life in the Woods.*

1855

Sanford R. Gifford departs for Europe, where he travels and studies for three years.

James Hamilton returns to Philadelphia from Europe and illustrates Dr. Elisha Kane Kent's *Arctic Explorations.*

Winslow Homer is apprenticed to the Boston lithographer J. H. Bufford, designing covers for sheet music.

James Abbott McNeill Whistler departs for Europe, where he visits London and settles in Paris, entering the studio of Charles Gleyre and studying in the Louvre.

Worthington Whittredge settles in Rome.

William Trost Richards makes a sketching trip up the Hudson River to the Adirondacks in June. In August he travels to Europe, stopping in Paris and then on to Switzerland and Italy; he visits Lago Maggiore, Genoa, Pisa, Florence, and Rome; by the spring of the next year he reaches Düsseldorf.

The Crayon, American journal promoting John Ruskin's views on Pre-Raphaelite painting, begins publication, continuing into 1861. Jasper Francis Cropsey publishes "Up among the Clouds," discussing his beliefs on working from nature.

Washington Irving: *Life of Washington* (the first of five volumes, the last published in 1859).

Henry David Longfellow: *The Song of Hiawatha.*

Herman Melville: "Benito Cereno," in October, November, and December issues of *Putnam's Monthly Magazine.*

Walt Whitman: *Leaves of Grass.*

1856

John Singer Sargent is born in Florence.

Thomas Doughty dies.

George Caleb Bingham studies art in Düsseldorf until 1858.

Frederic Edwin Church visits Niagara Falls.

William Stanley Haseltine, Emanuel Leutze, Worthington Whittredge, and Albert Bierstadt make a sketching trip down the Rhine. Bierstadt and Whittredge go on to Italy, where Sanford R. Gifford joins them.

John La Farge studies painting with Thomas Couture in Paris, then visits London, where he sees Pre-Raphaelite painting.

Elihu Vedder travels to France, followed by a several-year stay in Italy.

William Louis Sonntag travels to Florence to study.

James Buchanan is elected the fifteenth President of the United States.

The Massacre of Pottawatomie Creek, Kansas: free-staters murder slavers.

Ralph Waldo Emerson: *English Traits.*

1857

Albert Bierstadt returns to Massachusetts to paint and teach.

William Bradford begins to study art under Van Beesf.

Jasper Francis Cropsey travels to Europe, remaining in London until 1863.

Homer Dodge Martin submits paintings to the National Academy of Design.

Winslow Homer becomes an illustrator for *Ballou's Pictorial* of Boston and *Harper's Weekly* of New York City.

Frederic Edwin Church successfully exhibits the large *Niagara Falls* in New York and a chromolithograph of it is made, further extending its popularity. It is displayed in London during the summer, where critic John Ruskin views it.

The Tenth Street Building, designed by William Morris Hunt, is completed in New York. Its tenants over the years include Bierstadt, Church, Gifford, Haseltine, Heade, Homer, La Farge, Eastman Johnson, Kensett, and Whittredge.

Financial panic.

Chief Justice Taney delivers the Dred Scott decision: a Negro is not a citizen, so he cannot bring suit in a federal court.

Atlantic Monthly is founded in Boston; James Russell Lowell is the editor, and Oliver Wendell Holmes contributes "The Autocrat of the Breakfast Table."

1858

Albert Bierstadt travels to the Far West.

William Stanley Haseltine returns to America, settling in a studio in the Tenth Street Building, New York.

Alfred Thompson Bricher opens a studio in Newburyport, Mass.; he makes a sketching trip to Roxbury and spends the summer drawing at Desert Island, Me., with Charles Temple Dix and Haseltine.

Frederick Law Olmsted and Calvert Vaux win a $2000 prize and the commission to design Central Park in New York City, one of the first large public parks in the world.

Régis Gignoux paints *Niagara in Winter,* a companion piece to the Church painting.

Lincoln and Douglas debate in Illinois on the slavery issue.

Minnesota becomes the thirty-second state.

1859

Henry Ossawa Tanner is born.

Worthington Whittredge returns from Europe and settles in New York City, where he works until 1880.

Frederic Edwin Church completes the large picture *Heart of the Andes* (The Metropolitan Museum of Art, New York), purchased by William T. Blodgett for $10,000, the highest price yet paid for a painting by a living American artist. Exhibited with gas lighting and tropical foliage, the picture is a popular success in New York and London. *Niagara Falls* tours the U.S. to popular acclaim. Church travels to Newfoundland and Labrador.

Albert Bierstadt joins Colonel Frederick William Landers's survey expedition to the Far West, photographing and sketching the Indian encampments and landscape of the Wind River Range, Nebraska Territory. Upon his return to New York he rents a studio in the Tenth Street Building.

Eastman Johnson settles in New York City, also moving to the Tenth Street Building, as does Martin Johnson Heade.

John La Farge studies with William Morris Hunt in Newport.

Alfred Thompson Bricher moves to Boston and makes

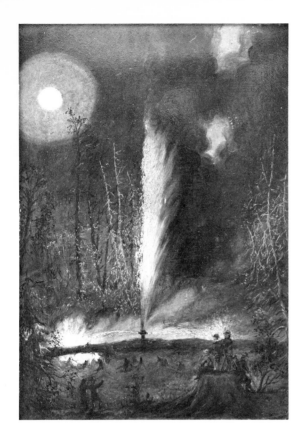

JAMES HAMILTON
Burning Oil Well at Night, near Titusville, Pa. c. 1859
Oil on canvas, 20 x 14 in. (50.8 x 35.5 cm.)
Collection Lee B. Anderson, New York

sketching trips to New England, the Catskills, and Long Island.

C. L. Weed makes the first stereograph photographs of Yosemite.

Reverend Louis Legrand Noble: *After Icebergs with a Painter,* illustrated by Frederic Edwin Church.

John Brown's raid on Harper's Ferry.

Silver is discovered in the Comstock Lode, Neb.

The first oil well is dug at Oil Creek, Pa.

Oregon is admitted to the Union.

1860

Albert Bierstadt exhibits his first Rocky Mountain picture.

Frederic Edwin Church paints *Twilight in the Wilderness* (The Cleveland Museum of Art).

William Trost Richards spends the summer painting open-air landscapes near Bethlehem, Pa.

South Carolina secedes from the Union.

Abraham Lincoln is elected sixteenth President of the United States.

The U.S. population reaches 31.5 million, of which 4 million are slaves and 450,000 are free Negroes.

Nathaniel Hawthorne: *Marble Faun.*

Walt Whitman: *Leaves of Grass* (third edition).

Henry David Thoreau: *Plea for John Brown,* delivered at the Concord, Mass., Town Hall.

1861

David Howard Hitchcock is born in Hawaii.

Frederic Remington is born in Canton, N.Y.

Albert Bierstadt visits Union army camps on the Potomac.

Thomas Eakins studies art at the Pennsylvania Academy of the Fine Arts under Christian Schussele, independently taking anatomy courses at the Jefferson Medical School, Philadelphia.

Sanford R. Gifford joins the Seventh New York Regiment and goes to Washington.

William Bradford makes his first trip to Labrador, after which he becomes well known in England and America for his paintings of the Arctic.

Elihu Vedder returns to New York City, where he spends the war years.

C. E. Watkins successfully produces his first stereographs and mammoth-plate views in Yosemite Valley.

Outbreak of the Civil War: Washington Peace Convention is unable to preserve the Union; Confederate States of America formed by Georgia, South Carolina, Alabama, Mississippi, Florida, and Louisiana; the Confederates take Fort Sumter and win victory at Bull Run.

T. H. O'Sullivan and A. J. Russell photograph the Civil War.

1862

Arthur B. Davies is born in Utica, N.Y.

Thomas Moran and his brother Edward travel to England, where they study Turner's art in London.

James Abbott McNeill Whistler meets English artists Dante Gabriel Rossetti, John Everett Millais, and Albert Moore.

Robert S. Duncanson makes a second trip to Scotland, where he remains during the Civil War.

Homer Dodge Martin moves to New York, where he sees the work of John Frederick Kensett.

Congress passes the Homestead Act, granting 160 acres of western land to settlers at $1.25 per acre.

Civil War: The first battle of the ironclads involves the *Merrimac* and the *Monitor* at Hampton Roads; the Battles of Antietam, Bull Run, Shiloh, Seven Days, and Murfreesboro are fought; the Union Army suffers heavy losses and defeat at Fredericksburg, Md.; General Sherman is defeated at Chickasaw Bayou.

1863

Martin Johnson Heade visits Brazil; trip is followed by excursions to Nicaragua in 1866 and Colombia, Jamaica, and Puerto Rico in 1870.

Albert Bierstadt makes his first trip to California to paint and visits Yosemite Valley with Fitz Hugh Ludlow.

Civil War: On January 1 Lincoln issues the Emancipation Proclamation, declaring freedom of slaves in all states of the rebellion; Stonewall Jackson dies at the Battle of Chancellorsville; the Confederates are defeated at the Battle of Gettysburg, and Lincoln delivers his commemorative address. The Confederate surrender of Vicksburg is the turning point of the war

West Virginia is admitted to the Union.

1864

Louis Michel Eilshemius is born in Newark, N.J.

Alfred Stieglitz is born in Hoboken, N.J.

Ralph Albert Blakelock studies art at the Free Academy of the City of New York.

Alfred Thompson Bricher exhibits his work for the first time at the Boston Athenaeum.

William Stanley Haseltine begins to travel and paint along the New England coast.

Frederic Edwin Church's *The Heart of the Andes* and Albert Bierstadt's *The Rocky Mountains* (both, The Metropolitan Museum of Art, New York) are exhibited at the New York Sanitary Fair.

President Lincoln signs a bill ceding Yosemite to California as a public park.

Civil War: Battles of the Wilderness and Cold Harbor take place; Grant and Lee wage battle in Virginia; a bread riot

occurs in Savannah; the Union Army takes Atlanta, forcing Sherman's March to the Sea.

Nevada is admitted to the Union.

Abraham Lincoln is reelected President of the United States.

1865

Fitz Hugh Lane dies.

Worthington Whittredge, Sanford R. Gifford, and John Frederick Kensett make a painting trip to the Rocky Mountains, returning in 1866.

Worthington Whittredge serves as President of the National Academy of Design.

Elihu Vedder goes to Italy to settle permanently.

T. H. O'Sullivan and Alexander Gardner produce the *Photographic Sketch Book of the War*.

Abraham Lincoln delivers his second inaugural address.

Civil War: Robert E. Lee surrenders to Ulysses S. Grant at Appomattox, ending the war on April 9.

Abraham Lincoln is assassinated by John Wilkes Booth on April 14. Andrew Johnson succeeds Lincoln as seventeenth President of the United States; he issues a proclamation for the reconstruction of former Confederate states.

The thirteenth amendment to the U.S. Constitution is passed, abolishing slavery.

The Ku Klux Klan is founded.

Walt Whitman: *Drum Taps*.

Mark Twain: "The Celebrated Jumping Frog of Calaveras County."

1866

William Trost Richards makes his second trip to Europe, remaining through the next year.

Winslow Homer departs for France, where he studies for 10 months, returning in 1867.

Thomas Eakins leaves for Paris, where he enrolls at the Ecole des Beaux-Arts. He enters the atelier of Jean-Léon Gérôme, studies portrait painting with Léon-Joseph-Florentin Bonnat, and sculpture with Augustin-Alexandre Dumont.

Martin Johnson Heade returns from Brazil and settles in Church's studio to paint.

Worthington Whittredge joins General John Pope's expedition to the West following the Pike's Peak gold rush.

Albert Bierstadt purchases land on the Hudson River and builds his house, Malkasten.

Homer Dodge Martin is elected to the Century Association.

James Abbott McNeill Whistler journeys to South America to join the Chilean war of independence.

C. E. Watkins photographs the J. D. Whitney Survey in Yosemite.

The fourteenth amendment to the Constitution prohibits voting discrimination and erases Confederate debts.

THOMAS MORAN. *Slaves Escaping through the Swamp*. 1863
Oil on canvas, 34 x 44 in. (86.4 x 111.8 cm.)
Philbrook Art Center, Tulsa, Oklahoma. Laura A. Clubb Collection

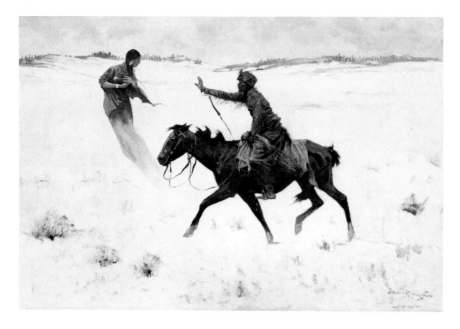

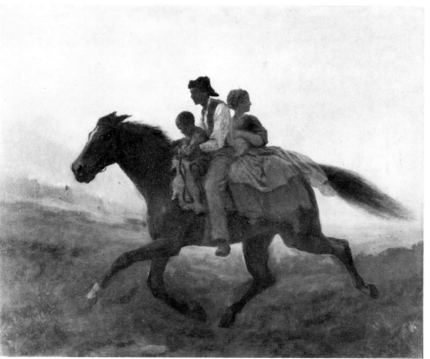

John Greenleaf Whittier: *Snow Bound.*
Alfred Nobel invents dynamite.

1867

Frederic Edwin Church is awarded a medal for *Niagara Falls* at the Paris International Exposition in April. In November he sails for France and in the next year and a half travels extensively in Europe and the Holy Land.

Albert Bierstadt paints *Domes of the Yosemite* (St. Johnsbury Athenaeum, St. Johnsbury, Vt.) a nearly 10 x 15 foot painting. He leaves for Europe, where he will remain for two years. He is received by Queen Victoria in London and gives her an autographed print of *The Rocky Mountains.*

Alaska is bought from Russia.

Nebraska becomes a state.

Gold is discovered in Wyoming.

The railroad is completed through the Brenner Pass.

Karl Marx: *Das Kapital* (first volume).

1868

Alfred Thompson Bricher moves to New York City to paint; he publishes chromolithographs and begins exhibiting at the National Academy of Design.

Eadweard J. Muybridge copyrights photographs of Yosemite. C. E. Watkins photographs in Oregon with William Keith.

The U.S. House of Representatives resolves to impeach President Andrew Johnson; the Senate convenes the Court of Impeachment, and President Johnson is summoned to appear before it, but the Senate fails to convict him.

Ulysses S. Grant is elected President of the United States.

The Wyoming Territory is organized by Congress out of parts of Dakota, Utah, and Idaho.

Thomas Edison patents his first invention, an electrical vote recorder.

1869

Thomas Eakins travels to Madrid, where he studies the work of Velázquez in the Prado.

Ralph Albert Blakelock travels to the Far West, sketching Indian tribes in Utah, Colorado, Nevada, the Wyoming Territory, and northern California.

The transcontinental railroad is completed, connecting east and west. A golden spike is driven at Promontory Point, Utah.

1870

Maxfield Parrish is born in Philadelphia.

Augustus Vincent Tack is born in Pittsburgh.

Frank Duveneck enters the Royal Academy in Munich. He studies with Wilhelm Leibl, who introduces him to the work of Goya, Hals, and Velázquez.

Thomas Eakins returns from Europe and settles in Philadelphia, where he begins painting scenes of outdoor sports, such as rowing and sailing.

Sanford R. Gifford, Worthington Whittredge, and John Frederick Kensett join F. V. Hayden's surveying expedition to the Rocky Mountains in Wyoming. W. H. Jackson photographs the expedition.

C. E. Watkins photographs Mounts Shasta and Lassen with Clarence King's Fortieth Parallel Survey.

The Metropolitan Museum of Art is founded in New York City. Among the trustees are John Jay, John Frederick Kensett, Thomas Worthington Whittredge, Frederic Edwin Church, and Eastman Johnson.

John D. Rockefeller founds Standard Oil Company.

Robert E. Lee dies.

1871

Albert Bierstadt sketches among the redwoods in California.

T. H. O'Sullivan photographs with Lt. George Wheeler's One Hundredth Meridian Survey in New Mexico, Arizona, Idaho, and Utah.

Thomas Moran joins the Hayden surveying expedition in the Yellowstone region.

The Great Chicago Fire decimates that city.

The U.S. population nears 39 million.

Charles Darwin: *The Descent of Man.*

Walt Whitman: *Democratic Vistas,* a volume of essays including "Democracy" and "Personalism."

1872

John Marin is born in Rutherford, N.J.

Gottardo Piazzoni is born in Switzerland.

George Catlin, Robert S. Duncanson, and John Frederick Kensett die.

Albert Bierstadt paints in Yosemite and the Sierras.

Eadweard J. Muybridge makes mammoth-plate negatives in the Sierra Nevada and photographs horses in motion for Leland Stanford.

Yellowstone is declared a national park, influenced by the Hayden Survey photographs by W. H. Jackson.

Ulysses S. Grant is reelected President, despite scandals during his administration.

Congress abolishes the federal income tax.

The Brooklyn Bridge is opened.

Susan B. Anthony is arrested for attempting to vote.

Thomas Edison develops the "duplex" telegraph.

1873

Frank Duveneck returns to the U.S. from Munich.

Julian Alden Weir studies art in Paris under Jean-Léon Gérôme and is later influenced by Bastien-Lepage.

Thomas Moran joins a geographical survey group to the Rocky Mountains led by Major John Wesley Powell; subsequently he sketches the Grand Canyon in northern Arizona.

T. H. O'Sullivan, C. E. Watkins, and Eadweard J. Muybridge exhibit photographs at the Vienna International Exposition.

A financial panic closes the New York Stock Exchange for ten days.

The U.S. Marines land in Panama to protect American interests.

1874

Worthington Whittredge becomes President of the National Academy of Design, serving until 1877.

John Singer Sargent enters the Paris atelier of Carolus-Duran.

Alfred Thompson Bricher makes his first sketching trip to Grand Manan Island, New Brunswick, by way of Halifax, Nova Scotia.

Thomas Hill helps plan the California School of Design in San Francisco, the first art school on the West Coast.

The unemployed riot in New York City.

Samuel J. Tilden is elected governor of New York after deposing the Tweed Ring.

The Whiskey Ring, involving U.S. officials, is exposed.

1875

Maynard Dixon is born in Fresno, Calif.

Abbott Handerson Thayer studies in the atelier of Gérôme in Paris.

Frank Duveneck exhibits five paintings at the Boston Art Club. Returning to Munich, he continues to study the Dutch masters and in a few years will establish a school at Polling with other rebels from the Munich Academy.

James Hamilton places all his unsold works at auction by the James S. Earle Galleries, Philadelphia, preparatory to a round-the-world trip. He only goes as far as San Francisco, however.

1876

Homer Dodge Martin travels to Europe, spending nine months in London where he studies the work of Constable and other English landscapists and becomes acquainted with Whistler's Nocturnes.

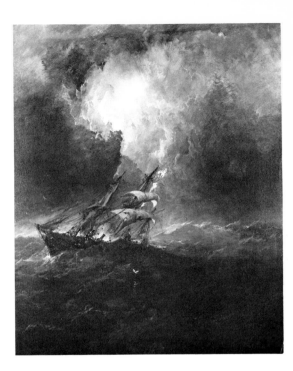

opposite above: FREDERIC REMINGTON
*How Order No. 6 Went Through
(The Vision).* 1899
Oil on canvas,
26 x 39 in. (66 x 99 cm.)
"21" Club, New York
Peter Kriendler, President

opposite below: EASTMAN JOHNSON
*A Ride for Liberty—
The Fugitive Slaves.* c. 1862
Oil on composition board, 22 x 26¼ in. (55.9 x 66.7 cm.)
The Brooklyn Museum, New York
Gift of Miss Gwendolyn O. L. Conkling

above: JAMES HAMILTON
Foundering. 1863
Oil on canvas,
59¾ x 48⅜ in. (151.8 x 122.6 cm.)
The Brooklyn Museum, New York
Dick S. Ramsay Fund

Thomas Eakins becomes an instructor at the Pennsylvania Academy of the Fine Arts.

Elihu Vedder is in London, where he meets major figures of English painting Alma-Tadema, Lord Leighton, and George Watts, who are influential in Vedder's turn to Neo-Classical subjects.

John La Farge accepts a commission to decorate the interior of Trinity Church in Boston, designed by the architect H. H. Richardson.

Thomas Wilmer Dewing studies in Paris at the Académie Julian under Boulanger and Lefebvre.

John Singer Sargent makes a sketching trip to Barbizon then Grez, France.

Albert Bierstadt, Jasper Francis Cropsey, John Frederick Kensett, Thomas Moran, and William Louis Sonntag are represented in the painting exhibition at the Philadelphia Centennial Exposition.

W. H. Jackson's photographs of the Hayden Survey are also shown at the Philadelphia Centennial Exposition.

Abbott Handerson Thayer leaves for Paris to study with Bonheur. He later enrolls at the Ecole des Beaux-Arts to study with Gérôme.

Rutherford B. Hayes is elected President by electoral vote over Samuel J. Tilden, 185 to 184.

Colorado is admitted to the Union.

Army officer George A. Custer is killed with all his command at the Battle of Little Big Horn.

Henry James: *Roderick Hudson.*

Mark Twain: *The Adventures of Tom Sawyer.*

Alexander Graham Bell invents the telephone.

1877

Marsden Hartley is born in Lewiston, Me.

Albert Pinkham Ryder makes his first trip to Europe.

Frederic Edwin Church is crippled by rheumatism, forcing him into years of inactivity.

The Society of American Artists is founded in opposition to the conservative National Academy of Design. The founders, all European-trained, are: Winslow Homer, George Inness, John La Farge, Homer Dodge Martin, Albert Pinkham Ryder, Walter Shirlaw, and Julian Alden Weir. They exhibit together annually beginning in 1878.

The Tile Club, a social group of artists who meet weekly, is founded. Among the initial members are Elihu Vedder, Julian Alden Weir, and William Merritt Chase.

In London, James Abbott McNeill Whistler sues critic John Ruskin for libel, winning the case, but enters bankruptcy in 1879 from the cost of the trial.

Congress passes the Electoral Commission Bill for recount of electoral votes.

The Reconstruction Era ends as federal troops are withdrawn from the South.

Thomas Edison invents the phonograph.

1878

James Hamilton dies in San Francisco.

William Trost Richards travels to London and Cornwall.

1879

Joseph Stella is born near Naples, Italy.

George Caleb Bingham dies.

Thomas Moran explores the Donner Pass and Lake Tahoe region of the Sierra Nevada, subsequently charting the Teton Range of Wyoming.

James Abbott McNeill Whistler travels to Venice, where he makes a series of watercolors, pastels, and etchings.

McKim, Mead and White, the most influential architectural firm in New York City for many years, is founded.

The "Duveneck boys," as Duveneck and his colleagues are known, move their academy from Munich to Italy, spending the winter in Florence and the summer in Venice.

Henry James: *Daisy Miller.*

Thomas Edison develops the electric light bulb.

The United States Geological Survey, led by Clarence King, consolidates large surveys.

1880

Arthur G. Dove is born in Canandaigua, N.Y.

Jonas Lie is born in Moss, Norway.

Sanford R. Gifford dies.

Frederic Remington travels West, prospecting and sketching.

William Louis Sonntag moves to New York City.

The U.S. population nears 50 million.

Andrew Carnegie produces the first large steel furnace.

The first practical electric lights are developed independently by the American Thomas Edison and Englishman Sir Joseph Wilson Swan.

1881

Winslow Homer visits Tynemouth, England, on the Atlantic Coast, where he stays until the following year.

Thomas Wilmer Dewing teaches at the Art Students League in New York City.

Homer Dodge Martin is commissioned by *Century Magazine* to make sketches of the English landscape. After a visit in England he travels to France the following year, remaining several years.

James A. Garfield is inaugurated President; he is assassinated in September and is succeeded by Vice President Chester Arthur.

1882

Edward Hopper is born in Nyack, N.Y.

George Bellows is born in Columbus, Ohio.

Albert Pinkham Ryder visits London and Paris, then Spain, Italy, and Switzerland.

Winslow Homer settles in Prout's Neck, Me., where he lives and paints for the rest of his life, traveling to the Adirondacks and Quebec in the summer, and to Florida, the Bahamas, and Bermuda in the winter.

Arthur B. Davies studies at The Art Institute of Chicago under Charles Corwin.

Thomas Eakins is named director of the Pennsylvania Academy of the Fine Arts.

1883

Alfred Stieglitz makes his first photographs in Germany.

Frederick Law Olmsted and Calvert Vaux develop a plan for the preservation of Niagara Falls and to build a park around it.

The U.S. Supreme Court rules that an American Indian is by birth an alien.

The first telephone connection is established between New York and Chicago.

"Buffalo Bill" Cody, frontiersman, organizes his "Wild West Show."

1884

In collaboration with the photographer Eadweard J. Muybridge, Thomas Eakins studies animal and human movement, utilizing sequential still photography.

Henry Ossawa Tanner studies with Eakins at the Pennsylvania Academy of the Fine Arts, remaining through 1888.

John Singer Sargent's portrait of *Madame Gautreau* (The Metropolitan Museum of Art, New York) causes a scandal at the Paris Salon.

David Howard Hitchcock meets Jules Tavernier, who encourages him to study painting.

Grover Cleveland is elected President of the United States.

Mark Twain: *Huckleberry Finn.*

1885

William Merritt Chase serves as President of the Society of American Artists.

Chase meets James Abbott McNeill Whistler in London.

Whistler attacks Ruskin and presents his views on art in his "Ten O'Clock Lecture" in London.

Maynard Dixon makes his first trip to the High Sierras. He

studies engravings by Frederic Remington and Howard Pyle published in the *Art Journal, Scribner's, Century Magazine,* and *Harper's Weekly.*

David Howard Hitchcock moves to San Francisco, where he studies under Virgil Williams at the San Francisco Art Association's School of Design.

Ulysses S. Grant dies.

George Eastman produces coated photographic paper.

Karl Marx: *Das Kapital* (second volume), published posthumously by Friedrich Engels.

1886

Asher B. Durand dies.

John La Farge travels to Japan and the South Seas, where he sketches and paints.

A major exhibition of French Barbizon and Impressionist paintings is organized in New York by the Parisian art dealer Paul Durand-Ruel; the exhibition is accepted by the critics.

Arthur B. Davies moves to New York, where he works as a magazine illustrator while attending classes at the Gotham Art School and the Art Students League.

James Abbott McNeill Whistler is elected President of the Society of British Artists in London, serving until 1888.

Frederic Remington illustrates Western subjects for *Harper's Weekly.*

Thomas Eakins resigns directorship of the Pennsylvania Academy of the Fine Arts after its board objects to his use of nude models in drawing classes.

The American Federation of Labor is founded.

General strikes are organized across the U.S. to demand an eight-hour day.

Hydroelectric installations are begun at Niagara Falls.

The Statue of Liberty is installed in New York.

1887

Georgia O'Keeffe is born in Sun Prairie, Wis.

Thomas Eakins visits North Dakota, where he paints cowboy and Western subjects.

Homer Dodge Martin returns to New York from abroad, and begins to use his French and English sketches in his paintings.

Edison and Swan collaborate to make Ediswan electrical lamps.

H. W. Goodwin invents celluloid film.

1888

Frank Duveneck returns to the U.S. and heads the Art Academy in Cincinnati.

Frederic Remington illustrates articles by Theodore Roosevelt about ranching life for *Century Magazine.*

Benjamin Harrison is elected President of the United States.

GEORGE INNESS
Niagara. 1893
Oil on canvas,
45¼ x 70⅛ in.
(114.9 x 177.9 cm.)
Hirshhorn Museum
and Sculpture Garden,
Smithsonian Institution,
Washington, D.C.

GEORGE INNESS
The Lackawanna Valley. 1855
Oil on canvas,
33⅞ x 50¼ in.
(86 x 127.5 cm.)
National Gallery of Art,
Washington, D.C.
Gift of
Mrs. Huttleston Rogers

JAMES ABBOTT
MCNEILL WHISTLER
*Nocturne in Black and Gold:
Entrance to Southampton Waters*
1876–77
Oil on canvas,
20 x 30 in.
(50.8 x 76.2 cm.)
The Art Institute of Chicago
Stickney Fund

JAMES ABBOTT
MCNEILL WHISTLER
Nocturne: Westminster
c. 1875–79
Oil on canvas,
$12\frac{1}{4}$ x $20\frac{1}{4}$ in.
(31.1 x 51.4 cm.)
John G. Johnson
Collection, Philadelphia

George Eastman develops the "Kodak" box camera.

1889

Maxfield Parrish studies at the Pennsylvania Academy of the Fine Arts under Thomas Anshutz.

John Singer Sargent travels from London to America, where he executes portrait commissions and works on mural decorations for the Boston Public Library.

North Dakota is admitted to the Union, followed by South Dakota, Montana, and Washington.

Oklahoma is opened to non-Indian settlement.

Mark Twain: *A Connecticut Yankee in King Arthur's Court.*

1890

Mark Tobey is born in Centerville, Wis.

David Howard Hitchcock travels to Paris, where he studies at the Académie Julian for three years.

Alfred Stieglitz manages a photoengraving company; experiments with hand-held cameras.

Frederic Remington records the Indian Wars.

James Abbott McNeill Whistler publishes *The Gentle Art of Making Enemies.*

Idaho and Wyoming are admitted to the Union.

The Sherman Antitrust Act is passed.

Emily Dickinson: *Poems,* published posthumously.

1891

Edwin Dickinson is born at Seneca Falls, N.Y.

McKim, Mead and White design Italian-Renaissance-style buildings for New York's Madison Square Garden, a multi-purpose sports arena, and The Century Association.

Maynard Dixon, impressed by Frederic Remington's illustrations of the Massacre at Wounded Knee, published in *Harper's Weekly* (December 29, 1890), sends Remington his sketchbooks; Remington encourages him to draw from nature.

Gottardo Piazzoni enters the California School of Design, where he studies under Raymond Yelland and Arthur F. Mathews.

William Trost Richards returns to Europe for an extended visit.

Henry Ossawa Tanner travels to Paris, where he studies with Benjamin Constant at the Académie Julian and spends the summer in Brittany. He will spend most of his life in France.

Emily Dickinson: *Poems* (second series).

Inception of wireless telegraphy.

1892

William Bradford dies.

William Merritt Chase begins teaching at his home at Shinnecock Hills, Long Island, N.Y.

John Sloan studies at the Pennsylvania Academy of the Fine Arts under Thomas Anshutz.

William Glackens, John Sloan, George Luks, and Everett Shinn meet in the studio of Robert Henri.

Grover Cleveland is elected President of the United States. The iron and steel workers strike.

1893

Charles Burchfield is born in Ashtabula Harbor, Ohio.

Milton Avery is born in Altmar, N.Y.

Worthington Whittredge travels to Mexico.

Arthur B. Davies, supported by patrons William Macbeth and Benjamin Altman, studies Venetian art in Italy.

Alfred Stieglitz becomes the editor of *The American Amateur Photographer,* continuing until 1896.

James Abbott McNeill Whistler settles in France, remaining until 1895.

Jonas Lie moves from Norway to New York, where he studies at the National Academy of Design and the Art Students League.

Maynard Dixon studies briefly at the California School of Design, San Francisco; he meets Raymond Yelland, the former director, whose work influences him. He makes his first sketching trip to Yosemite National Park.

Hawaii is proclaimed a republic.

Financial panic.

Henry Ford builds his first car.

The World's Columbian Exposition is held in Chicago.

1894

George Inness dies.

John Singer Sargent is elected an associate of the Royal Academy in London.

Homer Dodge Martin moves to St. Paul, Minn., where he lives until his death.

1895

Gottardo Piazzoni leaves for Paris during the summer to spend six months studying with Benjamin Constant, Henri Martin, and Paul Laurens.

Frederic Remington turns to sculpture, producing small bronzes that meet with popular success.

Cuba fights Spain for its independence.

The Chinese-Japanese War ends.

Stephen Crane: *The Red Badge of Courage.*

Henry James: *The Middle Years,* an autobiography.

Karl Marx: *Das Kapital* (third volume), published posthumously.

1896

William Trost Richards leaves Newport, R.I., for a four-year visit to Great Britain.

William Merritt Chase founds the Chase School (by 1900 known as the New York School of Art).

Henry Ossawa Tanner, praised by Jean-Léon Gérôme, wins honorable mention at the Paris Salon.

Gottardo Piazzoni enrolls at the Ecole des Beaux-Arts, Paris, under Gérôme; he remains for two years, returning to his father's ranch in Monterey, Calif., at the death of his mother and brother.

William McKinley is elected President of the United States.

Utah is admitted to the Union.

Frederic Remington and Richard Harding Davis are sent to Cuba by William Randolph Hearst to cover the uprising against Spain for the *New York Journal.*

Emily Dickinson: *Poems* (third series).

The Niagara Falls hydroelectric plant opens.

1897

Homer Dodge Martin dies.

Alfred Stieglitz becomes the editor of *Camera Notes,* the magazine of the recently founded Camera Club of New York.

Henry Ossawa Tanner travels to Egypt and Palestine. His *Raising of Lazarus* is awarded the Gold Medal at the Paris Salon, purchased by the French government, and hung in the Luxembourg Palace.

1898

The Ten American Painters is founded to organize group exhibitions of a smaller size and greater selectivity than those of the National Academy. Popularly known as "The Ten," the diverse group of Impressionists and tonalists include Frank Benson, Thomas Wilmer Dewing, Joseph De Camp, Childe Hassam, Willard Metcalf, Robert Reid, Edward Simmons, Edmund C. Tarbell, John H. Twachtman, and Julian Alden Weir.

Marsden Hartley studies art at the Chase School in New York and in the following year attends the National Academy of Design.

Frederic Remington returns to Cuba to cover the Spanish-American War for the *New York Journal.*

The battleship *Maine* is sunk by the Spanish in Havana harbor, and the Spanish-American War begins. Commodore Dewey, on orders from the assistant Secretary of the Navy, Theodore Roosevelt, destroys the Spanish fleet in Manila Bay. Late in the year a peace treaty is signed in Paris. The U.S. acquires Puerto Rico, Guam, and the Philippines and Cuba is guaranteed freedom.

Hawaii is annexed by the U.S.

1900

Jasper Francis Cropsey, Frederic Edwin Church, and William Louis Sonntag die.

Edward Hopper studies art at the New York School of Art under Robert Henri.

Marsden Hartley spends the first of many summers in Maine.

Gottardo Piazzoni returns to Europe with his family, traveling first to Switzerland, then to Paris.

Henry Ossawa Tanner receives a prize for his painting *Christ and Nicodemus* from the Pennsylvania Academy of the Fine Arts.

McKinley is reelected President; Theodore Roosevelt is elected Vice President.

Theodore Dreiser: *Sister Carrie.*

Sigmund Freud: *The Interpretation of Dreams.*

R. A. Fessenden transmits human speech via radio waves.

1901

William Trost Richards spends the summer in Norway.

President McKinley is assassinated at the Pan-American Exposition in Buffalo by an anarchist; he is succeeded by Theodore Roosevelt.

Cuba is made a U.S. protectorate.

J. P. Morgan organizes the U.S. Steel Corporation.

1902

Albert Bierstadt dies.

John Marin enrolls in the Art Students League, where he remains for two years.

Alfred Stieglitz founds Photo-Secession to show photography, treating it as "fine art."

Gottardo Piazzoni promotes the First Secessional Art Exhibition in protest against the San Francisco Art Association.

The U.S. Congress passes the Spooner Act enabling the government to build the Panama Canal.

Coal miners go on strike.

Henry James: *The Wings of the Dove.*

1903

Mark Rothko is born in Dvinsk, Russia.

Adolph Gottlieb is born in New York

James Abbott McNeill Whistler dies.

William Trost Richards spends the summer in Great Britain.

Arthur G. Dove graduates from Cornell University, Ithaca, N.Y.

Alfred Stieglitz publishes *Camera Work,* a quarterly, of which 50 numbers are published before its demise in 1917.

McKim, Mead and White design the Pennsylvania Railroad Station in New York.

The U.S. and Panama sign the Hay-Bunau-Varilla Treaty authorizing the building of the Panama Canal.

The Alaskan frontier is settled.

Henry James: *The Ambassadors.*

Edith Wharton: *Italian Villas,* with color illustrations by Maxfield Parrish.

Henry Ford founds the Ford Motor Company.

Wilbur and Orville Wright successfully fly an airplane.

1904

Arshile Gorky is born in Armenia.

Martin Johnson Heade dies.

Clyfford Still is born in Grandin, N. Dak. His family soon moves to Spokane, Wash.

Arthur G. Dove begins working in New York as a magazine illustrator.

George Bellows moves to New York, where he studies at the New York School of Art under Robert Henri.

Georgia O'Keeffe studies at The Art Institute of Chicago.

Arthur B. Davies and Philadelphia realists Robert Henri, George Luks, William Glackens, and John Sloan show their paintings at the National Arts Club, New York; they receive a hostile critical reaction.

Maynard Dixon travels to Mexico, living among the Indians and representing them in his work.

Theodore Roosevelt is elected President of the United States.

The Russo-Japanese War breaks out.

Henry James: *The Golden Bowl.*

Sigmund Freud: *The Psychopathology of Everyday Life.*

Max Weber: *The Protestant Ethic and the Birth of Capitalism.*

1905

Barnett Newman is born in New York.

William Trost Richards dies.

John Marin attends the Art Students League in New York, then travels to Paris.

Alfred Stieglitz and Edward Steichen found their avant-garde gallery at 291 Fifth Avenue, New York. "291" presents nearly 80 exhibitions of modern art before closing in 1917.

Maynard Dixon exhibits at the Bohemian Club, San Francisco, and sells his first painting, *Thunderheads.* During the year he also receives critical acclaim for his paintings of Indian lore at San Francisco's Sequoia Club show.

Gottardo Piazzoni travels to Rome, then goes on to Switzerland and France the next year.
Treaty of Portsmouth ends the Russo-Japanese War.
Sigmund Freud: *Three Contributions to the Theory of Sex.*
Albert Einstein develops the special theory of relativity, the law of mass-energy equivalence, and the photon theory of light.

1906

Eastman Johnson dies.
Joseph Stella works as a magazine illustrator in Pittsburgh, selecting subjects from the coal and steel industry.
Edward Hopper sketches city scenes in Paris.
Maynard Dixon loses most of his paintings in the San Francisco earthquake.
President Theodore Roosevelt visits the Panama Canal Zone.
U.S. troops occupy Cuba.
Frederick Jackson Turner: *The Rise of the New West.*
Upton Sinclair: *The Jungle,* exposing unsanitary conditions of the Chicago stockyards, resulting in passage of the U.S. Pure Food and Drugs Act.
Henry Adams: *The Education of Henry Adams.*
Earthquake in San Francisco kills 700.
New York population reaches 4 million.

1907

Mark Tobey studies at The Art Institute of Chicago.
Georgia O'Keeffe attends the Art Students League in New York under William Merritt Chase, F. Luis Mora, and Kenyon Cox.
Maynard Dixon moves to New York, remaining for five years and working as an illustrator.
Gottardo Piazzoni begins to receive mural commissions in San Francisco.
Pablo Picasso paints the *Demoiselles d'Avignon.*
Alfred Stieglitz visits Edward Steichen in Paris.
President Theodore Roosevelt bars Japanese immigration to the U.S.
Oklahoma is admitted to the Union.

1908

Alfred Thompson Bricher dies.
Arthur G. Dove travels to Paris and then to Cagnes. Influenced by Fauve art, he exhibits at the Salon d'Automne.
The Eight, a group of young painters including Robert Henri, John Sloan, George Luks, William Glackens, Everett Shinn, Maurice Prendergast, Ernest Lawson, and Arthur B. Davies, unite in opposition to the National Academy and exhibit together at the Macbeth Gallery in New York.

The first Matisse exhibition in America is held at gallery "291."
William Howard Taft is elected President of the United States.
Gertrude Stein: *Three Lives.*
The General Motors Corporation is founded, and the Ford Motor Company manufactures the Model "T."

1909

Frederic Remington dies.
Abbott Henderson Thayer publishes *Concealing Coloration in the Animal Kingdom,* a study of obliterative shading and concealing pattern that forms the basis of camouflage techniques for battle use.
Maynard Dixon travels to Idaho and Montana, one of his many trips to Indian reservations.
Joseph Stella travels to Italy.
Arthur G. Dove settles in New York, where he meets Stieglitz.
John Marin and Alfred Maurer exhibit together at "291."
Marsden Hartley is given his first one-man show at "291."
Sigmund Freud lectures in the U.S. on psychoanalysis.

1910

Morris Graves is born in Fox Valley, Ore.
Thomas Worthington Whittredge, Winslow Homer, and John La Farge die.
Stanton Macdonald-Wright meets Morgan Russell in Paris.
Exhibition of Independent Artists, New York, features the Eight.
John Marin is given a one-man show by Stieglitz's gallery, "291."
The exhibition *Younger American Painters* at "291" includes John Marin, Arthur G. Dove, Marsden Hartley, Edward Steichen, and Max Weber.
Pablo Picasso and Georges Braque develop Analytical Cubism.

1911

John Marin returns to the United States.
Gallery "291" exhibits Cézanne's watercolors and gives Picasso his first American one-man show.
Joseph Stella meets Italian Futurists and Picasso and Matisse in Paris.

1912

William Baziotes is born in Pittsburgh.
Jackson Pollock is born in Cody, Wyo.
Arthur G. Dove has a one-man show at Stieglitz's gallery, "291," including his abstractions and pastels called Nature Symbolized.

opposite: MAXFIELD PARRISH
The Spirit of Transportation. 1920
Oil on board, 35½ x 27½ in. (90.2 x 69.9 cm.)
Clark Equipment Company, Buchanan, Michigan

above: JONAS LIE
The Conquerors (Culebra Cut), Panama Canal. 1913
Oil on canvas, 59¾ x 49⅞ in. (151.8 x 126.7 cm.)
The Metropolitan Museum of Art, New York
George A. Hearn Fund, 1914

ALFRED THOMPSON BRICHER. *Morning at Grand Manan.* 1878. Oil on canvas,
25 x 50 in. (63.5 x 127 cm.). Indianapolis Museum of Art. Martha Delzell Memorial Fund

ALFRED THOMPSON BRICHER. *Indian Rock, Narragansett Bay.* 1871
Oil on canvas, 27 x 50¼ in. (68.6 x 127.7 cm.). Private collection

Gallery "291" exhibits Matisse sculpture.

Marsden Hartley and Charles Demuth meet in Paris.

Edwin Dickinson studies art under Charles W. Hawthorne at the Cape Cod School of Art in Provincetown.

Georgia O'Keeffe teaches art in Amarillo, Tex.

Joseph Stella returns to New York.

Camera Work publishes articles on Matisse and Picasso by Gertrude Stein

Wassily Kandinsky: *On the Spiritual in Art.*

New Mexico and Arizona are admitted to the Union.

Woodrow Wilson is elected President of the United States.

C. G. Jung: *The Theory of Psychoanalysis.*

R. F. Scott reaches the South Pole.

The S.S. *Titanic* sinks on its maiden voyage in a collision with an iceberg; 1,513 die.

1913

The American Synchromists Stanton MacDonald-Wright and Morgan Russell exhibit their paintings in Munich and Paris.

The International Exhibition of Modern Art (Armory Show) opens in New York in February, introducing European and American avant-garde art to the American public. Arthur B. Davies, Walt Kuhn, and Walter Pach make most of the selections. Among the artists on exhibition are Davies, George Bellows, Edward Hopper, Marsden Hartley, Jonas Lie, John Marin, Albert Pinkham Ryder, and Joseph Stella. Hopper sells his first picture from this show. The exhibition travels to Chicago and Boston.

The U.S. Federal Reserve System is established.

Sigmund Freud: *Totem and Taboo.*

Willa Cather: *O Pioneers!*

Robert Frost: *A Boy's Will.*

Henry Ford introduces the assembly line in his automobile factory.

1914

John Marin makes his first trip to Maine.

Marsden Hartley paints in Germany, where he becomes a friend of Franz Marc, the Expressionist painter.

Georgia O'Keeffe enrolls at Teachers College, Columbia University, to study with Arthur Wesley Dow.

Alfred Stieglitz begins publication of *291.*

Henry Bacon designs the Lincoln Memorial in Washington, D.C.

Gallery "291" shows the work of Braque, Picasso, and Brancusi.

Stanton Macdonald-Wright and Morgan Russell exhibit

Synchromist paintings at the Carroll Gallery, New York, the first American Synchromist show.

Pancho Villa leads an army against Mexico's dictator, President Victoriano Huerta; the U.S. almost goes to war with Mexico.

World War I: Archduke Francis Ferdinand of Austria is assassinated at Sarajevo; Austria declares war on Serbia; Germany declares war on Russia and France, and Britain declares war on Germany as that country invades Belgium in August.

The Panama Canal opens.

John B. Watson: *Behavior: An Introduction to Comparative Psychology.*

1915

Georgia O'Keeffe produces her first major works, a series of large abstractions in charcoal and landscapes in watercolor. Stieglitz exhibits them at "291" gallery the following year.

Italian Futurists exhibit at the Panama-Pacific Exposition in San Francisco and publish their manifesto in the catalogue.

Marcel Duchamp arrives in New York City, where he joins the Arensberg circle.

Joseph Stella meets Duchamp and Francis Picabia.

World War I: German submarines attack Le Havre, and the Germans blockade England; the *Lusitania* is sunk by a German U-boat; Italy joins the Allies: France, Russia, and Great Britain.

The first transcontinental telephone call is made between Thomas A. Watson in San Francisco and Alexander Graham Bell in New York.

1916

Thomas Eakins dies.

The *Forum Exhibition of Modern American Painters* at the Anderson Galleries, New York, a major exhibition of color abstractions, includes work by Arthur G. Dove, Marsden Hartley, and John Marin.

Charles Burchfield graduates from the Cleveland School of Art, and begins study in New York at the National Academy of Design.

Alfred Stieglitz exhibits work by Georgia O'Keeffe at "291" gallery. She meets Stieglitz after the show opens. O'Keeffe travels to Virginia and Texas.

World War I: First zeppelin raid on Paris; the Battle of Verdun is fought; Italy declares war on Germany.

Woodrow Wilson is reelected President; he sends American troops led by John J. Pershing into Mexico.

U.S. troops occupy Santo Domingo, the Dominican Republic, to settle a dispute.

John Dewey: *Democracy and Education.*

Carl Sandburg: *Chicago Poems.*

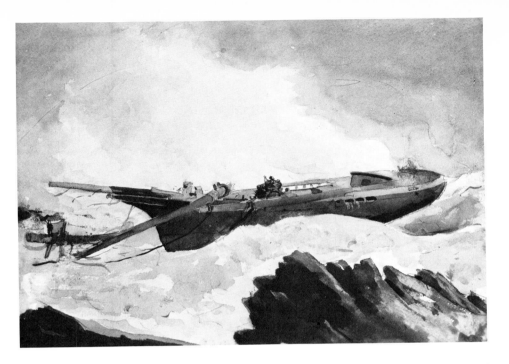

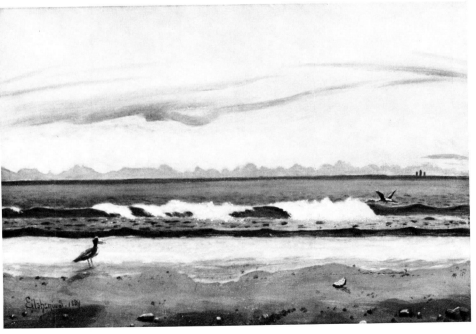

WINSLOW HOMER
The Wrecked Schooner
c. 1910
Watercolor,
15 x 21½ in.
(38.1 x 54.6 cm.)
The St. Louis
Art Museum

LOUIS MICHEL
EILSHEMIUS
Surf at Easthampton
1889
Oil on canvas,
14¼ x 20½ in.
(36.2 x 52.1 cm.)
Collection
Mr. and Mrs.
Meyer P. Potamkin

C. G. Jung: *Psychology of the Unconscious.*
Albert Einstein: *Relativity: The Special and General Theory.*

1917

Albert Pinkham Ryder dies.
Andrew Wyeth is born in Chadd's Ford, Pa.
Mark Tobey has his first one-man show at M. Knoedler & Co., New York.
The Society of Independent Artists, founded the previous fall by Marcel Duchamp, Katherine S. Dreier, Man Ray, George Bellows, John Covert, William Glackens, and Walter Pach, holds its first exhibition.
Georgia O'Keeffe has her first one-woman show at "291." The gallery closes in June.
The last issue of *Camera Work* appears.
World War I: The U.S. declares war on Germany; Germans withdraw on the Western Front.
Balfour Declaration on Palestine.
February Revolution in Russia; the Czar abdicates.
The eighteenth amendment (Prohibition) is passed by Congress.
Senate rejects the suffrage bill.
Sigmund Freud: *Introduction to Psychoanalysis.*

1918

Georgia O'Keeffe resigns from her Texas teaching job to paint full time.
The Whitney Studio Club is founded.
Duncan and Marjorie Phillips found the Phillips Collection in Washington, D.C.
Gottardo Piazzoni teaches landscape painting at the California School of Design.
World War I: President Wilson presents his 14 points for peace; the Allied offensive on the Western Front begins; the Armistice is signed between Germany and the Allies; war casualties: 8.5 million killed, 21 million wounded.
Assassination attempt on Lenin in Moscow.
Ex-Czar Nicholas II and family are executed.
The U.S. population is 103.5 million.
Willa Cather: *My Ántonia.*

1919

Ralph Albert Blakelock and Frank Duveneck die.
Adolph Gottlieb studies at the Art Students League under John Sloan and Robert Henri.
Marsden Hartley visits New Mexico, where he paints a series of landscapes.
The eighteenth amendment (Prohibition) is ratified.
President Woodrow Wilson presides over the first League of Nations meeting in Paris.

Germany signs Treaty of Versailles in Paris.
Third International is founded in Moscow.

1920

Arshile Gorky emigrates from Armenia to the United States. He studies at the Rhode Island School of Design and the New School of Design in Boston.
The Société Anonyme is founded in New York by Katherine S. Dreier with Man Ray and Marcel Duchamp.
Maynard Dixon marries documentary photographer Dorothea Lange.
Warren G. Harding is elected twenty-ninth President of the United States.
The Prohibition Enforcement Act (the Volstead Act), passed the previous year, goes into effect.
The nineteenth amendment gives the vote to American women.
The League of Nations begins in Paris; the Senate votes against U.S. membership.
Frederick Jackson Turner: *The Frontier in American History.*
Sinclair Lewis: *Main Street.*
Edith Wharton: *The Age of Innocence.*

1921

Abbott Handerson Thayer dies.

1922

Theodoros Stamos is born in New York City.
Mark Tobey moves to Seattle, where he teaches art.
Gottardo Piazzoni visits Italy, France, and Belgium.
Joseph Stella travels to Italy.
The Modernist Artists of America, Inc., is founded in New York.
Marsden Hartley travels to Berlin. He also visits Vienna, Florence, Arezzo, and Rome during the next year.
F. Scott Fitzgerald: *Tales of the Jazz Age* and *The Beautiful and the Damned.*

1923

Elihu Vedder dies.
Adolph Gottlieb studies at the Parsons School of Design, New York.
Joseph Stella returns to New York and lectures at the Société Anonyme.
Teapot Dome scandal hearings begin in Washington, D.C.

1924

Clyfford Still travels to New York.
Georgia O'Keeffe marries Alfred Stieglitz.
Mark Tobey, introduced to the Bahai World Faith and

interested in the Orient, begins to study Chinese calligraphy.
Woodrow Wilson dies.
Lenin dies.
The Harding administration is beset by scandals.
Calvin Coolidge wins a landslide victory for President of the United States.
Lewis Mumford: *Sticks and Stones,* a social history of architecture.

1925

George Bellows and John Singer Sargent die.
Mark Rothko moves to New York, having studied at Yale.
Clyfford Still visits New York for the first time, and returns to the West three months later.
Milton Avery moves to New York and begins his career as an artist.
Alfred Stieglitz directs the *Seven Americans* exhibition at the Anderson Galleries, New York, and exhibits paintings by John Marin, Marsden Hartley, Charles Demuth, Georgia O'Keeffe, and Arthur G. Dove, and photographs by himself and Paul Strand.
Stieglitz opens the Intimate Gallery, New York, where he shows the work of the seven artists again over the next three years.
Mark Tobey travels in Europe and in the next year visits the Near East.
The Scopes Trial: Prosecuted by William Jennings Bryant and defended by Clarence Darrow, Scopes is tried for teaching the theory of evolution.
F. Scott Fitzgerald: *The Great Gatsby.*
Gertrude Stein: *The Making of Americans.*
Theodore Dreiser: *An American Tragedy.*
John Dos Passos: *Manhattan Transfer.*
The New Yorker magazine begins publication.

1926

Thomas Moran dies.
A John Singer Sargent memorial exhibition is held at the Royal Academy, London.
Marsden Hartley lives near Aix-en-Provence for the next two years and studies the work of Cézanne.
Jackson Pollock begins study with Thomas Hart Benton at the Art Students League, New York.
The Supreme Court hears the case *Constantin Brancusi v. U.S. Bureau of Customs* on the issue of whether or not his *Bird in Space* is a work of art.
The Société Anonyme organizes the *International Exhibition of Modern Art* at the Brooklyn Museum, New York.
Ernest Hemingway: *The Sun Also Rises.*
John Maynard Keynes: *The End of Laissez-Faire.*

Hart Crane: *White Buildings.*
Kodak manufactures the first 16 mm movie film.

1927

Barnett Newman attends the Art Students League in New York City.

The Gallery of Living Art (Albert E. Gallatin Collection), exhibiting modern American and European art, opens at New York University.

Mark Tobey returns to Seattle from Europe, then divides his time between Seattle, New York, and Chicago.

Willa Cather: *Death Comes to the Archbishop.*

John Dewey: *The Public and Its Problems.*

Charles A. Lindbergh flies the "Spirit of St. Louis" nonstop from New York to Paris in 33½ hours.

1928

Arthur B. Davies dies.

Constantin Brancusi, aided by American art dealers and critics, wins court case against U.S. Bureau of Customs.

Morris Graves travels to the Orient as a seaman on a merchant ship.

Herbert Hoover wins the Presidency, defeating Alfred E. Smith.

Great Bull market; prices rise steeply.

Amelia Earhart is the first woman to fly across the Atlantic.

The first color motion pictures are shown by George Eastman in Rochester, N.Y.

1929

The Intimate Gallery, New York, closes.

Marsden Hartley spends the year in Paris and London.

Georgia O'Keeffe spends her first summer in Taos, N. Mex.

The Museum of Modern Art, New York, is founded by Lillie P. Bliss, Mrs. John D. Rockefeller, Jr., and Mrs. Cornelius J. Sullivan. Alfred H. Barr, Jr., is named director, and the museum opens with the exhibition *Cézanne, Gauguin, Seurat, van Gogh.* The second exhibition, *Paintings by 19 Living Americans,* includes works by Charles Burchfield, Edward Hopper, John Marin, and Georgia O'Keeffe.

Gottardo Piazzoni is commissioned to paint a series of murals for the San Francisco Public Library.

"Black Friday" in New York; stock market crashes.

William Faulkner: *The Sound and the Fury.*

Ernest Hemingway: *A Farewell to Arms.*

Thomas Wolfe: *Look Homeward Angel.*

John Dewey: *The Quest for Certainty.*

Richard E. Byrd, U.S. aviator, flies over the South Pole.

1930

Alfred Stieglitz opens the gallery An American Place, where he offers 75 exhibitions of American art before it closes in 1946.

Marsden Hartley returns to the U.S., living in New Hampshire.

Adolph Gottlieb has his first one-man show at Dudensing Galleries, New York.

Charles Burchfield: Early Watercolors 1916–1918 opens at The Museum of Modern Art, New York, in April.

Homer, Ryder, Eakins opens at the Museum in May.

The Museum of Modern Art acquires its first painting, Edward Hopper's *House by the Railroad.*

John Marin paints in Taos, N. Mex.

Unemployment mounts steadily to over 4 million.

The total national income falls from $81 billion in 1929 to $68 billion in 1930.

Hoover signs the Smoot-Hawley Tariff, raising tariffs to the highest point in American history.

1931

The Whitney Museum of American Art, New York, opens to the public.

1932

Morris Graves attends high school in Texas and receives his first painting instruction.

Marsden Hartley travels to Mexico and meets Mark Tobey there.

Gottardo Piazzoni receives critical acclaim for his San Francisco Public Library murals.

The Whitney Museum of American Art, New York, holds its First Biennial Exhibition of Contemporary American Paintings.

Stimson Doctrine warns against Japanese aggression in Manchuria.

Franklin Delano Roosevelt wins a landslide victory over Herbert Hoover; the expression "New Deal" appears.

The unemployed in the U.S. number 13.7 million; worldwide the number approaches 30 million.

William Faulkner: *Light in August.*

Ernest Hemingway: *Death in the Afternoon.*

1933

The Bauhaus is closed in Germany.

The Unemployed Artists Group is founded in New York.

Edward Hopper: Retrospective Exhibition opens at The Museum of Modern Art in October.

Hans Hofmann opens his art school in New York.

Clyfford Still begins teaching at the Washington State College.

CHARLES BURCHFIELD
Church Bells Ringing, Rainy Winter Night. 1917
Watercolor, 30 x 19 in. (76.2 x 48.3 cm.)
The Cleveland Museum of Art
Gift of Mrs. Louise M. Dunn,
in Memory of Henry G. Keller

above: JOSEPH STELLA
Tropical Sonata. 1920–21
Oil on canvas,
48 x 29 in. (121.9 x 50.8 cm.)
Whitney Museum of American Art, New York

opposite: JOSEPH STELLA
Tree of My Life. 1919
Oil on canvas,
83½ x 75½ in. (212.1 x 191.8 cm.)
Iowa State Education Association, Des Moines

Franklin Delano Roosevelt is inaugurated President.
The New Deal begins: the National Recovery Administration is launched, establishing minimum wages and maximum hours for workers; the Civilian Conservation Corps provides jobs for the unemployed.
Hitler is granted dictatorial powers in Germany.
Japan withdraws from the League of Nations.
C. G. Jung: *Psychology and Religion.*

1934

The Artists' Union is founded in New York, including approximately 200 artists. The official publication is *Art Front* (November 1934–December 1937).
Jonas Lie is elected President of the National Academy of Design, serving until 1939.
Marsden Hartley lives in New York and Bangor, Me., where he paints landscapes.
Mark Tobey visits the Far East for the first time.
Clyfford Still spends the summer at Saratoga Springs, N.Y., at the Trask Foundation and returns the following summer.
Whistler's *Portrait of the Artist's Mother* tours the U.S., appearing at The Museum of Modern Art.
The U.S.S.R. is admitted to the League of Nations.
Hitler and Mussolini meet in Venice; Hitler is voted Führer by German plebiscite.
F. Scott Fitzgerald: *Tender Is the Night.*

1935

Adolph Gottlieb travels to Europe, visiting museums in Paris and collecting African art.
Mark Tobey develops an early version of his calligraphic style.
The Whitney Museum of American Art organizes the exhibition *Abstract Painting in America.*
The exhibition *George Caleb Bingham, the Missouri Artist, 1811–1879,* opens at The Museum of Modern Art.
The Works Progress Administration is established, including the Federal Art Project, Federal Theater Project, and Federal Writers Project.
Jackson Pollock works on the WPA Federal Art Project; he becomes interested in the Mexican muralists.
Arshile Gorky begins work on the Newark Airport murals as part of the WPA Federal Art Project.
Maynard Dixon accompanies Dorothea Lange as she photographs migratory workers for the Resettlement Administration; he begins to include social commentary in his paintings.
Emergency Relief Appropriation Act is passed.
The C.I.O. is organized by John L. Lewis.

1936

American Abstract Artists organize in New York.
Marsden Hartley travels to Nova Scotia.
Arshile Gorky, Morris Graves, Adolph Gottlieb, and Mark Rothko work as easel painters on the WPA Federal Art Project.
At The Museum of Modern Art, Alfred H. Barr, Jr., organizes two important exhibitions: *Cubism and Abstract Art* (opening in March) and *Fantastic Art, Dada, Surrealism* (opening in December).
Julien Levy: *Surrealism,* first American publication of Surrealist art and literature.
John Marin: Watercolors, Oil Paintings, Etchings opens at The Museum of Modern Art in October.
President Roosevelt wins landslide victory.
Spanish Civil War begins.
Mussolini and Hitler proclaim the Rome-Berlin Axis.
Chiang Kai-Shek of China declares war on Japan.
J. M. Keynes: *General Theory of Employment, Interest and Money.*

1937

Henry Ossawa Tanner dies.
Andrew Wyeth has his first one-man show in New York.
Marsden Hartley paints Northeastern subjects after visits to Maine.
The *First Annual Exhibition of American Abstract Artists* is held at the Squibb Galleries, New York.
Andrew W. Mellon endows the National Gallery of Art in Washington, D.C.
The gallery An American Place, New York, organizes the show *Beginnings and Landmarks: "291," 1905–1917.*
The Japanese capture Peking; the Chinese Communists are led by Mao Tse-Tung and Chou En-Lai; Chung King becomes the new capital.
John Steinbeck: *Of Mice and Men.*
John Dos Passos: *U.S.A.*
Van Wyck Brooks: *The Flowering of New England.*
Amelia Earhart is lost during flight over the Pacific.
The Hindenburg disaster at Lakehurst, N.J., is described on a transcontinental radio broadcast. The dirigible bursts into flame as it reaches its mooring.

1938

Thomas Wilmer Dewing dies.
The Museum of Modern Art organizes the exhibition *Trois Siècles d'art aux Etats-Unis* for showing at the Jeu de Paume in Paris.

158

World War II: Hitler appoints himself War Minister, and Germany mobilizes; Prime Minister Chamberlain of Great Britain meets Hitler; Eden resigns in protest against Chamberlain's policy; Winston Churchill emerges as a leader; Roosevelt appeals to Hitler and Mussolini to stop aggression.

The 40-hour work week is established.

John Dewey: *Experience and Education.*

1939

The New York World's Fair opens.

A major Picasso retrospective is held at The Museum of Modern Art.

The Museum of Non-Objective Art, sponsored by Solomon R. Guggenheim, opens in New York.

World War II: Germany invades Poland; Britain and France declare war on Germany; Roosevelt proclaims U.S. neutrality; the U.S.S.R. invades Poland and Finland.

The U.S. economy moves from recession to prosperity.

John Steinbeck: *The Grapes of Wrath.*

1940

Jonas Lie dies.

The American Federation of Modern Painters and Sculptors is organized, asserting an internationalist view of art. Among its members are Milton Avery, Adolph Gottlieb, and Mark Rothko.

View, an American Surrealist publication, appears.

Morris Graves and Arshile Gorky are included in a traveling exhibition of Federal Art Project work by The Museum of Modern Art.

World War II: Germany invades Denmark and Norway; Winston Churchill becomes Prime Minister of Great Britain; Germany invades Belgium, Holland, and Luxembourg; the Battle of Dunkirk is fought; the Germans enter Paris; the Battle of Britain begins; Germany, Japan, and Italy sign pact; the Selective Service Act mobilizes the U.S. military; the London "Blitz" begins.

President Franklin Delano Roosevelt wins a third term.

Ernest Hemingway: *For Whom the Bell Tolls.*

Richard Wright: *Native Son.*

Thomas Wolfe: *You Can't Go Home Again.*

Carl Sandburg: *Abraham Lincoln: The War Years.*

The antibiotic penicillin is developed by Howard Florey.

1941

Louis Michel Eilshemius dies.

Adolph Gottlieb begins painting pictographs.

GOTTARDO PIAZZONI. *Silence.* c. 1910–13
Oil on panel, 26⅛ x 32¼ in. (66.4 x 81.9 cm.)
On loan to The Oakland Museum, Oakland, California, from
the M. H. de Young Memorial Museum, San Francisco
Gift of the Skae Fund Legacy

Peggy Guggenheim's Art of This Century gallery, designed by Frederick Kiesler, opens.

The National Gallery of Art, Washington, D.C., opens.

James Agee: *Let Us Now Praise Famous Men,* with photographs by Walker Evans, documents the life of tenant farmers in Alabama.

World War II: The Lend Lease Bill is signed; Germany mounts an offensive in North Africa; Stalin heads the Soviet Government; Germany invades Russia; Roosevelt and Churchill sign the Atlantic Charter; Japan bombs Pearl Harbor; Italy and Germany declare war on the U.S.

Manhattan Project for atomic research is begun.

Plutonium is discovered by two American scientists, Glenn T. Seaborg and Edwin McMillan.

1942

The Metropolitan Museum of Art, New York, organizes the *Artists for Victory,* a large exhibition of contemporary American art.

Wolfgang Paalen founds *Dyn.*

The exhibition *Artists in Exile* at the Pierre Matisse Gallery, New York, includes 14 artists who have come to America to live. They include Berman, Breton, Chagall, Ernst, Léger, Lipchitz, Masson, Matta, Mondrian, Ozenfant, Seligmann, Tanguy, Tchelitchew, and Zadkine.

The exhibition *First Papers of Surrealism,* organized by André Breton and Marcel Duchamp, opens at the Whitelaw Reid Mansion, New York. Among the Americans included is William Baziotes.

World War II: Rommel begins offensive; the Japanese take Singapore; Tokyo is bombed by General Doolittle; Americans win the Battle of Coral Sea; the Japanese are defeated at Midway; the Battle of Guadalcanal is fought; Germans arrive at Stalingrad; Jews are murdered in concentration camps; MacArthur becomes Commander-in-Chief in the Far East.

Enrico Fermi splits the atom.

The first U.S. jet plane is tested.

1943

Marsden Hartley and David Howard Hitchcock die.

Jackson Pollock's work appears in exhibition at Peggy Guggenheim's Art of This Century gallery, New York, in *Spring Salon for Young Painters;* he is later given a one-man show.

Adolph Gottlieb and Mark Rothko (anonymously assisted by Barnett Newman) send a letter to critic Edward Alden Jewell of the *New York Times* (printed June 13) presenting their aesthetic ideas, influenced by Surrealism and Jungian thought.

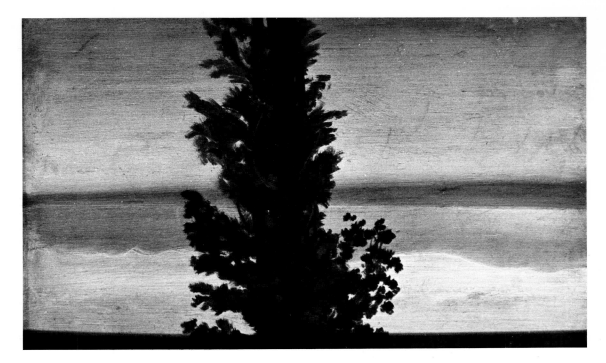

ARTHUR B. DAVIES. *Lake Tahoe.* c. 1914
Oil on panel, 5⅜ x 9⅜ in. (13.7 x 23.8 cm.). The Oakland Museum, Oakland, California
Gift of Concours d'Antiques, Art Guild, Oakland Museum Association

Clyfford Still is given a one-man show at the San Francisco Museum of Art.

Romantic Painting in America opens at The Museum of Modern Art, directed by James Thrall Soby and Dorothy Miller. Among the artists represented are Allston, Bellows, Bierstadt, Bingham, Blakelock, Burchfield (*Church Bells Ringing, Rainy Winter Night, The Night Wind,* and *The First Hepaticas*), Catlin, Church (*Cotopaxi*), Cole (*The Expulsion from Eden*), Cropsey, Davies, Dewing, Dickinson, Doughty, Duncanson, Durand (*Kindred Spirits*), Eakins, Eilshemius, Graves (*Snake and Moon, Little-Known Bird of the Inner Eye*), Hartley (*Evening Storm, Schoodic, Maine*), Heade (*Thunderstorm over Narragansett Bay*), Homer, Hopper, Inness, Johnson (*A Ride for Liberty—The Fugitive Slave*), La Farge, Marin, Moran, O'Keeffe (*Black Cross, New Mexico*), Remington, Sargent, Tobey, Vanderlyn, Whistler.

Frank Lloyd Wright begins his design for the Solomon R. Guggenheim Museum, New York.

World War II: Churchill and Roosevelt meet at Casablanca; the Russians defeat the Germans near Stalingrad; Hitler orders a "scorched-earth" policy; a Japanese convoy is sunk in the Battle of the Bismarck Sea; the Allies land in Sicily; Italy's surrender is announced by Eisenhower; Italy declares war on Germany; Roosevelt, Churchill, and Stalin hold the Teheran Conference; the Allies bomb Germany.

U.S. wage freeze; rationing of food.

1944

Adolph Gottlieb is elected President of the Federation of Modern Painters and Sculptors.

Sidney Janis assembles the exhibition *Abstract and Surrealist Art in America,* which circulates to five cities. Americans and Europeans are represented.

Mark Tobey has a one-man show at the Willard Gallery, New York.

World War II: the U.S. takes the Marshall and Solomon Islands; Berlin is bombed; the Allies take Rome; on D-Day, the Allies invade France; an assassination attempt on Hitler by German officers fails; the U.S. captures Guam; U.S. troops enter Germany and the Philippines; the Battle of the Bulge begins; Vietnam declares its independence from France; German General Rommel commits suicide.

Franklin Delano Roosevelt is elected for a fourth term as President; Harry S. Truman is elected Vice President.

1945

Gottardo Piazzoni dies.

A Mark Rothko exhibition is held at Peggy Guggenheim's Art of This Century gallery, New York.

An Arshile Gorky exhibition is held at the Julien Levy Gallery, New York.

The exhibition *A Problem for Critics,* organized by Howard Putzel, opens at 67 Gallery, New York. It includes works by Arshile Gorky, Adolph Gottlieb, Hans Hofmann, Lee Krasner, Mark Rothko, André Masson, Joan Miró, Pablo Picasso, and Hans Arp. It seeks to present "a new metamorphism" in American art.

World War II: Yalta Conference of Roosevelt, Churchill, and Stalin is held; the U.S. bombs Japan and Germany; Okinawa is won by the U.S.; the Russians arrive in Berlin; the United Nations Charter is signed and the League of Nations transfers its assets; Mussolini is assassinated; Hitler commits suicide; Germany surrenders; V.E. Day, May 8, brings the war to an end in Europe; the Potsdam Conference is held; the U.S. drops atomic bombs on Nagasaki and Hiroshima; Japan surrenders; war casualties number about 35 million; about 10 million die in Nazi concentration camps; the Nürnberg war-crimes trials begin.

1946

Arthur G. Dove, Maynard Dixon, and Joseph Stella die.

Clyfford Still has his first one-man show in New York at the Art of This Century gallery. In the fall he begins teaching at the California School of Fine Arts, San Francisco.

A fire in Arshile Gorky's Connecticut studio destroys 27 paintings, including 15 canvases painted the preceding year.

A Georgia O'Keeffe retrospective is held at The Museum of Modern Art in May.

The exhibition *Fourteen Americans* at The Museum of Modern Art includes the work of Arshile Gorky and Mark Tobey.

New York City becomes U.N. headquarters.

Winston Churchill delivers his "Iron Curtain" speech.

The Atomic Energy Commission is established by President Harry S. Truman.

Peace conference is held in Paris.

1947

The Art Institute of Chicago mounts the exhibition *Abstract and Surrealist American Art.*

Tiger's Eye, a quarterly magazine on contemporary literature and art, sponsored by John and Ruth Stephan, begins publication. Barnett Newman, Adolph Gottlieb, Mark Rothko, William Baziotes, and Theodoros Stamos are contributors.

The first, and only, issue of *Possibilities* appears; a magazine edited by Harold Rosenberg and Robert Motherwell, it is a forum for postwar ideas and art. William Baziotes, Jackson Pollock, and Mark Rothko are included in this issue. Pollock makes the statement, "the source of my painting is the unconscious."

Secretary of State Marshall cancels the exhibition *Advancing*

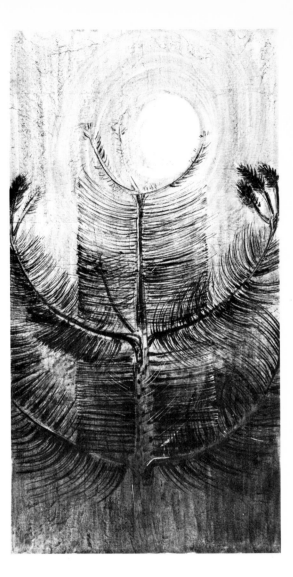

opposite: GEORGIA O'KEEFFE. *Orange and Red Streak.* 1919
Oil on canvas, 27¼ x 23¼ in. (69.2 x 59.1 cm.)
Collection Doris Bry, New York, for Georgia O'Keeffe

above: MORRIS GRAVES. *Joyous Young Pine.* 1944
Watercolor and gouache, 53⅝ x 27 in. (136.2 x 68.6 cm.)
The Museum of Modern Art, New York

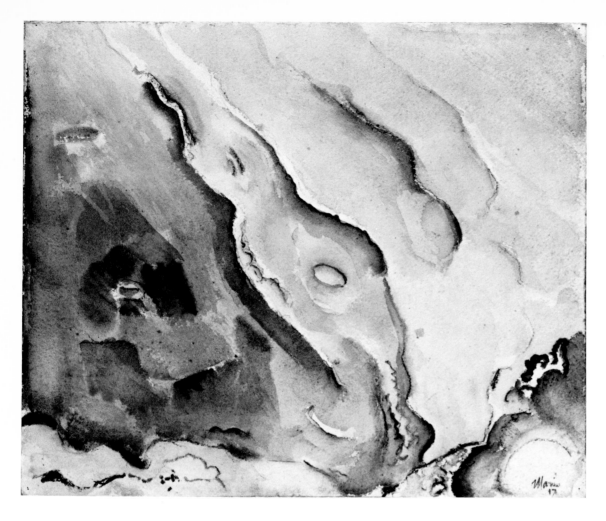

JOHN MARIN. *Palisades, Hudson River.* 1917
Watercolor, 16⅜ x 19½ in. (41.6 x 49.5 cm.)
Collection Lisa Marie Marin, courtesy Marlborough Gallery, New York

American Art, organized by the U.S. State Department for circulation abroad; members of the U.S. Congress accuse some of the artists shown of being Communist.
The McCarthy era begins.
The Taft-Hartley Act, restricting labor unions, is passed.

1948

Arshile Gorky dies.
The Club, founded by William Baziotes, David Hare, Robert Motherwell, Mark Rothko, and Clyfford Still, and called "The Subjects of the Artist," opens at 35 East Eighth Street, New York. Friday-evening lectures are open to the public.
"*Life* Round Table on Modern Art" is published in *Life* magazine (October 11). Clement Greenberg, Georges Duthuit, Sir Leigh Ashton, Francis Henry Taylor, Aldous Huxley, Alfred Frankenstein, James Johnson Sweeney, and A. Hyatt Mayor discuss work by Adolph Gottlieb, William Baziotes, Jackson Pollock, and other artists of the New York School.
Tiger's Eye (December 15) publishes "What Is Sublime in Art?" with contributions by Kurt Seligmann, Robert Motherwell, Barnett Newman, David Sylvester, Nicolas Calas, and John Stephan.
The Marshall Plan is passed by Congress.
The state of Israel is established.
The Berlin airlift begins.

1949

Augustus Vincent Tack dies.
Georgia O'Keeffe settles permanently near Abiquiu, N. Mex.
The Samuel M. Kootz Gallery, New York, opens the exhibition *The Intrasubjectives* (title from Ortega y Gasset), including work by Arshile Gorky, Adolph Gottlieb, Morris Graves, Mark Rothko, William Baziotes, and Mark Tobey.
Harry S. Truman is inaugurated President of the United States.
The North Atlantic Treaty is signed in Washington, D.C.
Chiang Kai-Shek steps down as President of China; Mao Tse-Tung and Chou En-Lai proclaim the Communist People's Republic of China.

1950

Barnett Newman has his first one-man show at the Betty Parsons Gallery, New York.
Clyfford Still moves to New York.
President Truman directs the Atomic Energy Commission to develop the hydrogen bomb.

1951

The ideas of the New York School are presented in a

three-day symposium at Studio 35, New York. Proceedings are published in *Modern Artists in America,* edited by Robert Motherwell, Ad Reinhardt, and Bernard Karpel.

Korean War: North Korean forces cross the thirty-eighth parallel.

The twenty-second amendment to the Constitution limits the Presidency to two terms.

1952

The exhibition *15 Americans* at The Museum of Modern Art includes the work of William Baziotes, Edwin Dickinson, Jackson Pollock, Mark Rothko, and Clyfford Still.

President Truman authorizes hydrogen-bomb tests in the Pacific.

Dwight D. Eisenhower is elected President of the U.S.

1953

John Marin dies.

The Korean armistice is signed at Panmunjon.

Stalin dies; he is succeeded by G. M. Malenkov; Khrushchev becomes First Secretary of the Communist Party.

Vietnamese insurgents attack Laos.

1956

Jackson Pollock dies.

Dwight D. Eisenhower is reelected President; Richard M. Nixon is elected Vice President.

Khrushchev denounces Stalin at the Twentieth Soviet Communist Party Conference.

Fidel Castro attempts to overthrow dictatorship of Fulgencio Batista in Cuba.

Martin Luther King emerges as civil rights leader.

1958

The New American Painting: As Shown in Eight European Countries, 1958–1959 is exhibited at The Museum of Modern Art at the conclusion of the tour. The artists are William Baziotes, James Brooks, Sam Francis, Arshile Gorky, Adolph Gottlieb, Philip Guston, Grace Hartigan, Franz Kline, Willem de Kooning, Robert Motherwell, Barnett Newman, Jackson Pollock, Mark Rothko, Theodoros Stamos, Clyfford Still, Bradley Walker Tomlin, and Jack Tworkov.

Desegregation attempts are made in Little Rock, Ark.

The European Common Market is formed.

1959

Paintings by Clyfford Still, a major retrospective, is held at The Buffalo Fine Arts Academy, Albright Art Gallery, Buffalo.

Alaska is admitted to the Union as the forty-ninth state.

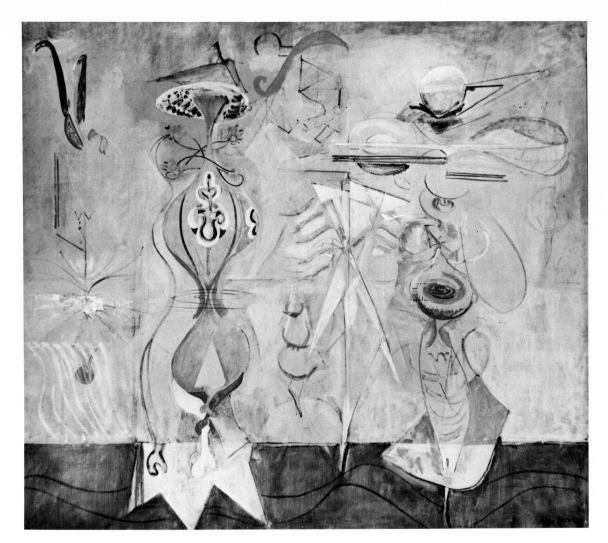

MARK ROTHKO. *Slow Swirl by the Edge of the Sea.* 1944
Oil on canvas, 75 x 84½ in. (190.5 x 214.6 cm.)
Estate of Mrs. Mark Rothko

Hawaii is admitted to the Union as the fiftieth state.
Fidel Castro becomes Premier of Cuba.
Charles de Gaulle assumes the Presidency of France.
Saul Bellow: *Henderson the Rain King*.

1961

A Mark Rothko retrospective is held at The Museum of Modern Art.
John F. Kennedy is inaugurated President of the U.S.

1962

Mark Tobey and Arshile Gorky retrospectives are held at The Museum of Modern Art.
Cuban missile crisis.
Telstar satellite is launched.
U.S. astronauts John Glenn, Scott Carpenter, and Walter Schirra orbit earth.
James Baldwin: *Another Country*.

1963

William Baziotes dies.
Civil-rights demonstrations take place in Birmingham, Ala. Martin Luther King is arrested by the police, and President Kennedy calls out National Guard to restore order.
The U.S. and the U.S.S.R. sign a nuclear-test-ban treaty.
President Kennedy is assassinated in Dallas on November 22; Vice President Lyndon Baines Johnson is sworn in as President.
Freedom March attracts 200,000 people to Washington, D.C., to demonstrate support for the civil-rights movement.

1964

Clyfford Still makes a gift of 31 paintings to the Albright-Knox Art Gallery, Buffalo.
Mr. and Mrs. John de Menil conceive a plan for a nondenominational chapel to be built in Houston, Tex., as a setting for a series of murals by Mark Rothko. The Institute of Religion and Human Development (called the Rothko Chapel) is completed in 1971.
Race riots occur in New York (Harlem) and in several other cities across the U.S. as blacks demand racial justice.
Vietnam War: A U.S. destroyer is allegedly attacked off North Vietnam; U.S. aircraft attack North Vietnam bases in reprisal; war escalates.
Martin Luther King wins the Nobel Peace Prize.
New York World's Fair opens.
Lyndon B. Johnson is elected President; Hubert H. Humphrey is elected Vice President.

1965

Milton Avery dies.
The Los Angeles County Museum of Art exhibition *New York School* includes work by William Baziotes, Arshile Gorky, Adolph Gottlieb, Barnett Newman, Jackson Pollock, Mark Rothko, and Clyfford Still.
Martin Luther King leads civil-rights demonstrators from Selma to Montgomery, Ala. Race riots occur in the Watts district of Los Angeles.
American demonstrations against the Vietnam War continue in Washington, D.C., and other U.S. cities.
U.S. Astronaut Edward White completes 21-minute space walk during Gemini flight.

1966

Maxfield Parrish dies.
A 48-hour Christmas truce is called in the Vietnam War.
The U.S. spacecraft Surveyor I lands on moon and sends TV images of the terrain back to earth. In the Gemini 12 mission, Edwin E. Aldrin steps outside of spacecraft for 129 minutes.

1967

Charles Burchfield and Edward Hopper die.
A Jackson Pollock retrospective is held at The Museum of Modern Art.
Six-day war between Israel and Arab nations.
Vietnam War: The U.S. bombs Hanoi; 50,000 people demonstrate in Washington, D.C., against the war.
The twenty-fifth amendment to the Constitution is ratified, providing for presidential appointment of the vice president if the position is vacated.
President Lyndon B. Johnson appoints the first black, Thurgood Marshall, to the Supreme Court.

1968

The exhibition *Dada, Surrealism, and Their Heritage* at The Museum of Modern Art includes work by William Baziotes, Adolph Gottlieb, Barnett Newman, Jackson Pollock, Mark Rothko, and Theodoros Stamos.
An Adolph Gottlieb retrospective is held at The Solomon R. Guggenheim Museum and the Whitney Museum of American Art in New York.
Vietnam War: Vietcong hit 30 South Vietnamese provincial capitals in Tet offensive.
Protests against the war continue across the U.S.
President Johnson announces he will not seek another term in office.
Martin Luther King, civil-rights leader, is assassinated in a Memphis motel.

Preliminary Vietnam peace talks begin in Paris.
Senator Robert F. Kennedy is assassinated in Los Angeles.
The Democratic National Convention in Chicago is the scene of violence over the Vietnam issue.
Richard M. Nixon is elected President of the U.S. by a narrow margin.
Apollo 7, with three men aboard, orbits the earth for eleven days.
Apollo 8, with three men aboard, orbits the moon.

1969

The exhibition *The New American Painting and Sculpture: The First Generation* opens at The Museum of Modern Art in June. Among the artists represented are William Baziotes, Arshile Gorky, Adolph Gottlieb, Barnett Newman, Jackson Pollock, Mark Rothko, Theodoros Stamos, and Clyfford Still.
Vietnam War: President Richard M. Nixon withdraws 75,000 troops; in one week, more than a hundred U.S. combat deaths are reported. U.S. Army Staff Sgt. David Mitchell and Lt. William Calley are ordered to stand trial on murder charges for massacre of civilians at Mylai.
Thousands of people in many U.S. cities participate in Moratorium Day on October 15 to demonstrate their opposition to the war.
Representatives of 39 nations meet in Rome to survey pollution of the seas.
U.S. spacecraft Apollo II lands on the moon on July 20. Neil A. Armstrong becomes the first man to set foot on the moon.

1970

Barnett Newman and Mark Rothko die.
The exhibition *New York Painting and Sculpture: 1940–1970* at The Metropolitan Museum of Art, New York, includes work by Milton Avery, Arshile Gorky, Adolph Gottlieb, Edward Hopper, Barnett Newman, Jackson Pollock, Mark Rothko, and Clyfford Still.
Vietnam War: The U.S. reduces troop strength in Vietnam to below 400,000 men. Meanwhile, President Nixon sends men into Cambodia to destroy enemy bases.
Kent State University, Ohio: four students are killed by the National Guard during a student protest over the Cambodian operation.
Widespread unrest on campuses continues.
Earth Day is celebrated.

1971

The Rothko Chapel, begun in 1964, opens in Houston.
The Museum of Modern Art mounts a major Barnett New-

man retrospective. The exhibition is later seen in Amsterdam, London, and Paris.

The twenty-sixth amendment to the Constitution is passed, lowering the voting age in all elections to eighteen.

Earthquake in Los Angeles kills 60 and causes $1 billion damage.

Vietnam War: The U.S. planes bomb Vietcong supply routes in Cambodia; fighting spreads to Laos and Cambodia; large-scale bombing raids are conducted by the U.S. against North Vietnam.

The "Pentagon Papers," classified documents on U.S. involvement in Vietnam, are published in the *New York Times*.

Domestic inflation worsens and President Nixon orders a 90-day freeze on wages and prices.

Paris peace talks end their second full year without progress toward peace in Vietnam.

1972

President Nixon visits China.

A constitutional amendment is passed banning discimination against women.

The Watergate break-in takes place.

President Nixon wins a landslide victory for reelection to the Presidency.

Vietnam Paris peace talks continue, and Secretary of State Henry Kissinger states: "Peace is at hand." The U.S. mines Vietnamese ports.

1973

The exhibition *American Art at Mid-Century* at the National Gallery of Art, Washington, D.C., places on exhibition its first acquisitions of Abstract Expressionist art. Among the artists included are William Baziotes, Arshile Gorky, Adolph Gottlieb, Barnett Newman, Jackson Pollock, Mark Rothko, Clyfford Still, and Mark Tobey.

Watergate: the Senate sets up an investigation committee; President Nixon appoints a special Watergate prosecutor, Archibald Cox, then discharges him; the Attorney General resigns; serious talk begins about impeachment of the President.

Vice President Spiro Agnew resigns.

Vietnam War: A ceasefire is signed in January. U.S. combat casualties: 45,948 dead, and 303,640 wounded.

Arab States place embargo on oil shipments to U.S.

1974

Adolph Gottlieb dies.

World-wide inflation increases and economic growth slows.

Watergate: Former White House aides are convicted in Watergate coverup; tapes reveal the President's involvement; three articles of impeachment are presented by the House Judiciary Committee; Nixon resigns and Gerald R. Ford, Vice President, becomes the thirty-ninth President.

Former President Nixon is pardoned by President Ford.

President Ford grants limited amnesty to Vietnam deserters and draft evaders.

Skylab 3 astronauts set record: spend 84 days in space.

1975

Major exhibitions of American art anticipating the Bicentennial:

Era of Exploration: The Rise of Landscape Photography in the American West, 1860–1885, organized by The Metropolitan Museum of Art, New York, and the Albright-Knox Art Gallery, Buffalo.

Heritage of American Art: Paintings from the Collection of The Metropolitan Museum of Art, organized by The American Federation of Arts for circulation in the United States.

Seascape and the American Imagination, Whitney Museum of American Art, New York.

1976

Mark Tobey dies.

Clyfford Still presents 28 of his paintings to the San Francisco Museum of Modern Art, which places them on permanent exhibition.

The American Bicentennial begins. Museums across the country organize special exhibitions of American art. Among them are:

America as Art, National Collection of Fine Arts, Washington, D.C.

American Art: An Exhibition from the Collection of Mr. and Mrs. John D. Rockefeller 3rd, M. H. de Young Memorial Museum, San Francisco, and Whitney Museum of American Art, New York.

American Art in the Making: Preparatory Studies for Masterpieces of American Painting 1800–1900, organized by the Smithsonian Institution, Washington, D.C., for circulation in the United States.

American Art, 1750–1800: Towards Independence, Yale University Art Gallery, New Haven, Conn., and The Victoria and Albert Museum, London.

American Art since 1945, organized by The Museum of Modern Art, New York, for circulation in the United States.

American Marine Painting, Virginia Museum, Richmond.

American Master Drawings and Watercolors, organized by The American Federation of Arts for circulation in the United States.

The European Vision of America, The Cleveland Museum of Art, National Gallery of Art, Washington, D.C., and the Réunion des Musées Nationaux, Paris.

The Eye of Thomas Jefferson, National Gallery of Art, Washington, D.C.

The Golden Door: Artist Immigrants of America, 1876–1976, Hirshhorn Museum and Sculpture Garden, Washington, D.C.

Heritage and Horizon: American Painting 1776–1976, Albright-Knox Art Gallery, Buffalo, The Detroit Institute of Art, The Cleveland Museum of Art, and The Toledo Museum of Art.

Philadelphia: Three Centuries of American Art, Philadelphia Museum of Art.

Two Hundred Years of American Art, organized by the Baltimore Museum of Art and circulated abroad by the United States Information Service to Bonn, Warsaw, Belgrade, and Rome.

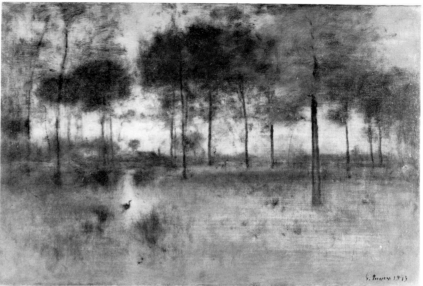

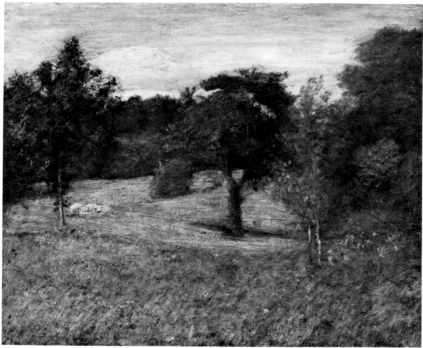

opposite left above:
THOMAS EAKINS. *The Meadows, Gloucester, N.J.* c. 1882
Oil on canvas, 32¼ x 45¼ in. (81.9 x 114.9 cm.)
Philadelphia Museum of Art. The Thomas Eakins Collection

opposite left below:
ALBERT PINKHAM RYDER. *Weir's Orchard.* c. 1885–90
Oil on canvas, 17⅛ x 21 in. (43.5 x 53.3 cm.)
Wadsworth Atheneum, Hartford
The Ella Gallup Sumner and Mary Catlin Sumner Collection

opposite right above:
GEORGE INNESS. *The Home of the Heron.* 1893
Oil on canvas, 30 x 45 in. (76.2 x 104.3 cm.)
The Art Institute of Chicago
Edward B. Butler Collection

opposite right below:
HENRY OSSAWA TANNER. *Abraham's Oak.* c. 1897
Oil on canvas, 21¼ x 28⅜ in. (54 x 72 cm.)
Frederick Douglass Institute,
Museum of African Art, Washington, D.C.

right above:
WILLIAM TROST RICHARDS. *Landscape.* 1860
Oil on canvas, 17 x 23¼ in. (43.1 x 58.7 cm.)
Yale University Art Gallery, New Haven, Connecticut
Gift of Mrs. Nigel Cholmeley-Jones

right below:
MARTIN JOHNSON HEADE. *View from Fern Tree Walk, Jamaica.* 1887
Oil on canvas, 53 x 96 in. (134.7 x 243.8 cm.)
Collection Mr. and Mrs. Patrick A. Doheny, Los Angeles

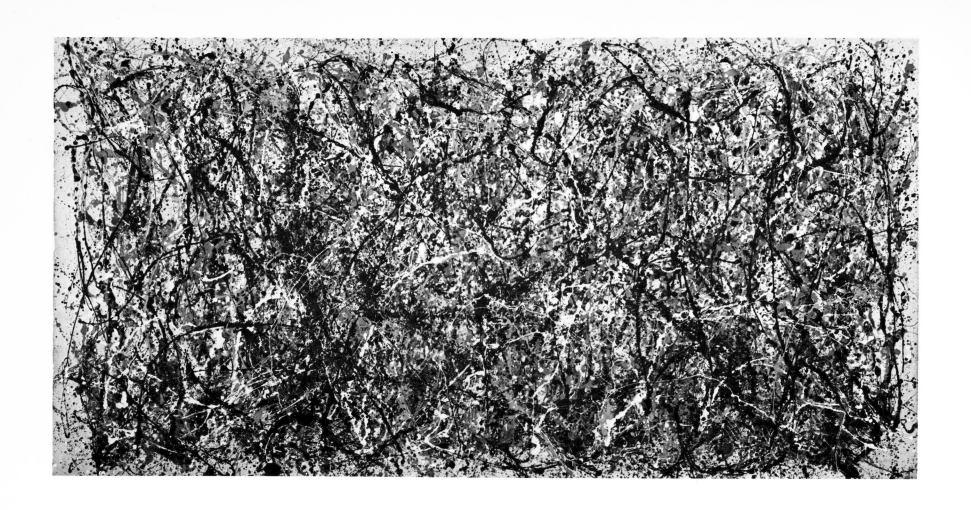

JACKSON POLLOCK. *One (Number 31, 1950)*. 1950
Oil and enamel on canvas, 106 x 209⅝ in. (269.2 x 532.5 cm.)
The Museum of Modern Art, New York. Gift of Sidney Janis

SELECTED BIBLIOGRAPHY

ROBERT S. DUNCANSON. *Land of the Lotos-Eaters.* 1861
Oil on canvas, $52\frac{3}{4}$ x $88\frac{5}{8}$ in. (134 x 225 cm.)
His Majesty, the King of Sweden

THIS BIBLIOGRAPHY is not intended to be comprehensive. Many of the publications cited here provide bibliographies that will guide the reader to other valuable material. Primary source material exists in collections such as the Archives of American Art and The New-York Historical Society.

This list is divided in three sections, the first providing the most general information about the artists represented; the second containing cultural and intellectual histories as well as surveys of American art, critical writings, and exhibition catalogues; and the third containing specific references for each artist illustrated here.

Mary Davis

DICTIONARIES AND ENCYCLOPEDIAS

The Britannica Encyclopedia of American Art. New York: Chanticleer Press, 1973.

Clement, Clara Erskine, and Hutton, Laurence. Artists of the Nineteenth Century and Their Works. Boston, 1879. Rev. ed., Boston and New York: Houghton Mifflin, 1884.

Cummings, Paul. A Dictionary of Contemporary American Artists. New York: St. Martins Press, 1971.

Dunlap, William, History of the Rise and Progress of the Arts of Design in the United States. 2 vols. New York, 1834. Rev. ed., edited by Rita Weiss. 3 vols. New York: Dover, 1969.

Fielding, Mantle. Dictionary of American Painters, Sculptors, and Engravers. Philadelphia: Lancaster Press, 1926.

Groce, George C., and Wallace, David H. The New-York Historical Society's Dictionary of Artists in America, 1564–1860. New Haven, Conn.: Yale University Press, 1957.

Tuckerman, Henry T. Book of the Artists. New York: Putnam, 1867. New York: Reprint, James F. Carr, 1966.

BOOKS, EXHIBITION CATALOGUES, AND ARTICLES

Alloway, Lawrence. Topics in American Art since 1945. New York: Norton, 1975.

Art in America (New York), Jan.–Feb. 1976. American Landscape Issue.

Ashton, Dore. The New York School: A Cultural Reckoning. New York: Viking, 1973.

_____. The Unknown Shore: A View of Contemporary Art. Boston and Toronto: Little, Brown, 1962.

Atlanta. The High Museum of Atlanta. The Beckoning Land, Nature and the American Artist: A Selection of Nineteenth Century Paintings. Apr. 17–June 13, 1971. Text by Donelson F. Hoopes.

_____. The Düsseldorf Academy and the Americans: An Exhibition of Drawings and Watercolors. Sept. 23–Oct. 28, 1973. Shown earlier at the Munson-Williams-Proctor Institute, Utica, N.Y., and the National Collection of Fine Arts, Washington, D.C.

Baur, John. I. H. "American Luminism," Perspectives (New York), Autumn 1954, pp. 90–98.

_____. Revolution and Tradition in Modern American Art. Cambridge, Mass.: Harvard University Press, 1951.

Bermingham, Peter. American Art in the Barbizon Mood. Washington, D.C.: National Collection of Fine Arts, Smithsonian Institution Press, 1975.

Billington, Ray A. The Far Western Frontier, 1830–1860. New York: Harper and Row, 1956.

Born, Wolfgang. American Landscape Painting: An Interpretation. New Haven, Conn.: Yale University Press, 1948.

Boston. The Museum of Fine Arts. M. and M. Karolik Collection of American Paintings 1815 to 1865. Essay by John I. H. Baur, Introduction by Maxim Karolik, Foreword by G. H. Edgel. Cambridge, Mass.: Harvard University Press, 1949.

Boyle, Richard J. American Impressionism. Boston: New York Graphic Society, 1974.

Brown, Milton W. American Painting from the Armory Show to the Depression. Princeton, N.J.: Princeton University Press, 1955.

_____. The Story of the Armory Show. New York: The Joseph H. Hirshhorn Foundation, distributed by New York Graphic Society, 1963.

Brooks, Van Wyck. The Dream of Arcadia: American Writers and Artists in Italy, 1760–1915. New York: Dutton, 1958.

_____. The Flowering of New England. New York: Dutton, 1936. Reprint, New York, 1952.

Buffalo. Albright-Knox Art Gallery. Heritage and Horizon: American Painting 1776–1976. Mar. 6–Apr. 11, 1976. Jointly organized by and circulated to The Detroit Institute of Arts, The Toledo Museum of Art, and The Cleveland Museum of Art.

Burke, Edmund. A Philosophical Enquiry into the Origin of Our Ideas of the Sublime and Beautiful. London, 1757. 2d ed., London, 1759. Annotated edition based on 2d ed., edited by James T. Boulton. South Bend, Ind.: University of Notre Dame Press, 1968.

The Cleveland Museum of Art. The European Vision of America. Text by Hugh Honour. Exhibition organized with the collaboration of the National Gallery of Art, Washington, D.C., and the Réunion des Musées Nationaux, Paris. 1975–77.

Coke, Van Deren. The Painter and the Photograph. Albuquerque: University of New Mexico Press, 1964.

Dallas Museum of Fine Arts. The Romantic Vision in America. Oct. 9–Nov. 28, 1971. Introduction by John Lunsford.

The Detroit Institute of Arts. The World of the Romantic Artist: A Survey of American Culture from 1800 to 1875. Dec. 28, 1944–Jan. 28, 1945. Text by E. P. Richardson.

Düsseldorf. Kunstmuseum. The Hudson and the Rhine: Die Amerikanische Malerkolonie in Düsseldorf im 19. Jahrhundert. Apr. 4–May 16, 1976. Introduction by Wend von Kalnein.

Flexner, James Thomas. American Painting: First Flowers of Our Wilderness. Boston: Houghton Mifflin, 1947.

_____. American Painting: The Light of Distant Skies, 1760–1835. New York: Harcourt, Brace, 1954.

_____. Nineteenth Century American Painting. New York: Putnam, 1970.

_____. That Wilder Image: The Painting of America's Native School from Thomas Cole to Winslow Homer. Boston: Little, Brown, 1962.

Geldzahler, Henry. American Painting in the Twentieth Century. New York: The Metropolitan Museum of Art, distributed by New York Graphic Society, 1965.

_____. New York Painting and Sculpture, 1940–1970. New York: Dutton, in association with The Metropolitan Museum of Art, 1969.

Goodrich, Lloyd. A Century of American Landscape Painting, 1800 to 1900. New York: Whitney Museum of American Art, 1938.

Greenberg, Clement. "'American-Type' Painting," Partisan Review (New Brunswick, N.J.), Spring 1955, pp. 179–96. Reprinted in Greenberg. Art and Culture: Critical Essays. Boston: Beacon, 1961.

Harris, Neil. The Artist in American Society: The Formative Years, 1790–1860. New York: Braziller, 1966. Reprint, New York: Simon and Schuster, 1970.

Honour, Hugh. The New Golden Land: European Images of

ALBERT PINKHAM RYDER. *Macbeth and the Witches.* c. 1890–1908
Oil on canvas, 28¼ x 35¾ in. (71.8 x 90.9 cm.)
The Phillips Collection, Washington, D.C.

America from the Discoveries to the Present Time. New York: Random House, 1975.

Howat, John K. *The Hudson River and Its Painters.* New York: Viking, 1972.

Hunter, Sam, and Jacobus, John. *American Art of the 20th Century: Painting, Sculpture, Architecture.* New York: Abrams, 1974.

Hussey, Christopher. *The Picturesque.* Hamden, Conn.: Archon, 1967.

Huth, Hans. *Nature and the American.* Berkeley: University of California Press, 1957. Reprint, Lincoln: University of Nebraska Press, 1972.

Jackson, William H. *The Pioneer Photographer.* Yonkers-on-Hudson, N.Y.: World Book, 1929.

Jarves, James Jackson. *The Art-Idea.* New York: Hurd and Houghton, 1864. Reprint, edited by Benjamin Rowland, Jr. Cambridge, Mass.: Harvard University Press, 1960.

Jones, Agnes Halsey. *Hudson River School.* Geneseo, N.Y.: State University of New York, 1968.

Journals of Ralph Waldo Emerson. Edited by E. W. Emerson and W. E. Forbes. 10 vols. Boston: Houghton Mifflin, 1909–1914.

Kootz, Samuel M. *Modern American Painters.* New York: Brewer and Warren, 1930.

Kouwenhoven, John A. *Made in America.* Garden City, N.Y.: Doubleday, 1948. Reprint, New York: Doubleday, Anchor, 1962.

Lanman, Charles. *Letters from a Landscape Painter.* Boston: J. Munroe, 1845.

Larkin, Oliver W. *Art and Life in America.* New York: Holt, Rinehart, and Winston, 1949. Rev. ed., 1960.

Lewis, Richard W. *The American Adam.* Chicago: The University of Chicago Press, 1955.

Lindquist-Cock, Elizabeth. "The Influence of Photography on American Landscape Painting, 1839–1880." Unpublished Ph.D. dissertation, New York University, 1968.

McCoubrey, John W. *American Art, 1700–1960: Sources and Documents.* Englewood Cliffs, N.J.: Prentice Hall, 1965.

Marx, Leo. *The Machine in the Garden: Technology and the Pastoral Ideal in America.* New York: Oxford University Press, 1964. Reprint, 1972.

Matthiessen, F. O. *American Renaissance: Art and Experience in the Age of Emerson and Whitman.* New York: Oxford University Press, 1941.

Miller, Perry. *The American Transcendentalists.* New York: Doubleday, Anchor, 1957.

———. *Errand into the Wilderness.* Cambridge, Mass.: Harvard University Press, 1956. Reprint, 1975.

———. *Nature's Nation.* Cambridge, Mass.: Belknap Press, 1967.

Muir, John. *Our National Parks.* Boston: Houghton Mifflin, 1909.

Naef, Weston J., and Wood, James N. *Era of Exploration: The Rise of Landscape Photography in the American West, 1860–1885.* Boston: New York Graphic Society, 1974.

Nash, Roderick. *Wilderness and the American Mind.* New Haven, Conn.: Yale University Press, 1967. Rev. ed., 1973.

Newhall, Beaumont. *The Daguerreotype in America.* New York: Duell, Sloan and Pearce, 1961.

———. *The History of Photography from 1839 to the Present Day.* 4th, rev. ed. New York: The Museum of Modern Art, 1964. 1st ed., 1937; 2d ed., 1938; 3d ed., 1949.

New York. The American Federation of Arts and The Metropolitan Museum of Art. *The Heritage of American Art: Paintings from the Collection of The Metropolitan Museum of Art.* Sept. 1975–Sept. 1976. Essay by John K. Howat and Natalie Spassky; catalogue and biographies by Mary Davis. Circulated to Dallas Museum of Fine Arts, Denver Art Museum, Des Moines Art Center, and The Minneapolis Institute of Arts.

New York. The Metropolitan Museum of Art. *American Paintings: A Catalogue of the Collection of The Metropolitan Museum of Art. Vol. I: Painters Born by 1815.* 1965. Albert TenEyck Gardner and Stuart P. Feld, eds.

———. *19th-Century America: Paintings and Sculpture; An Exhibition in Celebration of the Hundredth Anniversary of The Metropolitan Museum of Art.* Apr. 16–Sept. 7, 1970. Texts by John K. Howat, John Wilmerding, and Natalie Spassky.

New York. The Museum of Modern Art. *The New American Painting: As Shown in Eight European Countries, 1958–1959.* May 28–Sept. 8, 1959.

———. *The Photographer and the American Landscape.* Sept. 24–Dec. 1, 1963. Text by John Szarkowski.

———. *Romantic Painting in America.* Nov. 17, 1943–Feb. 6, 1944. Texts by James Thrall Soby and Dorothy C. Miller.

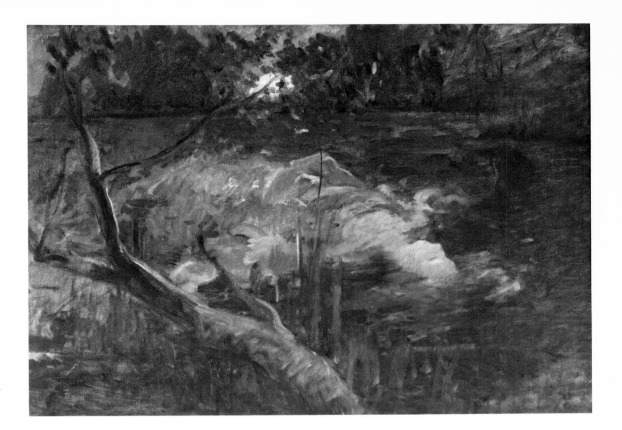

FRANK DUVENECK. *Ophelia.* c. 1885–90
Oil on canvas, 21¼ x 30¼ in. (54 x 76.8 cm.)
Collection Mr. and Mrs. Frank Duveneck, Los Altos Hills, California

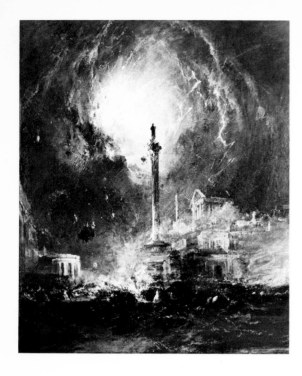

JAMES HAMILTON
The Last Days of Pompeii. 1864
Oil on canvas, 60⅛ x 48⅛ in. (152.8 x 122.2 cm.)
The Brooklyn Museum, New York
Dick S. Ramsay Fund

New York. Queens County Art and Cultural Center. *19th-Century American Landscape.* Nov. 10-Dec. 10, 1970. By Mary Davis and John K. Howat. Also shown at The Metropolitan Museum of Art, New York; Memorial Art Gallery of the University of Rochester, Rochester, N.Y.; and the Sterling and Francine Clark Art Institute, Williamstown, Mass., in 1973.

New York. Whitney Museum of American Art. *The 1930's: Painting and Sculpture in America.* Oct. 15-Dec. 1, 1968. Text by William C. Agee.

Novak, Barbara. "American Landscape: The Nationalist Garden and the Holy Book," *Art in America* (New York), Jan.-Feb. 1972, pp. 46-58.

———. *American Painting of the Nineteenth Century: Realism, Idealism, and the American Experience.* New York, Washington, and London: Praeger, 1969.

———. "Americans in Italy: Arcady Revisited," *Art in America* (New York), Jan. 1973, pp. 56-70.

———. *The Arcadian Landscape: Nineteenth Century American Painters in Italy.* Introduction by Charles E. Eldredge. Lawrence, Kans.: University Museum of Art, 1972.

———. "Grand Opera and the Small Still Voice," *Art in America* (New York) Mar.-Apr. 1971, pp. 68-73.

O'Doherty, Brian. *American Masters: The Voice and the Myth.* New York: Random House, 1973.

Prown, Jules D. *American Painting: From Its Beginnings to the Armory Show.* Cleveland: World, 1969.

Rathbone, Perry T. *Westward the Way.* St. Louis: City Art Museum of St. Louis, 1954.

Richardson, Edgar P. *American Romantic Painting.* Edited by Robert Freund. New York: Weyhe, 1944.

———. *Painting in America.* New York: Crowell, 1965.

———, and Wittman, Otto, Jr. *Travelers in Arcadia: American Artists in Italy, 1830-1875.* Detroit: The Detroit Institute of Arts, 1951.

Ritchie, Andrew C. *Abstract Painting and Sculpture in America.* New York: The Museum of Modern Art, 1951.

Rose, Barbara. *American Art since 1900: A Critical History.* New York and Washington: Praeger, 1967. Rev. ed., 1975.

———. *American Painting: The Twentieth Century.* Cleveland: World, 1969.

———. *Readings in American Art 1900-1975: A Critical History.* New York: Praeger, 1968. Rev. ed., 1975.

Rosenberg, Harold. "The American Action Painters," *Art News* (New York), Dec. 1952, pp. 22-23, 48-50. Reprinted in Geldzahler. *New York Painting and Sculpture, 1940-1970,* pp. 341-49.

Rosenblum, Robert. "The Abstract Sublime," *Art News* (New York), February 1961, pp. 38-41, 56-58. Reprinted in Geldzahler. *New York Painting and Sculpture, 1940-1970, pp.* 350-59.

———. *Modern Painting and the Northern Romantic Tradition: Friedrich to Rothko.* New York: Harper and Row, 1975.

Ruskin, John. *Modern Painters by a Graduate of Oxford.* 2 vols. London, 1843.

Sandler, Irving. *The Triumph of American Painting: A History of Abstract Expressionism.* New York and Washington, D.C.: Praeger, 1970.

Sanford, Charles L. *The Quest for Paradise: Europe and the American Moral Imagination.* Urbana: University of Illinois Press, 1961.

San Francisco. M. H. de Young Memorial Museum. *American Art: An Exhibition from the Collection of Mr. and Mrs. John D. Rockefeller 3rd.* Apr. 17-July 31, 1976. Text by E. P. Richardson. Also shown at the Whitney Museum of American Art, New York.

———, and The California Palace of the Legion of Honor. *The Color of Mood: American Tonalism, 1880-1910.* Jan. 22-Apr. 2, 1972. Text by Wanda M. Corn.

Sears, Clara Endicott. *Highlights among the Hudson River Artists.* Boston: Houghton Mifflin, 1947.

The Selected Writings of Ralph Waldo Emerson. Edited by Brooks Atkinson. New York: Modern Library, 1950.

Shepard, Paul. *Man in the Landscape.* New York: Knopf, 1967.

Smith, Henry Nash. *Virgin Land.* Cambridge, Mass.: Harvard University Press, 1970.

Stebbins, Theodore E., Jr. *The American Study of Light, 1860-1875.* Cambridge, Mass.: Fogg Art Museum, Harvard University, 1966.

Stein, Roger B. *John Ruskin and Aesthetic Thought in America, 1840-1900.* Cambridge, Mass.: Harvard University Press, 1967.

———. *Seascape and the American Imagination.* New York: Clarkson N. Potter, in association with the Whitney Museum of American Art, 1975.

St. Louis. City Art Museum of St. Louis. *Mississippi Panorama*. Autumn 1949.

Sweet, Frederick A. *The Hudson River School and the Early American Landscape Tradition*. Chicago: The Art Institute of Chicago, 1945.

Taylor, Joshua. *America as Art*. Washington, D.C.: Published for the National Collection of Fine Arts by the Smithsonian Institution Press, 1976.

Thoreau, Henry David. *The Writings of Henry David Thoreau*. 20 vols. Boston: Houghton Mifflin, 1906.

Utica, N.Y. Munson-Williams-Proctor Institute. *1913 Armory Show 50th Anniversary Exhibition*. Feb. 17–Mar. 31, 1963. Also shown at the Armory of the Sixty-ninth Regiment, New York.

Valsecchi, Marco. *Landscape Painting of the 19th Century*. Greenwich, Conn.: New York Graphic Society, 1971.

Vogel, Stanley N. *German Literary Influences on the American Transcendentalists*. New Haven, Conn.: Yale University Press, 1955.

Washington, D.C. National Collection of Fine Arts. *National Parks and the American Landscape*. June 23–Aug. 27, 1972. Texts by William H. Truettner and Robin Bolton-Smith.

Washington, D.C. The National Endowment for the Arts and the Corcoran Gallery of Art. *Wilderness*. Oct. 9–Nov. 14, 1971.

Washington, D.C. Smithsonian Institution Traveling Exhibition Service. *American Art in the Making: Preparatory Studies for Masterpieces of American Painting, 1800–1900, 1976*. Essay by David Sellin.

Whitman, Walt. *Leaves of Grass*. Brooklyn, 1855. Rev. ed., Philadelphia: D. McKay, 1891–92.

Wilmerding, John. *A History of American Marine Painting*. Boston: Little, Brown, 1968.

————, ed. *The Genius of American Painting*. New York: Morrow, 1973.

SOURCES FOR INDIVIDUAL ARTISTS

WASHINGTON ALLSTON
Richardson, Edgar P. *Washington Allston: A Study of the Romantic Artist in America*. Chicago: University of Chicago Press. 1948. Rev. ed., New York: Apollo, 1967.

MILTON AVERY
Washington, D.C. National Collection of Fine Arts. *Milton Avery*. Dec. 12, 1969–Jan. 25, 1970. Introduction by Adelyn Breeskin. Also shown at The Brooklyn Museum and Columbus Gallery of Fine Arts, Columbus, Ohio.

WILLIAM BAZIOTES
New York. The Solomon R. Guggenheim Museum. *William Baziotes: A Memorial Exhibition*. Feb. 5–Mar. 21, 1965. Introduction by Lawrence Alloway. Also shown at 11 other museums in the United States.

GEORGE BELLOWS
Young, Mahonri Sharp. *The Paintings of George Bellows*. New York: Watson-Guptill, 1973.

ALBERT BIERSTADT
Hendricks, Gordon. *Albert Bierstadt: Painter of the American West*. New York: Abrams, in association with the Amon Carter Museum of Western Art, 1974.

GEORGE CALEB BINGHAM
Bloch, E. Maurice. *George Caleb Bingham, The Evolution of an Artist: A Catalogue Raisonné*. 2 vols. Berkeley and Los Angeles: University of California Press, 1967.

RALPH ALBERT BLAKELOCK
Santa Barbara. The Art Galleries, University of California. *The Enigma of Ralph A. Blakelock, 1847–1919*. Jan. 7–Feb. 2, 1969. Texts by David Gebhard and Phyllis Stuurman. Also shown at California Palace of the Legion of Honor, San Francisco; Phoenix Art Museum, Phoenix, Ariz.; and Heckscher Museum, Huntington, N.Y.

WILLIAM BRADFORD
Lincoln, Mass. De Cordova Museum. *William Bradford: 1823–1892*. Nov. 2–Dec. 28, 1969. Text by John Wilmerding. Also shown at Whaling Museum of New Bedford, Mass.

ALFRED THOMPSON BRICHER
Indianapolis, Ind. Indianapolis Museum of Art. *Alfred Thompson Bricher 1837–1908*. Sept. 12–Oct. 28, 1973. Text by Jeffrey R. Brown.

CHARLES BURCHFIELD
Utica, N.Y. Munson-Williams-Proctor Institute. *Charles Burchfield: Catalogue of Paintings in Public and Private Collections*. Apr. 9–May 31, 1970.

GEORGE CATLIN
Catlin, George. *Episodes from Life among the Indians, and Last Rambles*. Edited by Marvin C. Ross. Norman: University of Oklahoma Press, 1959.

 Roehm, Marjorie, ed. *The Letters of George Catlin and His Family: A Chronicle of the American West*. Berkeley and Los Angeles: University of California Press, 1966.

ALBERT PINKHAM RYDER
Diana. 1900
Oil on leather, $29\frac{1}{8}$ x 20 in. (74 x 50.8 cm.)
Chrysler Museum at Norfolk, Virginia
Gift of Walter P. Chrysler, Jr.

FREDERIC EDWIN CHURCH
Huntington, David C. *The Landscapes of Frederic Edwin Church: Vision of an American Era.* New York: Braziller, 1966.

Washington, D.C. National Collection of Fine Arts. *Frederic Edwin Church.* Feb. 12–Mar. 13, 1966. Also shown at Albany Institute of History and Art, Albany, N.Y., and M. Knoedler & Co., New York.

THOMAS COLE
Noble, Rev. Louis Legrand. *The Course of Empire, Voyage of Life and Other Pictures of Thomas Cole.* New York: Cornish, Lamport, 1853. Rev. ed., *The Life and Works of Thomas Cole.* New York, 1856. Rev. ed., edited by Elliot S. Vesell. Cambridge, Mass.: Harvard University Press, 1964.

Rochester, N.Y. Memorial Art Gallery of the University of Rochester. *Thomas Cole.* Feb. 14–Mar. 23, 1969. Text by Howard S. Merritt. Also shown at Munson-Williams-Proctor Institute, Utica, N.Y.; Albany Institute of History and Art, Albany, N.Y.; Whitney Museum of American Art, New York.

JASPER FRANCIS CROPSEY
The Cleveland Museum of Art. *Jasper Francis Cropsey, 1823–1900.* July 8–Aug. 16, 1970. Essay by William S. Talbot. Also shown at Munson-Williams-Proctor Institute, Utica, N.Y., and National Collection of Fine Arts, Washington, D.C.

ARTHUR B. DAVIES
Cortissoz, Royal. *Arthur B. Davies.* New York: Whitney Museum of American Art, 1931.

Utica, N.Y. Munson-Williams-Proctor Institute. *Arthur B. Davies. 1862–1928: A Centennial Exhibition.* July 8–Aug. 26, 1962. Texts by John Gordon, Walter Pach, and Harris K. Prior.

THOMAS WILMER DEWING
Caffin, Charles H. "The Art of Thomas W. Dewing," *Harper's Magazine* (New York), Apr. 1903, pp. 714–24.

EDWIN DICKINSON
New York. Whitney Museum of American Art. *Edwin Dickinson.* Oct. 20–Nov. 28, 1965.

MAYNARD DIXON
Burnside, Wesley M. *Maynard Dixon: Painter of the West.* Provo, Utah: Brigham Young University Press, 1974.

THOMAS DOUGHTY
Goodyear, Frank H., Jr. *Thomas Doughty, 1793–1856: An American Pioneer in Landscape Painting.* Philadelphia: Pennsylvania Academy of the Fine Arts, 1973.

ARTHUR G. DOVE
Haskell, Barbara. *Arthur Dove.* San Francisco: San Francisco Museum of Art, distributed by New York Graphic Society, 1974.

ROBERT S. DUNCANSON
Fine, Elsa Honig. *The Afro-American Artist: A Search for Identity.* New York: Holt, Rinehart and Winston, 1973.

ASHER B. DURAND
Asher B. Durand papers. The New-York Historical Society and New York Public Library, Manuscript Division.

Durand, John. *The Life and Times of Asher B. Durand.* New York: Scribner's, 1894. Reprint, New York: Da Capo, 1968.

FRANK DUVENECK
Cincinnati Art Museum. *Exhibition of the Work of Frank Duveneck.* May 23–June 21, 1936. Preface by Walter H. Siple.

Duveneck, Josephine W. *Frank Duveneck: Painter-Teacher.* San Francisco: J. Howell, 1970.

THOMAS EAKINS
Hendricks, Gordon. *The Life and Work of Thomas Eakins.* New York: Grossman, 1974.

New York. Whitney Museum of American Art. *Thomas Eakins: Retrospective Exhibition.* Sept. 22–Nov. 21, 1970. Text by Lloyd Goodrich.

LOUIS MICHEL EILSHEMIUS
New York. Bernard Danenberg Galleries. *The Romanticism of Eilshemius.* Apr. 3–28, 1973. Text by Paul Karstrom.

SANFORD R. GIFFORD
New York. The Metropolitan Museum of Art. *A Memorial Catalogue of the Paintings of Sanford Robinson Gifford, N.A., with a Biographical and Critical Essay by Prof. John F. Weir.* 1881.

Weiss, Ila Joyce. "Sanford Robinson Gifford, 1823–1880." Unpublished Ph.D. dissertation, Columbia University, New York, 1968.

ARSHILE GORKY
Levy, Julien. *Arshile Gorky.* New York: Abrams, 1966.

Schwabacher, Ethel K. *Arshile Gorky.* New York: Published for the Whitney Museum of American Art by Macmillan, 1957.

Seitz, William. *Arshile Gorky: Paintings, Drawings, Studies.* New York: The Museum of Modern Art, 1962.

ADOLPH GOTTLIEB
New York. Whitney Museum of American Art and The Solomon R. Guggenheim Museum. *Adolph Gottlieb.* Feb. 14–Mar. 31, 1968. Texts by Robert Doty and Diane Waldman. New York: Praeger, 1968.

MORRIS GRAVES
Wight, Frederick S.; Baur, John I. H.; and Phillips, Duncan. *Morris Graves.* Berkeley: University of California Press, 1956.

JAMES HAMILTON
The Brooklyn Museum. *James Hamilton: American Marine Painter.* Mar. 28–May 22, 1966. Essay by Arlene Jacobwitz.

MARSDEN HARTLEY
McCausland, Elizabeth. *Marsden Hartley.* Minneapolis: University of Minnesota Press, 1952.

MARTIN JOHNSON HEADE
Stebbins, Theodore E., Jr. *The Life and Works of Martin Johnson Heade.* New Haven, Conn.: Yale University Press, 1975.

DAVID HOWARD HITCHCOCK
Oakland, Calif. The Oakland Museum. *Tropical: Tropical Scenes by the 19th Century Painters of California.* Oct. 5–Nov. 14, 1971.

WINSLOW HOMER
New York. Whitney Museum of American Art. *Winslow Homer.* Apr. 3–June 3, 1973. Text by Lloyd Goodrich. Also circulated to Los Angeles County Museum of Art and The Art Institute of Chicago.

Wilmerding, John. *Winslow Homer,* New York: Praeger, 1972.

EDWARD HOPPER
Goodrich, Lloyd. *Edward Hopper.* New York: Abrams, 1971.

GEORGE INNESS
Cikovsky, Nicolai, Jr. *George Inness.* New York: Praeger, 1971.

EASTMAN JOHNSON
New York. Whitney Museum of American Art. *Eastman Johnson.* Mar. 28–May 14, 1972. Directed by Patricia Hills. Also shown at The Detroit Institute of Arts, Cincinnati Art Museum, and Milwaukee Art Center.

JOHN FREDERICK KENSETT
New York. The American Federation of Arts. *John Frederick Kensett, 1816–1872.* 1968–69. Text by John K. Howat. Circulated to Whitney Museum of American Art, New York; Columbus Gallery of Fine Arts, Columbus, Ohio; M. H. de Young Memorial Museum, San Francisco; Museum of Fine Arts, Houston; Cummer Gallery of Art, Jacksonville, Fla.

JOHN LA FARGE
Cortissoz, Royal. *John La Farge: A Memoir and a Study.* Boston and New York: Houghton Mifflin, 1911.

FITZ HUGH LANE
Wilmerding, John. *Fitz Hugh Lane.* New York: Praeger, 1971.

JONAS LIE
Geldzahler, Henry. *American Painting in the Twentieth Century.* New York: The Metropolitan Museum of Art, 1965.

JOHN MARIN
Reich, Sheldon. *John Marin: A Stylistic Analysis and Catalogue Raisonné.* 2 vols. Tucson: The University of Arizona Press, 1970.

HOMER DODGE MARTIN
Mather, Frank Jewett, Jr. *Homer Martin: Poet in Landscape.* New York, 1912.
 Howat, John K. *The Hudson River and Its Painters.* New York: Viking, 1972.

THOMAS MORAN
Wilkins, Thurman. *Thomas Moran: Artist of the Mountains.* Norman: University of Oklahoma Press, 1966.

BARNETT NEWMAN
Hess, Thomas B. *Barnett Newman.* New York: The Museum of Modern Art, 1971.

GEORGIA O'KEEFFE
Goodrich, Lloyd, and Bry, Doris. *Georgia O'Keeffe.* New York: Whitney Museum of American Art, 1970.

MAXFIELD PARRISH
Ludwig, Coy. *Maxfield Parrish.* New York: Watson-Guptill, 1973.

GOTTARDO PIAZZONI
"Gottardo Piazzoni, 1872 . . . , Biography and Works." *California Art Research,* vol. 7, 1st series, WPA Project 2874, 1937. Typescript in San Francisco Museum of Modern Art.

JACKSON POLLOCK
O'Connor, Francis V. *Jackson Pollock.* New York: The Museum of Modern Art, 1967.
 O'Hara, Frank. *Jackson Pollock.* New York: Braziller, 1959.
 Robertson, Bryan. *Jackson Pollock.* New York: Abrams, 1960.
 Rubin, William. "Jackson Pollock and the Modern Tradition, Parts I–IV," *Artforum* (Los Angeles), Feb.–May 1967.

FREDERIC REMINGTON
Hassrick, Peter H. *Frederic Remington.* Fort Worth, Tex.: Amon Carter Museum of Western Art, 1973.

WILLIAM TROST RICHARDS
The Brooklyn Museum. *William Trost Richards: American*

ALBERT PINKHAM RYDER. *The Temple of the Mind.* Before 1888
Oil on wood, 17¾ x 16 in. (45.1 x 40.7 cm.)
Albright-Knox Art Gallery, Buffalo. Gift of R. B. Angus, Esq.

Landscape and Marine Painter, 1833–1905. June 20–July 29, 1973. Essay by Linda S. Ferber.

MARK ROTHKO
New York. The Museum of Modern Art. *Mark Rothko.* Jan. 18–Mar. 12, 1961. Text by Peter Selz.

ALBERT PINKHAM RYDER
Goodrich, Lloyd. *Albert P. Ryder.* New York: Braziller, 1959.

ROBERT SALMON
Wilmerding, John. *Robert Salmon: Painter of Ship and Shore.* Introduction by Charles D. Childs. Salem, Mass.: Peabody Museum of Salem, 1971.

JOHN SINGER SARGENT
Ormond, Richard. *John Singer Sargent: Paintings, Drawings, Watercolors.* New York: Harper and Row, 1970.

WILLIAM LOUIS SONNTAG
Howat, John K. *The Hudson River and Its Painters.* New York: Viking, 1972.

THEODOROS STAMOS
Pomeroy, Ralph. *Stamos.* New York: Abrams, 1974.

JOSEPH STELLA
Jaffe, Irma Blumenthal. *Joseph Stella.* Cambridge, Mass.: Harvard University Press, 1970.

CLYFFORD STILL
Thirty-Three Paintings in the Albright-Knox Art Gallery. Buffalo: The Fine Arts Academy, 1966.

Clyfford Still. San Francisco: San Francisco Museum of Modern Art, 1976.

AUGUSTUS VINCENT TACK
Austin. University Art Museum, The University of Texas at Austin. *Augustus Vincent Tack, 1870–1949: Twenty-six Paintings from The Phillips Collection.* Aug. 27–Oct. 3, 1972. Also shown at University of Maryland Art Gallery, College Park, Md.

HENRY OSSAWA TANNER
Matthews, Marcia. *Henry Ossawa Tanner: American Artist.* Chicago and London: University of Chicago Press, 1969.

ABBOTT HANDERSON THAYER
White, Nelson C. *Abbott H. Thayer: Painter and Naturalist.* Hartford, Conn.: Connecticut Printers, 1951.

MARK TOBEY
Seitz, William C. *Mark Tobey.* New York: The Museum of Modern Art, 1962.

Washington, D.C. National Collection of Fine Arts. *Tribute to Mark Tobey.* June 7–Sept. 8, 1974.

JOHN TRUMBULL
Sizer, Theodore. *The Works of Colonel John Trumbull: Artist of the American Revolution.* New Haven, Conn.: Yale University Press, 1950. Rev. ed., 1967.

JOHN VANDERLYN
Binghamton, N.Y. University Art Gallery, State University of New York. *The Works of John Vanderlyn: From Tammany to the Capitol.* Oct. 11–Nov. 9, 1970. Text by Kenneth C. Lindsay.

ELIHU VEDDER
Soria, Regina. *Elihu Vedder: American Visionary Artist in Rome, 1836–1923.* Rutherford, N.J.: Fairleigh Dickinson University Press, 1970.

JAMES ABBOTT MCNEILL WHISTLER
Chicago. The Art Institute of Chicago. *James McNeill Whistler.* Jan. 13–Feb. 25, 1968. By Frederick A. Sweet. Also shown at Munson-Williams-Proctor Institute, Utica, N.Y.

Duret, Théodore. *Histoire de J. McN. Whistler et de son oeuvre.* Paris, 1904. Published in English, Frank Rutter, trans. Philadelphia: Lippincott, 1917.

Pennell, E. R., and Pennell, J. *The Life of James McNeill Whistler.* 2 vols. London and Philadelphia: Lippincott, 1908.

THOMAS WORTHINGTON WHITTREDGE
Utica, N.Y. Munson-Williams-Proctor Institute. *Worthington Whittredge (1820–1910): A Retrospective Exhibition of an American Artist.* Oct. 12–Nov. 16, 1969. Introduction by Edward H. Dwight. Also shown at Albany Institute of History and Art, Albany, N.Y., and Cincinnati Art Museum.

ANDREW WYETH
Boston. The Museum of Fine Arts. *Andrew Wyeth.* 1970. Introduction by David McCord, selection by Frederick A. Sweet.

Corn, Wanda M. *The Art of Andrew Wyeth.* Greenwich, Conn.: New York Graphic Society, 1973.

PHOTOGRAPH CREDITS

Photographs not acknowledged in the following list have been supplied by the owners or custodians of the works:

Dave Allison, New York: 166 *bottom right;* Babcock Galleries, New York: 108 *top;* Henry B. Beville, Annapolis, Md.: 19; E. Irving Blomstrann, New Britain, Conn.: 22, 62 *bottom,* 166 *bottom left;* The Brooklyn Museum: 98; Doris Bry, New York: 117 *top,* 160; Childs Gallery, Boston: 78 *top;* Geoffrey Clements, New York: 25 *top,* 28 *top right,* 53 *top,* 91, 114 *top right,* 118 *bottom,* 156; Coe Kerr Gallery, New York: 114 *bottom;* Chris Focht, Binghamton, N.Y.: 99 *bottom right;* Hirschl and Adler Galleries, New York: 81, 90, 96; Peter A. Juley & Son, New York: 109 *bottom;* Kate Keller, New York: 32 *top left,* 82 *top left,* 111; Kate Keller and Dave Allison, New York: 144 *top;* Frank Kelly, Manchester, N.H.: 92 *top:* Henry A. LaFarge, New Canaan, Conn.: 138; Los Angeles County Museum of Art: 167 *bottom;* Bob McCormack, Tulsa, Okla.: 143; Manley Commercial Photography, Tucson, Ariz.: 16 *top;* Robert E. Mates and Paul Katz, New York: 118 *top;* Robert E. Mates and Gail Stern, New York, 162; James Mathews, New York: 35 *top,* 122, 168; Menil Foundation, Inc., Houston: 121; The Metropolitan Museum of Art, New York: 51, 82 *bottom left;* National Collection of Fine Arts, Smithsonian Institution, Washington, D.C.: 76; Neefus Studio, Hudson, New York: 49, 82 *bottom right;* Otto E. Nelson, New York: 14 *left,* 31 *bottom,* 100; The Oakland Museum, Oakland, Calif.: 136 *top;* Piaget, St. Louis: 23; Eric Pollitzer, New York: 17 *left,* 163; Walter Rosenblum, L.I., N.Y., for Borgenicht Gallery, New York: 117 *bottom;* John D. Schiff, New York: 68; Schopplein Studio, San Francisco: 16 *bottom,* 173; Adolph Studly, Pennsburg, Pa.: 54; Soichi Sunami, New York: 30, 31 *top,* 33, 34 *right,* 35 *bottom,* 36 *right and top left,* 108 *bottom,* 109 *top,* 113, 114 *top left,* 120, 123, 161; Joseph Szaszfai, Yale University Art Gallery, New Haven, Conn.: 36 *bottom left,* 167 *top;* Malcolm Varon, New York: 112; Herbert P. Vose, Wellesley Hills, Mass.: 139; Vose Galleries of Boston: 152 *bottom;* A. J. Wyatt, Philadelphia Museum of Art: 34 *bottom left,* 166 *top left.*

TRUSTEES OF THE MUSEUM OF MODERN ART

William S. Paley
Chairman of the Board

Gardner Cowles
David Rockefeller
Vice Chairmen

Mrs. John D. Rockefeller 3rd
President

J. Frederic Byers III
Mrs. Bliss Parkinson
Vice Presidents

Neal J. Farrell
Treasurer

Mrs. Douglas Auchincloss	John L. Loeb
Edward Larrabee Barnes	Ranald H. Macdonald*
Alfred H. Barr, Jr.*	Donald B. Marron
Mrs. Armand P. Bartos	Mrs. G. Macculloch Miller*
Gordon Bunshaft	J. Irwin Miller
Shirley C. Burden	Samuel I. Newhouse, Jr.
William A. M. Burden	Richard E. Oldenburg
Thomas S. Carroll	Peter G. Peterson
Ivan Chermayeff	Gifford Phillips
Mrs. C. Douglas Dillon	Nelson A. Rockefeller*
Mrs. Edsel B. Ford*	Mrs. Wolfgang Schoenborn*
Gianluigi Gabetti	Mrs. Bertram Smith
Paul Gottlieb	James Thrall Soby*
George Heard Hamilton	Mrs. Alfred R. Stern
Wallace K. Harrison*	Mrs. Donald B. Straus
Mrs. Walter Hochschild*	Walter N. Thayer
Mrs. John R. Jakobson	Edward M. M. Warburg*
Philip Johnson	Mrs. Clifton R. Wharton, Jr.
Mrs. Frank Y. Larkin	Monroe Wheeler*
Gustave L. Levy	John Hay Whitney

* *Honorary Trustee*